BRITISH WATERCOLORS

BRITISH WATERCOLORS

Drawings of the 18th and 19th Centuries

from the Yale Center for British Art

by SCOTT WILCOX

Introduction by Patrick Noon

Hudson Hills Press · New York

in Association with the Yale Center for British Art

and the American Federation of Arts

Published in the United States by Hudson Hills Press, Inc.,
Suite 301, 220 Fifth Avenue, New York, NY 10001.

Distributed in the United States by Viking Penguin Inc.
Distributed in Canada by Irwin Publishing Inc.
Distributed in Japan by Yohan (Western Publications Distribution Agency).

Editor and Publisher: Paul Anbinder

Copy editor: Irene Gordon

Designer: Howard I. Gralla Composition: Michael & Winifred Bixler

Manufactured in Japan by Toppan Printing Company.

LIBRARY OF CONGRESS CATALOGING IN PUBLICATION DATA

Wilcox, Scott, 1952–
British watercolors.

Catalog of a traveling exhibition to be held in various cities.
Bibliography: p. Includes index.
1. Watercolor painting, British–Exhibitions.
2. Watercolor painting–18th century–Great Britain–Exhibitions.
3. Watercolor painting–19th century–Great Britain–Exhibitions.
4. Yale Center for British art–Exhibitions.
I. Yale Center for British Art. II. Title.
ND1928.W533 1985 759.2'074'013 84–27779

ISBN 0–933920–68–7

This book has been published in conjunction with the exhibition
BRITISH WATERCOLORS
Drawings of the 18th and 19th Centuries from the Yale Center for British Art
organized by the Yale Center for British Art and the American Federation of Arts.
The exhibition and publication have been supported by the J. C. Penney Company, Inc.,
the Mabel Pew Myrin Trust, and the National Patrons of the AFA.
The publication has been supported by
the J.M. Kaplan Fund and the DeWitt Wallace Fund
through the AFA's Revolving Fund for Publications.

AFA Exhibition 82–12 / Circulated April 1985 – August 1986

COVER: William Turner of Oxford, *View from the Dean's Garden,
Christ Church, Oxford* (detail), ca. 1829–30?

CONTENTS

List of Artists

FOREWORD

The development of watercolor painting in the eighteenth and nineteenth centuries is one of the distinct accomplishments of British artists. Nowhere outside England is the evidence of this achievement more fully represented than in the holdings of the Yale Center for British Art. The Center and the American Federation of Arts—which has had as one of its ongoing commitments since its founding in 1909 the organizing of exhibitions of exceptional quality from important museum collections—have welcomed the opportunity to organize this exhibition of British watercolors dating from these two remarkable centuries. This collaboration has provided the unique opportunity to share some of the jewels of the Center's superb collection with other institutions and audiences across the country.

There are many whom we wish to thank for making this project possible: Patrick Noon, Curator, and Scott Wilcox, Assistant Curator, of the Department of Prints and Drawings at the Center, who selected the exhibition and researched and wrote the catalogue; their many colleagues who gave assistance; and Edmund Pillsbury and Andrew Wilton, formerly Director of the Center and Curator of Prints and Drawings respectively, who originally proposed the exhibition to the AFA.

At the American Federation of Arts we wish to express our appreciation to Jeffery J. Pavelka, Assistant Director, Exhibition Program, for overseeing the organizational and administrative aspects of the project. Other AFA staff to whom we are grateful for their contributions include: Jane S. Tai, Associate Director and Director, Exhibition Program; Amy McEwen, Coordinator, Scheduling; Carol O'Biso, Registrar; and Sandra Gilbert, Public Information Director. For their varied skills and support, we also acknowledge Konrad G. Kuchel, Susan MacGill, Carolyn Lasar, Teri Roiger, Fran Falkin, Mary Ann Monet, and Lindsay South.

We are indebted to Howard I. Gralla for the design of the book; to Irene Gordon for editing the manuscript; to Joseph Szaszfai for the color photography; and to Paul Anbinder, President, Hudson Hills Press, for his continued commitment to the publication.

We wish to express our appreciation to the J. M. Kaplan Fund and the DeWitt Wallace Fund for their generous support of the American Federation of Arts's Revolving Fund for Publications. Finally, we are deeply grateful to the J. C. Penney Company, Inc., the Mabel Pew Myrin Trust, and the National Patrons of the AFA for their support of the traveling exhibition and this publication.

Wilder Green
DIRECTOR, THE AMERICAN FEDERATION OF ARTS

Duncan Robinson
DIRECTOR, YALE CENTER FOR BRITISH ART

INTRODUCTION

LANDSCAPE was that branch of the pictorial arts to which British painters made their most significant contribution in the international arena. It should not be surprising then to find that the rapid sophistication of the techniques of watercolor painting in England during the century traced by this exhibition, commencing about 1760, was accomplished largely by landscapists, and that their collective achievement was without parallel elsewhere in Europe. This is not to deny the contributions by such artists as Richard Westall (cat. no. 18), an illustrator who was considered by his contemporaries to be as innovative as J. M. W. Turner (cat. nos. 31, 44, 56), or Samuel Shelley (1756–1808), a portrait miniaturist whose use of pigments heavily laden with gum arabic for greater translucency and richness anticipated much of later practice. Nevertheless, precedence must be accorded the landscapists who conspicuously outnumbered their colleagues working in other genres, and who directed the struggle to overcome the attitudes of condescension and indifference that often greeted their serious purpose. The selection of objects for this exhibition, indeed the Center's collections as a whole, reflect this precedence.

Watercolor painting did not burst suddenly on the English art scene, nor were artists and connoisseurs immediately sensible of its potential as a vehicle for the most advanced forms of aesthetic exploration. From the seventeenth century and through much of the eighteenth, the medium had been the instrument of cartographers, topographers, and decorators of engravings. In each of these functions it was employed sparingly, to enliven an otherwise linear transcription of visual data. As a result of these utilitarian ties, even the most ingenious painters in watercolor were still referred to as draftsmen before 1800. Like other types of drawing,

watercolors were often consigned to the portfolio, beautiful enough to be relished in solitude, but still thought of as preparatory works, or as lacking the conceptual interest of oil paintings. It was not until the first decade of the nineteenth century that such prejudices were confounded.

The flowering of the British school of watercolor painting proceeded from a complex array of causes, among them: a recognition of *naturalistic* landscape painting as a worthy pursuit of high art; a growing perception of the medium itself as an appropriate means for this type of investigation; experimentation with new painting methods; and the improvement of pigments and drawing papers. Each of these factors contributed in like part to the progress of the art. The belief that the contemplation of natural scenery was a pleasurable, even vital, experience, which could be revived by the artifices of painting, was fundamental to the development of the romantic landscape. Such pleasures could take the form of poetic or nostalgic associations, sublime rapture, or simple delight in nature's animation. What mattered was the individual's experience and the artist's ability to re-create the stimuli. We take for granted such an attitude, but for the eighteenth-century mind, nurtured on seventeenth-century landscape painting and admonished by theorists to elevate and improve "common nature," the notion that serious art should mirror natural phenomena or concern itself with real views was novel at best. The inscription on Jonathan Skelton's watercolor of 1757 (cat. no. 2), declaring that his view of Harbledown was painted from nature after a summer rain shower, is as refreshing as it is unexpected, but it would be another quarter-century before the formulas of old master painting would cease to dictate exclusively the terms of landscape composition.

As attitudes toward landscape painting changed—and they did so very rapidly in the last twenty years of the eighteenth century—watercolorists found themselves in a rather advantageous position. Theirs was the one medium that lent itself most readily to plein-air sketching and to evoking with its diaphanous washes of pure color the "unaffected breadth, clearness of tone, general harmony and aerial effect" of nature. As the career of a William Marlow (cat. no. 5) or a Thomas Hearne (cat. no. 20) attests, radical changes in taste require the cumulative efforts of many artists who, in the larger tide of events, may contribute only modestly themselves. There are the gifted few, however, who set the tenor of the debate. In landscape painting, such professional watercolorists as John Robert Cozens (cat. nos. 9, 13) and Paul Sandby (cat. nos. 3, 16) demonstrated that topography could be elevated by interpretative genius allied with inventive painting techniques. Their immediate successors, artists of acute sensitivity such as Thomas Girtin (cat. no. 24) and J. M. W. Turner, who trained as topographical draftsmen, rapidly absorbed, then enlarged, their vision. Specifically, it was Girtin's Yorkshire views of

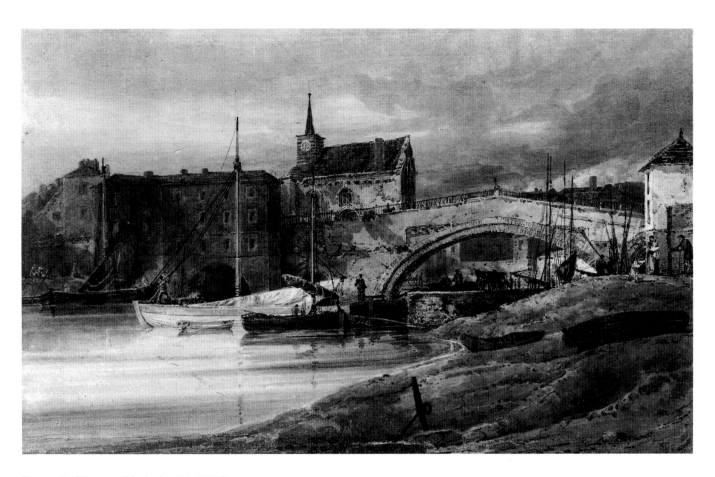

Figure 1. Thomas Girtin (1775–1802).
The Ouse Bridge, 1800.
Watercolor over pencil, 327 x 525 mm (12⅞ x 20⅝ in.). B1977.14.363.

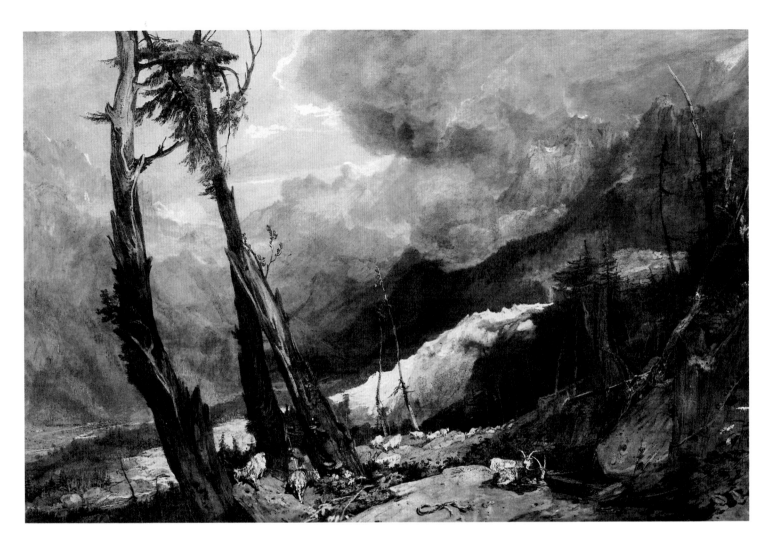

Figure 2. J. M. W. Turner (1775–1851).
Glacier and Source of the Arveiron, ca. 1803.
Watercolor over pencil with scraping out, 685 x 1,018 mm (27 x 40 in.).
B1977.14.4650.

1800–1802 (fig. 1) and Turner's Swiss watercolors of 1803–9 (fig. 2) that leveled whatever opposition remained to the idea that watercolor painting was incapable of fostering the highest flights of creative expression.

During the first decades of the new century, the ranks of the watercolor painters grew appreciably. They grouped together into exhibiting societies that courted public enthusiasm but certain objections to their demands for serious consideration had yet to be redressed. These often centered on the fugitive nature of watercolor pigments. To the advancement of the art but to the detriment of many objects that survive today, these reservations were not always taken seriously. The devastating effects of light on watercolor pigments were well known as early as the sixteenth century, but as watercolors became grander in scale and replaced oil paintings as wall decorations, the problem became the subject of heated debate. It was not uncommon for critics to caution against the folly of expending one's energies, or one's hard-earned capital, on pictures that might not survive their creators. For such critics, there seemed to be something immoral in an artist's not toiling for posterity. However, in an age when premature death was almost a prerequisite for the accolade of "genius," it was also proposed that watercolor's very vulnerability bespoke a courageousness on the part of its users that demanded public support. In the end, the variety of practical persuasions that were offered in watercolor's favor outweighed most concerns for longevity. To cite but a few examples: the basic techniques were easily learned by amateurs who were encouraged to test their skills while improving their mental and physical health out of doors; it was an inexpensive educational device in that its portability and its rapidness of production made art available to a much larger and geographically diverse audience than frequented annual exhibitions of oil paintings. Its smaller size, while initially an embarrassment, became a positive asset. In 1824, Stendhal, writing of his search for an apartment in Paris, quipped about the smallness of the available rooms compared to the gargantuan proportions of the paintings then exhibiting at the Salon and concluded:

> The century of painting has passed. . . . Our new mores, in abandoning hotels, demolishing châteaux, render a taste for paintings impossible; only engraving is useful to the public, and consequently, perhaps encouraged by it.[1]

Stendhal had a low opinion of watercolors. If he ignored their potential to perform the same domestic function as engravings but more decoratively, he nevertheless recognized a very important development: the art market throughout Europe was bulging with middle-class

patrons intent on furnishing dwellings of modest pretension. There also emerged in the 1830s a clamor among amateurs to assemble albums of watercolors, or sentimental keepsakes, and this mania marked the emergence of an entirely new clientele, the female collector.

An appreciation of British watercolor painting abroad, an event usually underestimated or ignored in scholarly literature, was relatively slow in maturing. This can be explained partially by the Napoleonic Wars, which deprived the British school of its Continental audience at precisely that moment when it began to assert itself forcefully at home. The isolation of English artists until 1816 also had the effect of generating on both sides of the channel the conviction that watercolor painting was peculiarly English. Especially in France, where the Davidian taste for large neoclassical pictures and the rigid distinction between the sketch and the finished work had reigned for some time, watercolor painting, as a legitimate discipline, was unthinkable before the sensation created at the 1824 Salon by the strong showing of professional British watercolorists. Although the more xenophobic critics would decry watercolor painting as a poor genre and lump it with other pernicious imports, from cayenne pepper to the poetry of Lord Byron, the younger artists—Eugène Delacroix (1798–1863), Paul Huet (1803–1869), Alexandre Decamps (1803–1860)—quickly grasped the possibilities of this medium and sent a tremor through the academic hierarchy. But by the time watercolor painting began to attract widespread public endorsement in Europe, the English had already registered many of their most notable successes, and Turner was pushing the descriptive capacity of the medium to its limits.

The variety of styles, techniques, and subjects of watercolor painting in the nineteenth century is one of the most extraordinary aspects of its history. The reopening of the Continent was providential for landscapists, for by 1820 every English site of special interest had been "'booked by the graphic tourist' over and over again, to the very resemblance of each ivy-grown buttress, ruined pinnacle, glassless window, and almost individual stone."[2] For the delight of experienced travelers and hearthside dreamers, a new generation of topographers, including William Callow (cat. no. 63), David Roberts (cat. no. 62), William James Müller (cat. no. 58), and most importantly Samuel Prout, the "Columbus of his art" (cat. no. 39), would return from foreign tours with a stock of scenic novelties—majestic, quaintly picturesque, or redolent of Oriental exoticism. With regard to stylistic concerns, a longstanding British predilection for painterly "color and effect" had become a source of national pride by 1825, and it was repeatedly contrasted with the French preoccupation with the "science of design" in the propaganda wars waged by the respective presses in the 1820s and 1830s. The

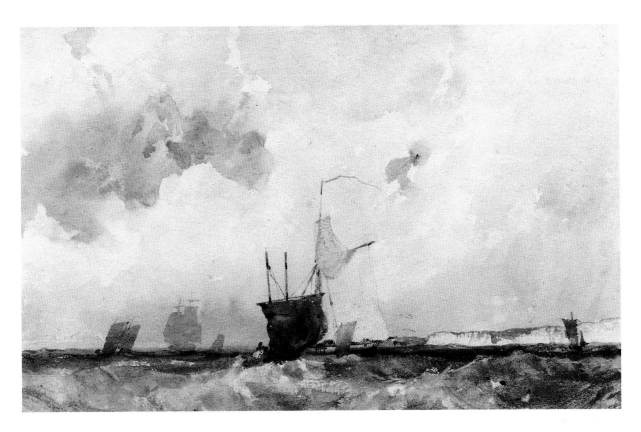

Figure 3. Richard Parkes Bonington (1802–1828).
Boats in a High Wind, ca. 1824.
Watercolor over pencil with scraping out, 140 x 212 mm (5⅝ x 8⁷/₁₆ in.).
B1977.14.6105.

conscientious pursuit of naturalism, renewed contact with the bright, clear atmosphere of the Mediterranean basin, growing interest in Venetian painting, and a desire to enliven and enrich exhibition pieces, all encouraged bravura handling and coloring. Although John Constable (1776–1837) and other sensible critics, John Ruskin for instance (cat. no. 70), would caution against meretricious displays of technique, artists during the second quarter of the century gambled increasingly on virtuosity in the production of what they considered "finished" paintings. The following passage, which might just as easily describe Turner's view of Rhodes (cat. no. 44), is typical of the public response:

> The new powers which have been developed in the violin by Paganini, are scarcely less matter of astonishment to the professors of music, than those discovered of late in the use of water-colours. . . . We certainly do exist at a period when perception is pushed almost to the utmost stretch of possibility. . . . Every year screws colouring up to a higher scale according to Exhibition pitch, until the very shadow of a cloud is rendered more intensely blue than Byron's classic sea. . . .[3]

If splendorous chromatic effects and resonant chiaroscuro were aims common to most water-colorists, executive skill revealed itself in diverse ways toward mid-century. The more traditional method of transparent washes fluidly touched to a clean sheet of paper was championed by older artists such as David Cox (cat. nos. 45, 69) and by the many imitators of Richard Parkes Bonington (1802–1828), perhaps the most immediately influential artist of his generation (fig. 3). A parallel trend favored more fastidious definition, aiming at greater detail and density, and relying on admixtures of opaque gouache and a miniaturist's technique. This development is quite apparent if one compares an early and a late work by William Henry Hunt (cat. no. 43 and fig. 4) or an Edward Lear study and one of his exhibition pieces carefully wrought in the studio (cat. no. 73). Instances of technical prowess played to popular Victorian taste, but that taste was capable, paradoxically, of reviving interest in Thomas Girtin at the same time that it doted on the most elaborate confections of John Frederick Lewis (cat. no. 59 and fig. 5), in which all distinctions between watercolor and oil painting are blurred.

After 1860, disagreement among professional watercolorists increased, prompted by a genuine concern for the future of the medium. Could watercolorists, it was asked, be true to their principles in forsaking the time-honored wash style for the realism of the photograph or the prestige of being likened to oil painters? It was a rather moot point, for the artistic revolt that would engulf Europe after mid-century would eventually call for the renunciation of traditional pictorial values and, with them, the abiding faith in and commitment to naturalistic

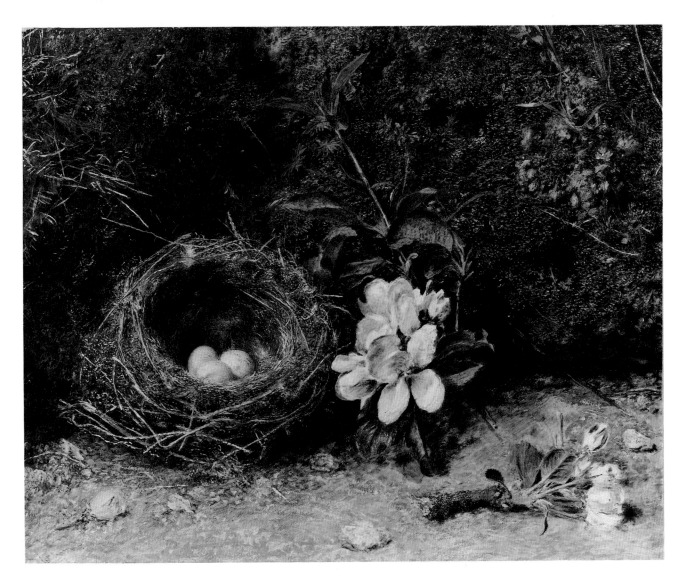

Figure 4. William Henry Hunt (1790–1864).
Bird's Nest with Sprays of Apple Blossoms, ca. 1845–50.
Watercolor and bodycolor, 255 x 307 mm (10 x 12⅛ in.). B1975.3.965.

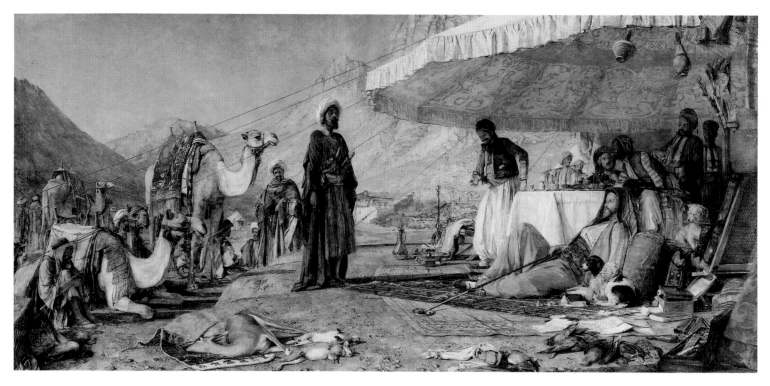

Figure 5. John Frederick Lewis (1805–1876).
A Frank Encampment in the Desert of Mount Sinai, 1842, 1856.
Watercolor and bodycolor over pencil, 648 x 1,343 mm (25½ x 52⅞ in.).
B1977.14.143.

representation. The imitative function of landscape painting would yield to preoccupations with the expressive properties of color and less formal design. The roots of this inexorable change are deep in the romantic conception of creativity. The symptoms were only later lamented by Ruskin who literally, but futilely, had his day in court against the premier spokesman for the avant-garde, J. A. M. Whistler (1834–1903), whom he berated for "flinging a pot of paint in the public's face." It is beyond the scope of this exhibition, but it is worth recalling that the watercolor "sketch," at which so many English artists excelled, would once again ascend in stature at the end of the century. A host of competent artists, such as H. B. Brabazon (1821–1906), Henry Moore (cat. no. 75), and Thomas Collier (1840–1891), would sustain, with their breezy styles, the level of earlier achievements; but it was left to such foreigners as Sargent and Whistler, Cézanne and Demuth, Prendergast and Nolde, to redefine the objectives of this common inheritance for a new age.

THE Department of Prints and Drawings at the Yale Center for British Art is the repository of nearly 15,000 watercolors and drawings and 35,000 engraved works, ranging in date from the seventeenth century to the first decades of the twentieth. Unlike most major print cabinets, its collections have no common history before the 1960s, when there began a concerted effort to assemble a representative selection of graphic art as a complement to a rapidly growing paintings collection. That such a body of works as now exists could be formed on short notice, and at such a late date, is a tribute to the sagacity of Paul Mellon and the expertise of his curators, in particular Dudley Snelgrove, who dared venture into an area of taste that had few partisans at that time outside Great Britain.

The core of the watercolor collection comprises portions of several outstanding private collections, including those of Iolo Williams and Martin Hardie, whose monographs on the history of the English watercolor remain standard references, and of Tom Girtin, the descendant of the great artist. But by far the largest number of sheets were acquired singly in the competitive marketplace. If its strengths reside in impressive holdings of works by acknowledged masters—Turner, Girtin, Lewis, Rowlandson—its important as a study collection is owing to the incredible number of artists, both professional and amateur, that it represents. In the selection of objects for this exhibition, the organizers have been guided by these criteria

of quality and comprehensiveness. Consequently, the visitor will discover watercolors by the famous and the obscure, by the landscapists, the satirists, and the figural draftsmen. If certain artists of importance have been omitted, it is because an object of suitable merit was unavailable. Fortunately, such lacunae are rare. Specific masterpieces were excluded on the basis of their unstable condition, their long exhibition histories, or their unwieldy proportions, but as Christopher White noted in his introduction to the Center's inaugural catalogue, the depth of the collection is such that comparable alternates are readily available. In addition to presenting a wide assortment of artists and subjects, the selection also illustrates the range of the water-color's functions: as memorandum, as a study for engraving, as a finished presentation or exhibition piece. It is regrettable that the extreme fragility of most large watercolors executed specifically for public exhibition made it impossible to represent that very important aspect of the tradition more abundantly. Although limited by these considerations and by the number of objects allowable in a traveling exhibition, it is our belief that the final selection explores the collections and the subject in a meaningful way.

When the Center opened its doors to the public in 1977, it had a clear mandate to en-courage, by its programs and facilities, an interest in British art on this side of the Atlantic. Temporary exhibitions, resident fellowships, and loans of individual objects to exhibitions organized elsewhere have been effective avenues to this end. But for the non-specialist and for the general public at some remove from New Haven, only a traveling exhibition of a selection of the Center's holdings would suffice. With this in mind, the project was initiated by the Center's first director, Edmund Pillsbury, and its first curator, Andrew Wilton. It might well have stalled, however, had it not been for the enthusiastic encouragement of the present director, Duncan Robinson, and for the timely intercession of the American Federation of Arts. If, then, the character and content of the exhibition reflect the preferences and contri-butions of many individuals, the ultimate responsibility and credit for its coherence belong to Scott Wilcox, Assistant Curator of Prints and Drawings.

In choosing a format for this publication, we were conscious of the many excellent cata-logues and published surveys that have preceded our project. The standard format of the ''collections catalogue,'' with its dense documentation of provenances, exhibition histories, and bibliographical citations, did not seem appropriate in this instance. For this reason, we adopted a less frequently used scheme for the entries—a series of brief essays which treat each object in depth, but which also link together in a continuous narrative. These prefatory remarks, then, are intended only to introduce the more thorough account of the history of this art form that

follows. We are deeply indebted to Scott Wilcox for participating in the selection of the exhibits and for undertaking to write that account. It is a perceptive personal assessment of artists and ideas that is as enjoyable to read as it is informative. Also deserving special thanks for their valuable contributions to the preparation of the exhibition and catalogue are a number of his colleagues at the Center and at Yale, in particular, Catherine Douglass, Randi Joseph, Rob Meyers, Theresa Fairbanks, Sylvia Rodgers, Constance Clement, Timothy Goodhue, Katherine DiGiulio, and Bruce Robertson. With her welcome and characteristic alacrity, Leslyn Keil typed the manuscript, while Joseph Szaszfai rephotographed all the works especially for this publication.

Patrick Noon
CURATOR

Notes

1. Stendhal [Henri Beyle], "Exposition de 1824," *Journal de Paris* (September 2, 1824).
2. *Library of the Fine Arts*, vol. 1, no. 6 (July 1831), pp. 509–10.
3. Ibid., pp. 511, 515.

BRITISH WATERCOLORS

Alexander Cozens (ca. 1717–1786)
Landscape with a Ruined Temple, ca. 1746–50

It is customary for accounts of British watercolor painting to begin with some reference to its topographical origins. The remarkable achievements in watercolor of the later eighteenth and nineteenth centuries were to a great extent the progeny of those simple tinted drawings of the early eighteenth century which recorded, with more or less fidelity, the appearance of actual places. Watercolor would remain to some degree bound to topography, as is evident from many examples in this exhibition. Yet watercolorists were by no means confined to this documentary role, and the earliest work in our selection, *Landscape with a Ruined Temple* by Alexander Cozens, demonstrates a quite different approach.

Cozens, one of the first British landscape painters to travel to Italy, arrived in Rome in 1746.[1] His sketchbook from his Roman visit[2] includes records in pencil outline of the Roman landscape and antiquities, but Cozens was not a topographer. More frequent in the sketchbook are compositional studies which show that Cozens was absorbing the traditions of imaginative landscape established in the seventeenth century by artists such as Claude Lorrain (1600–1682) and Gaspard Dughet (1615–1675).

Landscape with a Ruined Temple is a product of the Roman visit, dated by Andrew Wilton to the years directly after Cozens's return to England in late 1746 or 1747.[3] While the landscape with its classical round temple has a decidedly Roman character, it is purely Cozens's invention. Its rugged and somewhat severe appearance suggests that Cozens was studying not only Claude and Dughet, but also the earlier Italianate Dutch artists, such as Bartolomaeus Breenbergh (1599–1659).

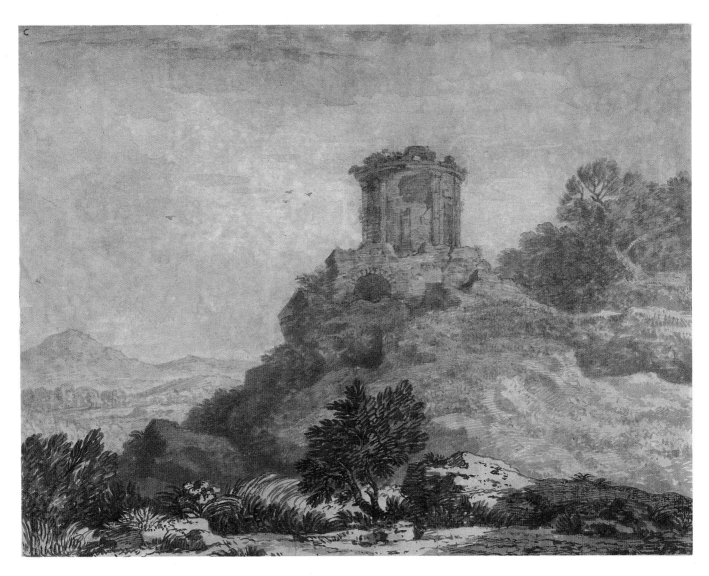

1. Alexander Cozens (ca. 1717–1786)
Landscape with a Ruined Temple, ca. 1746–50
brown wash over pencil
356 x 438 mm (14 x 17¼ in.)
Inscribed, upper left: *C*
B1975.4.1802

As Wilton has pointed out, the technique of this drawing demonstrates Cozens's indebtedness to such landscape engravers as François Vivares (1709–1780).[4] The brush is used almost like a pencil—or an engraver's burin—modeling forms with hatched lines rather than with fluid washes.

Cozens was by no means unusual in his employment of formulas derived from past landscape masters in the creation of original compositions. What sets him apart is the rigor with which he pursued a conceptual rather than a descriptive basis for landscape. Even when his attention was focused on natural phenomena, on types of trees or clouds, he was intent on classification.[5] His theoretical and pedagogical bent was already apparent in the Roman sketchbook, which he filled with lists of procedures for drawing and study. Years later, his patron William Beckford (1760–1844) would describe him as being "almost as full of Systems as the Universe."[6]

After Cozens returned to England, he was forced, as were so many watercolorists of the eighteenth and nineteenth centuries, to make his living as a drawing master. Unlike many, John Sell Cotman (cat. no. 51) and David Cox (cat. nos. 45, 69), for example, he seems to have found teaching congenial. He worked as drawing master at Christ's Hospital from 1749 to 1754 and at Eton from about 1763 to the end of his life.

Just before his death he published *A New Method of Assisting the Invention in Drawing Original Compositions of Landscape*, in a sense the culmination of a lifetime of teaching and theorizing. Through his method of deriving landscape compositions from inkblots, he sought not to subvert or undermine the tenets of classical landscape, but to open up fresh avenues into imaginative landscape. *A New Method* was much misunderstood and earned him the sobriquet "Blotmaster-General to the town."[7]

1. The most complete account of Alexander Cozens's life and art is A. P. Oppé, *Alexander and John Robert Cozens* (London: Adam and Charles Black, 1952). Andrew Wilton, *The Art of Alexander and John Robert Cozens*, exhibition catalogue (New Haven: Yale Center for British Art, 1980), adds much valuable information, particularly regarding those works in the Center's collection.

2. Yale Center for British Art, B1978.43.166. It is fully described and the notes transcribed in A. P. Oppé, "A Roman Sketch-book by Alexander Cozens," *Walpole Society*, vol. 16 (1927–28), pp. 81–93. See also Wilton, *Cozens*, pp. 19–23.

3. Wilton, *Cozens*, p. 24.

4. Ibid., pp. 9, 24.

5. In 1771, Cozens published *The Shape, Skeleton and Foliage of Thirty-two Species of Trees*. Included in his *New Method* of 1785 is a series of plates illustrating different types of skies.

6. Letter to Mrs. Harcourt, August 15, 1781; quoted in Oppé, *Alexander and John Robert Cozens*, p. 34.

7. *The Works of the Late Edward Dayes Containing . . . Professional Sketches of Modern Artists* (London: Mrs. Dayes, 1805), p. 325.

Jonathan Skelton (ca. 1735-1759)

Harbledown, a Village near Canterbury, 1757

Iolo Williams was the first to posit a distinct school of mid-eighteenth-century watercolor centered on the figure of George Lambert (1700–1765), the foremost landscape painter of the period.[1] The most accomplished watercolorists of this school are William Taverner (cat. no. 4) and Jonathan Skelton, presumably both pupils of Lambert.

Stylistic links in the work of these three artists seem persuasive. There is, however, no documentary evidence connecting Lambert with Taverner, and the only evidence of a connection between Lambert and Skelton is Skelton's recurring references to a "Mr. Lambert" in his letters from Rome.[2] Apart from these letters, which provide a record of Skelton's life from his arrival in Rome in late 1757 to his premature death there in 1759, we know virtually nothing of his life. Indeed, his work was completely unknown until the rediscovery of eighty-four of his drawings in a 1909 sale.[3]

In his earliest known watercolors, a series of views of Croydon dated 1754, Skelton's technique closely resembles that of Lambert. By 1757, the year of *Harbledown, a Village near Canterbury*, Skelton had refined the style inherited from Lambert into a more expressive and atmospheric instrument. The buildings and foliage are at once more solid and more delicate, and his compositions have gained an offhand grace lacking in his earlier work.

Skelton produced *Harbledown* in the standard manner of the tinted drawing. Over a pencil outline, he has modeled the forms in gray wash, then added washes of color, finally strengthening the outlines with pen. Yet Skelton uses this technique with great subtlety. Because of the richness of his color and the delicate, fluttering character of his pen work, this drawing has none of the hard, linear quality that the term *tinted drawing* suggests.

Harbledown belongs to a group of eight watercolors of Canterbury and its environs, all signed and dated 1757. These may have been intended as a set, on the model of other sets of watercolors or engraved views of a specific locality, such as the six views from Cranbourne Lodge at Windsor of 1752 by Thomas Sandby (1721–1798).[4] Skelton's *Harbledown* records the buildings of a particular institution, the lepers' hospital. Yet the emphasis of the drawing seems less on the features of the hospital than on the fall of light and the texture of brick and tile and old wood.

Skelton's concern with light and atmosphere is further demonstrated by an inscription on the drawing's old mount (now removed) which reads: "Harbledown, a village near Canterbury J. Skelton 1757/N: B: Drawn immediately after a heavy summer-shower." While the inscription does not make clear whether Skelton actually colored the drawing on the spot, we do know from his Roman letters that in Italy he worked outdoors in oils, bodycolor, and watercolor.

It was undoubtedly to break out of the narrow confines of topography that Skelton journeyed to Rome at the end of 1757. There he came under the influence of the seventeenth-century masters of the classical landscape, Gaspard Dughet (1615–1675) and Claude Lorrain (1600–1682). Although he continued to draw and paint actual places, frequently working out of doors, his works began to assume a more measured Claudian structure. But it was nature that he acknowledged as his chief master. In one of his letters, he related with some pride a discussion between visiting English gentry as to whether his manner was more like Claude's or like Lambert's. Lord Brudenell had the final word, asserting that "he could not tell what Master I immitated, He thought my manner very like Nature's manner."[5]

1. Iolo Williams, *Early English Watercolours* (London: Connoisseur, 1952; reprint Bath: Kingsmead Reprints, 1970), pp. 20–24.

2. Skelton's letters, written to his patron William Herring, are transcribed in Brinsley Ford, "The Letters of Jonathan Skelton Written from Rome and Tivoli in 1758," *Walpole Society*, vol. 36 (1960), pp. 23–82.

3. S. P. Pierce, "Jonathan Skelton and His Watercolours," *Walpole Society*, vol. 36 (1960), pp. 10–22.

4. Bruce Robertson associates Skelton's drawings of Canterbury with such sets of views in his dissertation in progress on Paul Sandby and his contemporaries (Yale University).

5. August 20, 1758; in Ford, "Letters," pp. 54–55.

2. Jonathan Skelton (ca. 1735–1759)
Harbledown, a Village near Canterbury, 1757
watercolor and pen and gray ink over pencil
203 x 540 mm (8 x 21¼ in.)
Inscribed by the artist, verso: *Harbledown Hospital J. Skelton 1757*
B1975.4.1956

3. Paul Sandby (1731–1809)
Italianate Landscape with Travelers, ca. 1765
watercolor with pen and gray ink over pencil
372 x 536 mm (14⅝ x 21⅛ in.)
B1975.3.982

Paul Sandby (1731–1809)
Italianate Landscape with Travelers, ca. 1765

Paul Sandby was active in the formation of the Society of Artists in 1760.[1] Eight years later he was a founding member of the Royal Academy. These organizations offered artists a new sense of status and, through annual exhibitions, provided a new public for their art. That Sandby, essentially a watercolorist trained as a topographer, should be directly and significantly involved in these developments speaks much of his personal prestige and of the rising fortunes of watercolor.

Italianate Landscape with Travelers, one of a pair of watercolors based on Continental models,[2] dates from the mid-1760s. While it cannot be identified as a work that Sandby exhibited, it does represent the type of carefully finished drawing he would have sent to the Society of Artists exhibitions. It also reflects his longstanding interest in imaginative landscape and in the compositional formulas of ideal landscape which had been established on the Continent. These formulas Sandby could imitate, as in this example, which echoes the landscapes of Marco Ricci (1676–1730), or incorporate into his topographical works.

Sandby began his career as a draftsman for the Board of Ordnance. From 1747 to 1751 he was employed on a military survey of Scotland after the suppression of the Jacobite Rebellion. The military connection resurfaced later when, from 1768 to 1796, he was Chief Drawing Master at the Royal Military Academy, Woolwich. Yet from the outset, Sandby's artistic interests and ambitions far outstripped the dry records of fact that military draftsmanship implies. The traditional designation of Sandby as the father of English watercolor can be rejected as overemphasizing his precedence and innovations and giving too orderly and sim-

plistic a picture of the eighteenth-century development of watercolor painting, but there is no denying that Sandby stood very much at the center of that development.

1. For Sandby, see A. P. Oppé, *The Drawings of Paul and Thomas Sandby in the Collection of His Majesty the King at Windsor Castle* (Oxford and London: Phaidon Press, 1947). This entry and the Sandby entry below (cat. no. 16) draw on the research carried out by Bruce Robertson in connection with his dissertation in progress at Yale University and the forthcoming exhibition devoted to Sandby at the Yale Center for British Art.

2. The other watercolor is also in the Yale Center for British Art, B1975.3.981.

William Taverner (1703-1772)
Nymphs Bathing in a Glade, ca. 1765-70

To English artists and connoisseurs of the eighteenth century, the landscapes of Claude Lorrain (1600–1682), Gaspard Dughet (1615–1675), and Nicolas Poussin (1594–1665) represented a pinnacle of achievement to be admired and emulated. The landscapes of the earlier Italianate Dutch artists such as Bartolomaeus Breenbergh (1599–1659) and Cornelis Poelenburgh (1586–1667), though their prestige was not as great, were also much appreciated and collected. Their influence can be seen in the works of English artists through much of the eighteenth century.

Nymphs Bathing in a Glade is one of a number of works of nude figures in the landscape by William Taverner which echo the Arcadian landscapes of Poelenburgh. In fact, the inscription by an unidentified hand on the verso of this drawing suggests that Taverner may actually have taken this composition from a specific painting by Poelenburgh.

Taverner was not a professional artist. Like his father, also named William, he practiced law. Yet his paintings and drawings were highly respected by his contemporaries. His obituary in the *Gentleman's Magazine* called him "one of the best landscape painters England ever produced."[1] George Vertue, in the notebooks he kept toward the writing of a history of art in England, recorded that Taverner had "a wonderful genius to drawing of landskap in an excellent manner adorned with figures in a stile above the common."[2] Horace Walpole, who, after Vertue's death in 1756, compiled his *Anecdotes of Painting in England* from Vertue's notes, acknowledged that although Taverner was an amateur, he "would have made a considerable figure amongst the renowned professors of the art."[3]

Taverner shared with Jonathan Skelton certain stylistic traits, which they both presumably learned from George Lambert (1700–1765). *Nymphs Bathing*, however, reflects a

tradition quite different from that of the tinted drawing of Skelton's *Harbledown* (cat. no. 2). Executed largely in transparent watercolor washes, *Nymphs Bathing* also contains a considerable amount of opaque color, or bodycolor (also known by the French term *gouache*). This allies the drawing to a tradition of decorative landscape painting in bodycolor introduced into England by such Continental artists as Marco Ricci (1676–1730).

Taverner's drawing is a sort of hybrid, a demonstration that the distinctions between tinted drawing and bodycolor painting were not rigidly observed.[4] While the figures and the foliage are outlined, the build-up of individual touches of watercolor and the use of bodycolor indicate a more painterly approach, which anticipates the advances of a later generation of watercolor artists.

Few of Taverner's drawings bear dates, making any chronology of his work difficult. *Nymphs Bathing* has previously been dated circa 1750, but Bruce Robertson in his study of Paul Sandby and his contemporaries suggests that this is a more mature work of circa 1765–70.[5]

1. *Gentleman's Magazine*, vol. 20 (1772), p. 496.
2. "The Vertue Note Books," *Walpole Society*, vol. 22 (1933–34), p. 68.
3. Horace Walpole, *Anecdotes of Painting in England*, vol. 4 (London, 1756), p. 109.

4. Even the eighteenth-century terminology was inconsistent. "Watercolor" was frequently used to describe a work in bodycolor, whereas most work in transparent watercolor was termed either "tinted" or "stained" drawing.
5. Dissertation in progress (Yale University).

4. William Taverner (1703–1772)
Nymphs Bathing in a Glade, ca. 1765–70
watercolor with touches of bodycolor
305 x 388 mm (12 x 15⁵⁄₁₆ in.)
Inscribed, verso: *Nymphs bathing | Polinburg*
B1975.4.1854

5. William Marlow (1740–1813)
An Oxcart in the Grotto of Posillipo, ca. 1770
watercolor over pencil
270 x 376 mm (10⅝ x 14¹³⁄₁₆ in.)
B1981.25.2649

William Marlow (1740-1813)
An Oxcart in the Grotto of Posillipo, ca. 1770

The Grotta Vecchia of Posillipo, a tunnel probably excavated during the reign of Nero, linked the Cape of Posillipo, the site of Virgil's villa, to the city of Naples. A Roman columbarium located over the grotto and above the viewpoint that William Marlow has adopted in his watercolor, was traditionally celebrated as Virgil's tomb. Marlow presents the view from within the entrance of the grotto facing toward Naples. From the grotto the road curves upward between the deeply cut rock toward the church of Santa Maria di Piedigrotta, whose tower appears directly above the oxcart. The dramatic nature of the ancient excavation, as well as the classical association with Virgil, recommended the site to British artists. A view by Francis Towne of the other entrance to the grotto is in the Yale Center.[1]

Marlow, a pupil of Samuel Scott (ca. 1702–1772) and a student at the St. Martin's Lane Academy, visited France and Italy in 1765 and 1766.[2] Like Richard Wilson (1713?–1782) before him, or the generation of British landscapists in watercolor who came to Italy after him, he was profoundly affected by his brief Italian experience. Marlow was a regular exhibitor with the Society of Artists from 1762, and its vice-president in 1778. From 1767, Italian subjects formed the majority of his exhibited work. An Oxcart in the Grotto of Posillipo is perhaps the "View of Part of Pausilippo near Naples" that he exhibited at the Society in 1770 (no. 76). Certainly this is a finished work, painted in rich, bold watercolor over only the sketchiest of pencil outlines. In its modeling of form through touches of local color rather than gray washes, and in the absence of any firm pencil or pen outlines, Marlow announces in this drawing the very innovations for which the British watercolor painters in Italy in the following decade— William Pars (cat. no. 6), John "Warwick" Smith (cat. no. 19), Francis Towne (cat. no. 14), and John Robert Cozens (cat. nos. 9, 13)—have generally been given credit.

1. B1975.4.1416. For other British views of Posillipo, see Duncan Bull, *Classic Ground: British Artists and the Landscape of Italy, 1740–1830*, exhibition catalogue (New Haven: Yale Center for British Art, 1981), pp. 37–39.

2. It has generally been stated that Marlow remained in Italy until 1768, but Michael Liversidge's research has revealed that Marlow was back in England in 1766 (letter from M. Liversidge).

William Pars (1742-1782)
The Falls of the Powerscourt, ca. 1771

In 1770 the second Viscount Palmerston asked William Pars to accompany him on a tour of Switzerland. Palmerston was a member of the Society of Dilettanti, an association of gentlemen formed to promote the appreciation of ancient art. In 1764, the Society had commissioned the Oxford antiquarian Richard Chandler to record the classical ruins of Greece and Asia Minor. Pars, then a young artist of twenty-two, was chosen to accompany Chandler's expedition as its draftsman. On the return of the expedition two years later, Pars submitted his drawings to the Society of Dilettanti, which voted its approval of his work. The drawings were engraved and published in 1769 under the title *Ionian Antiquities*.[1]

Palmerston must have been impressed with Pars's clear and delicate watercolor views. The Swiss Alpine views that Pars produced for Palmerston, which he exhibited at the Royal Academy in 1771, displayed a similar sensitivity and clarity. His views of both Asia Minor and the Swiss Alps were novelties in British art, breaking important ground for subsequent artist travelers.

Palmerston engaged Pars yet again in 1771 for a tour through Ireland. *The Falls of the Powerscourt* is a product of this tour, depicting the waterfall on the estate of the Viscount Powerscourt in county Wicklow. Pars's Irish views move away from the crisp forms, clear washes, and color of his Ionian and Swiss watercolors toward a softer, more atmospheric, and almost monochromatic treatment. In representing the wooded slopes of Powerscourt, Pars employs a fine, squiggly pen line to indicate the shapes of trees, but he expresses the density and texture of the woods through the accumulation of individual touches of the brush. Outline is absorbed into the overall masses of the view.

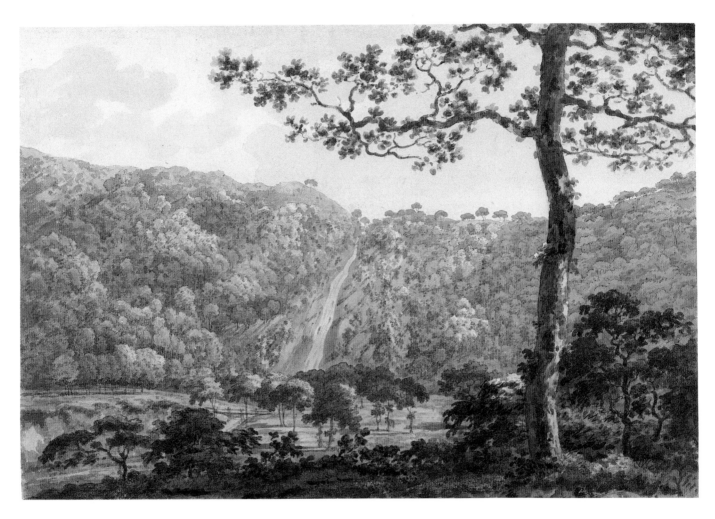

6. William Pars (1742–1782)
The Falls of the Powerscourt, ca. 1771
watercolor over pencil
267 x 381 mm (10½ x 15 in.)
B1975.4.1354

If the Irish views do not have quite the clean, decorative strength of the earlier series, they mark a significant step toward a richer, more varied use of the watercolor medium. In both its technique and its muted color range, *The Falls of the Powerscourt* brings to mind the achievements of John Robert Cozens (cat. nos. 9, 13). Yet in 1771, those achievements were still years away. When J. R. Cozens made his first trip to Italy in 1776, which signaled his emergence as a watercolorist of genius, Pars was already residing there. Awarded a scholarship by the Society of Dilettanti in 1775 to further his artistic studies in Italy, he spent the last seven years of his life in Rome, at the center of a circle of British artists who each in his own way furthered the development of watercolor painting.

1. For Pars's Ionian watercolors, see Andrew Wilton, "William Pars and His Work in Asia Minor," in Richard Chandler, *Travels in Asia Minor, 1764–1765*, ed. Edith Clay (London: British Museum, 1971). For Pars's Swiss views, see Andrew Wilton, *William Pars: Journey through the Alps* (Dubendorf, Zurich: De Clivo Press, 1979). Both publications include a complete chronology of Pars's life.

Charles Gore (1729-1807)
Lisbon from the Convent of St. Francis, 1774

Despite the exacting demands of the medium, watercolor has always appealed to the amateur. Its basic materials and techniques are more easily comprehended by the non-professional, and its effects, on the most rudimentary level, are more easily achieved than those of oil painting. While the story of British watercolor centers on professional artists expanding the capabilities of the medium, these achievements must be seen against a background of amateur activity.

Within this background a few gifted individuals stand out. William Taverner (cat. no. 4) achieved a semiprofessional status, his works respected by professional artists and sought by collectors. Another amateur who gained a considerable reputation among artists and cognoscenti was the Lincolnshire landowner Charles Gore.

Gore's art was praised by no less a cultural giant than Johann Wolfgang Goethe.[1] He was a friend and sketching companion of the German landscape painter, Jakob Philipp Hackert (1737–1807), the watercolorist John Robert Cozens (cat. nos. 9, 13), and the influential connoisseur and art theorist Richard Payne Knight (1750–1824). It would be only natural to assume that the style of Gore's numerous topographical watercolors was shaped by his association with these artists and critics. Yet, *Lisbon from the Convent of St. Francis*, drawn before he had met them, shows that he was already a precise and sensitive draftsman.

An avid collector of the marine drawings of the van de Veldes (Willem the Elder, 1611–1693, and Willem the Younger, 1633–1707), Gore copied their drawings and in the case of some slighter examples actually worked up the original van de Velde sheets into more finished objects.[2] It was no doubt this experience of working with the van de Velde drawings that refined the draftsmanship and shaped the style evident in his view of Lisbon.

His wife's poor health required that they winter abroad. The winter of 1773/74 was spent in Lisbon. Later in 1774 they moved on to Italy, residing in Florence and Rome, and traveling throughout the peninsula until 1778. It was during these Italian years that he became acquainted and worked with Hackert, Cozens, and Knight.[3]

In *Lisbon from the Convent of St. Francis*, the strange steplike division between drawing and blank sheet suggests that Gore was looking over obstructing walls or buildings which he has omitted from his composition, or that the view was taken with some optical device through which he framed one segment of the view at a time, moving it downward to the right to follow the contour of the land as it fell away to the harbor. The ribbon of closely observed and precisely detailed drawing separating the freely washed blue of the sky from the uncolored expanse of the bottom third of the sheet, together with the lengthy inscription running neatly along the lower edge, creates an effect so elegant that one feels it to be not simply a work broken off in progress, but a conscious, studied statement.

1. Goethe appended a biography of Gore to his *Philipp Hackert, Biographische Skizze* of 1811.

2. A drawing by Willem van de Velde the Elder (1611–1693) "finished" by Gore, in the National Maritime Museum, Greenwich, was shown in their exhibition *On Many Waters: Marine Watercolours 1650–1930* (1983), no. 6.

3. An account of Gore's life, concentrating on his association with Cozens and Knight, is included in C. F. Bell and Thomas Girtin, "The Drawings and Sketches of John Robert Cozens," *Walpole Society*, vol. 23 (1934–35), pp. 8–11.

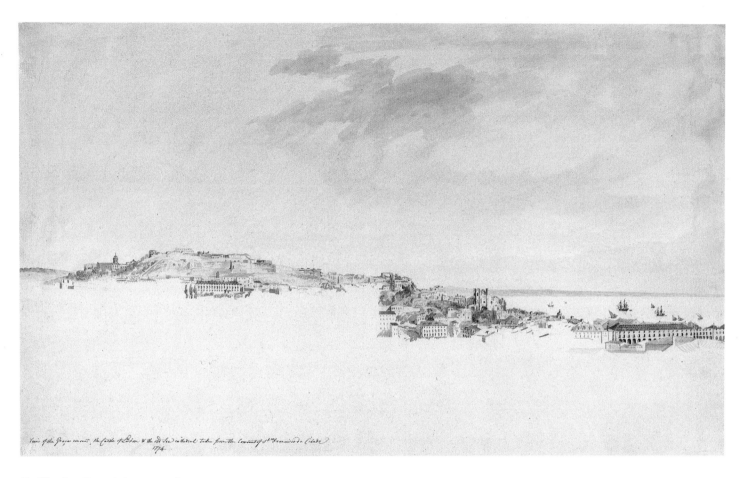

7. Charles Gore (1729–1807)
Lisbon from the Convent of St. Francis, 1774
watercolor with pen and black ink over pencil
275 x 444 mm (10¹³⁄₁₆ x 17½ in.)
Inscribed by the artist, lower left:
View of the Graca convent the Castle of Lisbon & the old See Cathedral taken from the Convent of St Francisco da Cidade | 1774
B1975.4.1813

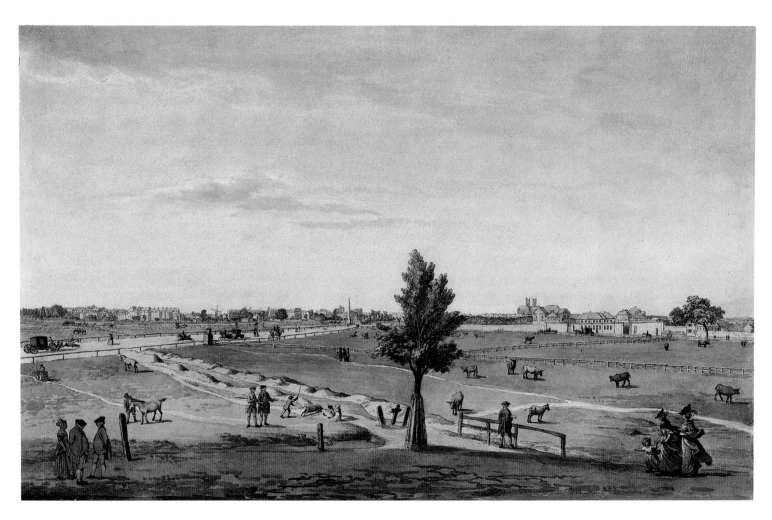

8. Samuel Hieronymous Grimm (1733–1794)
Kennington Common, 1776
watercolor with pen and gray ink and bodycolor
338 x 520 mm (13⁵⁄₁₆ x 20½ in.)
Signed and dated along fence rail: *S H Grimm fecit 1776*
B1975.4.1531

Samuel Hieronymous Grimm (1733-1794)

Kennington Common, 1776

Samuel Hieronymous Grimm, a Swiss poet and watercolorist, settled in London in 1768, the year of the foundation of the Royal Academy.[1] To the first Royal Academy exhibition the following year he contributed four watercolors, and he continued to exhibit for a number of years at the Royal Academy, the Society of Artists, and the Free Society. His work, which consisted mostly of topographical views and caricatures, was popular in England. As Edward Edwards (1738–1806) sourly put it in his collection of capsule biographies of his fellow artists, Grimm "had constant employment as his prices were low."[2] This is not fair to Grimm's achievement, limited though it was, for his watercolors show him to have been an avid observer and a gifted recorder of his adopted home.

Grimm was employed by the naturalist Gilbert White to produce illustrations for his *Natural History and Antiquities of Selborne*. White described Grimm's working method, which followed standard eighteenth-century topographical practice:

> He first of all sketches his scapes with a lead pencil; then he pens them all over, as he calls it, with Indian ink, rubbing out the superfluous pencil strokes; then he gives a charming shading with a brush dipped in Indian ink; and last he throws a light tinge of water-colours over the whole. The scapes, many of them at least, looked so lovely in their Indian-ink shading that it was with difficulty the artist could prevail on me to permit him to tinge them; as I feared the colours might puzzle the engravers: but he assured me to the contrary.[3]

While Grimm arrived in London a fully formed artist, the influence of the doyen of British topographers, Paul Sandby (cat. nos. 3, 16), can certainly be detected in the bright, pleasant color and delicate, humorous figures of *Kennington Common*. The strangely open and unclassical composition is, on the other hand, quite unlike Sandby.

Although this watercolor has been known as "Kennington Green," Kennington Green was a nineteenth-century development. The extent of the open space in Grimm's drawing and its relation to such distant landmarks as Westminster Abbey on the horizon at the right suggest that this is actually a view looking northwest across Kennington Common. In the eighteenth century, Kennington was still largely meadowland, much of it marshy and crossed by drainage ditches. The opening of Westminster Bridge and Kennington Road in the middle of the century made the area more accessible to London and Westminster, and from about the time of Grimm's depiction it began to be developed as a residential area. The Common itself was known as a place of execution and a meeting ground for itinerant preachers.[4]

1. For Grimm's life and work, see Rotha Mary Clay, *Samuel Hieronymous Grimm* (London: Faber and Faber, 1941).

2. Edward Edwards, *Anecdotes of Painting* (London, 1808; reprint London: Cornmarket, 1970), p. 217.

3. Rashleigh Holt-White, ed., *The Life and Letters of Gilbert White of Selborne* (London: John Murray, 1901), vol. 1, p. 326.

4. For the history of this area, see "Kennington," in *The Parish of St. Mary Lambeth*, ed. F. H. W. Sheppard, Greater London Council, *The Survey of London*, Part 2, Southern Area, vol. 26 (London: Athlone Press, 1956), ch. 1, pp. 19–56.

John Robert Cozens (1752-1797)

Interlaken, 1776

In August and September of 1776 John Robert Cozens traveled through Switzerland on his way to Italy. He was presumably in the company of Richard Payne Knight (1750–1824), the young connoisseur who would later author several influential works on art theory.[1] *Interlaken* was a product of the Swiss journey, one of fifty-seven drawings in an album that was inscribed: "Views in Swisserland, a present from R. P. Knight, and taken by the late Mr. Cozens under his inspection during a Tour in Swisserland in 1776."[2]

The monochrome wash drawings that came from this album have been considered as sketches from nature, but Oppé and Wilton have both argued that the careful and uniform execution of the drawings and the absence of more pronounced pencil underdrawing suggest that the set was worked up later, perhaps after Cozens's arrival in Rome in November.[3] While some of the drawings are inscribed with specific dates in August and September, these inscriptions may refer only to the date when Cozens and Knight visited that site. There is another more fully colored version of *Interlaken* in the British Museum.[4] It is one of several reworkings in color of subjects from the Knight series.

In its essentially monochromatic washes and its rugged alpine scenery, the Yale version recalls the mountainous landscape compositions for which Cozens's father, Alexander (cat. no. 1), was noted. Yet John Robert's drawings in the Knight series are all views of actual Swiss scenes. Although John Robert absorbed something of his father's poetic, evocative approach to landscape, the son unlike the father always retained a solid topographical basis for his art. If the father's work predisposed the son to mountainous landscape, a more direct precedent for

his view-taking excursion with Knight was the set of alpine watercolors produced by William Pars (cat. no. 6) when he accompanied Lord Palmerston to Switzerland in 1770.

While Alexander Cozens's fantastic mountain landscapes have roots in the Mannerist landscapes of the sixteenth century, the taste for mountainous scenery was largely an eighteenth-century development, part of the century's growing preoccupation with the aesthetic category of the Sublime. The appreciation of Sublime nature inspired Pars, J. R. Cozens, and other watercolorists, such as Francis Towne (cat. no. 14), to produce dramatic alpine views in the 1770s and 1780s. Cozens's view in *Interlaken*, however, lacks the terrific, overwhelming character that would stamp it as Sublime. The peaks of the Jungfrau rise majestically but distantly within a classically framed landscape.

1. Among Knight's many publications reflecting his wide-ranging interests, *The Landscape, A Didactic Poem* (London, 1794) and *An Analytical Inquiry into the Principles of Taste* (London, 1805) played an important role in the period's theoretical debates on taste and landscape. For a consideration of Knight as writer, collector, and patron, see Michael Clarke and Nicholas Penny, eds., *The Arrogant Connoisseur: Richard Payne Knight, 1751–1824* (Manchester: University Press, 1982).

2. Twenty-four of the drawings are now in the British Museum; the rest are scattered among various collections. The album itself no longer exists. A. P. Oppé, *Alexander and John Robert Cozens* (London: Adam and Charles Black, 1952), p. 126, expressed reservations about the authenticity of the inscription and the provenance of the album; Andrew Wilton, *The Art of Alexander and John Robert Cozens*, exhibition catalogue (New Haven: Yale Center for British Art, 1980), p. 39, sees no reason to doubt the inscription.

3. Oppé, *Alexander and John Robert Cozens*, p. 217; Wilton, *Cozens*, p. 39.

4. British Museum, London, 1910.2.12.242.

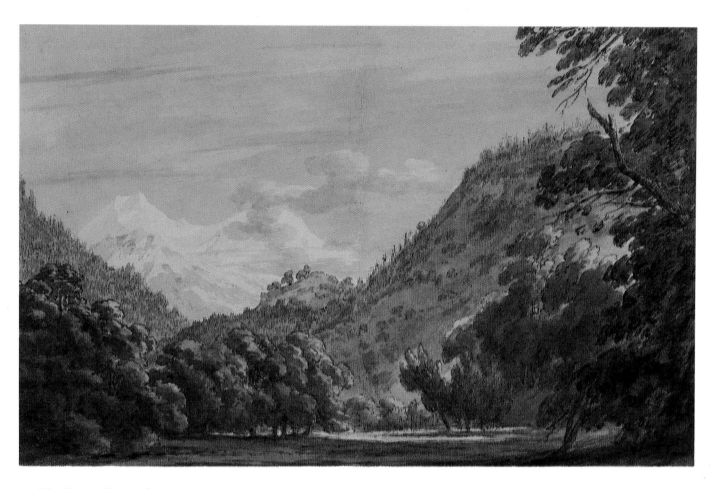

9. John Robert Cozens (1752–1797)
Interlaken, 1776
brown and gray wash with pen and brown ink over pencil
232 x 356 mm (9⅛ x 14 in.)
Inscribed, verso: *From the Road between the Lake of Thun & Underseen* and *16*
B1975.3.1000

Thomas Jones (1743–1803)
Tivoli, 1777

Thomas Jones visited Tivoli from November 9 to 16, 1777. This watercolor of the famous Cascade, one of the most popular subjects with British artists in Italy, derives from that visit. In his *Memoirs*, based in part on diaries kept during his stay in Italy between 1776 and 1783, Jones recorded that the countryside at Tivoli "seems formed in a peculiar manner by Nature for the Study of the Landscape-Painter." His staccato description of the view of the Great Cascade enumerates its features in terms conditioned by the aesthetic categories of the Sublime and the Picturesque:

> At Tivoli – the foaming Torrents rush down the Precipices into the deep Abyss with a fearful Noise and horrid Grandeur – the immense Masses of Stone rise abrupt – luxuriantly fringed with Shrubs, and crowned with antique towers and Temples – Where the perpendicular & hanging Sides admit of no vegetation, & you discover the naked Rock – the Eye is charmed with the most beautiful variegated Tints – White, Grey, Red & Yellow – opposing, or blending their different Dyes together – But here is wanting the large Umbrageous Tree – to deck the foreground – The Plantations being chiefly Olive, which growing thin & stragling, cast not the Venerable Shade of the Forest – though, in the distance – they have a good Effect. . . .[1]

Echoing Jonathan Skelton's observations of almost twenty years earlier, he asserted that the style of landscape painting of Gaspard Dughet (1615–1675) had been founded on the country around Tivoli and that of Claude Lorrain (1600–1682), on the Campagna.

As such comments suggest, Jones was by no means indifferent to the important precedent of these seventeenth-century masters. His larger exhibition oils display their influence, mediated by his teacher Richard Wilson (1713?–1782). After studying under Henry Pars

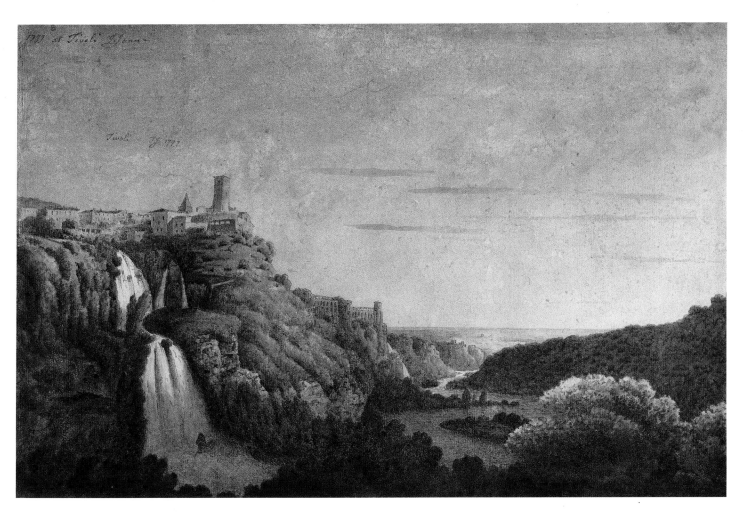

10. Thomas Jones (1743–1803)
Tivoli, 1777
watercolor over pencil with gum arabic
277 x 413 mm (10⅞ x 16¼ in.)
Inscribed, upper left: *6 | 1777 at Tivoli T. Jones | Tivoli—TJ 1777;*
on verso: *for the painting*
B1981.25.2638

(1734–1806) at William Shipley's School in the Strand, Jones worked in Wilson's studio between 1763 and 1765. When he arrived in Rome in 1776, he wrote, "I had seen and Copyed so many Studies of that great Artist Mr *Richard Wilson*, which he had made here, and was so familiarized with, & enamoured of *Italian* forms, that I enjoyed pleasures unfelt by my Companions."[2] There is, however, little of Dughet, Claude, or Wilson in the remarkably fresh and direct oil sketches and watercolors that Jones produced during his Italian years.

It was a fruitful and liberating period for British landscape artists in Italy. Jones's years in "Magick Land," as he referred to it, coincided with the visits of William Pars (cat. no. 6), whom he had known at Shipley's, John "Warwick" Smith (cat. no. 19), Francis Towne (cat. no. 14), and John Robert Cozens (cat. nos. 9, 13). All were friends and sketching companions.

Since the appearance on the market in 1954 of a group of previously unknown oil sketches,[3] Jones has been celebrated as an original and precocious practitioner of open-air sketching in oils. Presumably *Tivoli*, and Jones's other Italian watercolors which share its format and technique, were also the products of his outdoor sketching. Yet the dense buildup of forms through layers of wash and individual touches, the intensity of the color, and the use of gum arabic suggest a more elaborate process than one would expect in open-air sketching. Whether the numbers and inscriptions that these watercolors bear are working sketchbook notations or the numbering and labeling of a set of finished views remains an open question. In either case, they display a fresh and sensitive approach to the classical landscape. The inscription on the verso indicates that Jones may have based an untraced oil painting on this drawing.[4]

1. "Memoirs of Thomas Jones," *Walpole Society*, vol. 32 (1946–48), pp. 66–67. The memoirs provide a major source of information on both Jones and the other British artists at work in Italy during the period.

2. Ibid., p. 60.

3. These works had been passed down in the artist's family. *Tivoli* was part of a group of objects in the possession of another descendant, Canon J. H. Adams, which came on the market in 1975.

4. Duncan Bull, *Classic Ground: British Artists and the Landscape of Italy, 1740–1830*, exhibition catalogue (New Haven: Yale Center for British Art, 1981), pp. 63–64n, suggests that this oil may be the one painted for Mr. Blackden and mentioned in the "Memoirs," pp. 75, 87.

George Barret, Sr. (1728/32–1784)
Park Landscape with Sheep, ca. 1778

In his *Essays on Painting*, the watercolor artist Edward Dayes (cat. no. 21) grouped George Barret with Richard Wilson (1713?–1782) and Thomas Gainsborough (1727–1788) as the three great masters of English landscape painting.[1] After a modicum of success in the 1760s, Wilson found little public favor with his landscapes in the 1770s. Gainsborough earned his living not with his landscapes, which he himself most valued, but with his portraits. For the Irishman Barret, however, popular success as a landscape painter followed directly on his arrival in London in 1762.

Although he enjoyed the support of such influential patrons as his compatriot Edmund Burke and William Lock of Norbury Park,[2] Barret's success was achieved in large measure through those societies which were at that time being established to improve the lot of artists and to bring their work before a wider public in annual exhibitions. In 1764, the first year of his exhibiting, Barret won the first premium in landscape at the Society of Arts. He was also a regular exhibitor first with the Society of Artists and, from 1768, with the Royal Academy, of which he was a founding member.

His popularity may well have had a detrimental effect on his painting. Dayes attributed the variable quality of his work to the great demand for it;[3] Edward Edwards (1738–1806) criticized Barret's "want of harmony throughout his pictures";[4] Wilson, embittered by his own lack of success, characterized his rival's landscapes sharply as "spinach and eggs."[5] The criticisms were directed at his oil paintings, which represented his primary field of endeavor. His watercolors, such as *Park Landscape with Sheep*, are altogether fresher in both color and composition. The technique is yet again that of the tinted drawing, in which the play of light

and the masses of foliage are established in gray wash over which pale washes of color are applied.

Park Landscape with Sheep came from an album of drawings that belonged to the artist's descendants. Other drawings in the album were signed and dated 1778, providing an approximate date for the present watercolor.

1. *The Works of the Late Edward Dayes Containing . . . Essays on Paintings . . .* (London: Mrs. Dayes, 1805), p. 195.

2. It was through the influence of Burke that Barret was appointed Master Painter to Chelsea Hospital. For Lock, Barret decorated a room at Norbury Park with a panoramic landscape representing the Cumberland hills.

3. *The Works of the Late Edward Dayes Containing . . . Professional Sketches of Modern Artists* (London: Mrs. Dayes, 1805), p. 316.

4. Edward Edwards, *Anecdotes of Painting* (London, 1808; reprint London: Cornmarket, 1970), pp. 97–98.

5. Wilson's remark was related by William Beechey and recorded by Dawson Turner; see Dawson Turner, *Outlines in Lithography* (Yarmouth, 1840), p. 91.

11. George Barret, Sr. (1728/32–1784)
Park Landscape with Sheep, ca. 1778
watercolor over pencil
372 x 501 mm (14⅝ x 19¾ in.)
Inscribed, upper right: *G. Barrett*
B1977.14.6096

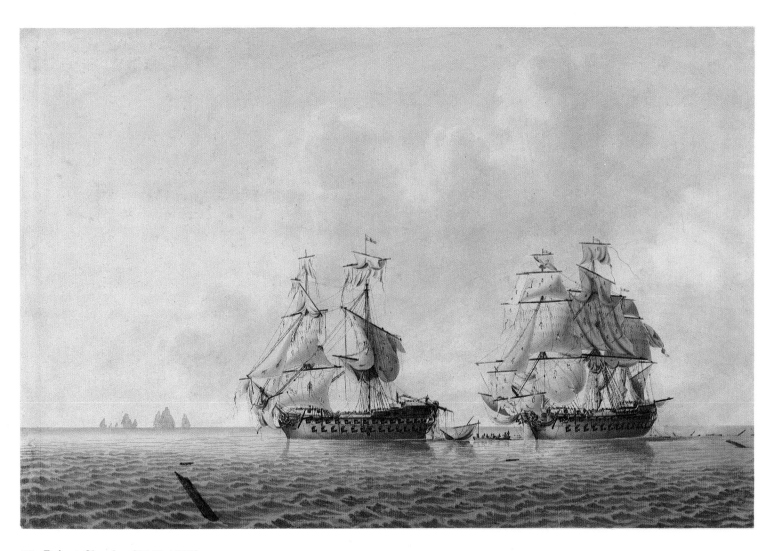

12. Robert Cleveley (1747–1809)
An English Man-of-War Taking Possession of a Captured Ship, 1783
watercolor over pencil with pen and gray ink
343 x 505 mm (13½ x 19⅞ in.)
Signed and dated on wreckage, lower left: *Rt. Cleveley del. 1783*
B1975.4.1476

Robert Cleveley (1747-1809)

An English Man-of-War Taking Possession of a Captured Ship, 1783

Eighteenth-century marine painting was a specialized branch of art. Its practitioners were generally men with an intimate knowledge of ships and shipping, and its patrons were frequently sea captains, merchants, and naval officers who insisted on accuracy of detail. Robert Cleveley's father, John Cleveley the Elder (ca. 1712–1777), was a shipwright turned marine artist. Robert and his twin brother, John (1747–1786), grew up amid the shipyards of Deptford and both followed their father in working in the shipyards before becoming artists.

Joseph Farington (1747–1821) recorded that "Robert Clevely, the ship painter when young was bred a Caulker but not liking the business quitted it. Admiral Vandeput has been his great friend. He was Clerk to the Admiral when Captn. of a Yacht & on other service. . . . When Clevely was a Caulker He was laughed at for working in Gloves."[1] From shipyard worker, a station in life for which he obviously felt himself unsuited, he rose by means of his art. A regular exhibitor at the Royal Academy from 1780 to 1803, he became Marine Draughtsman to the Duke of Clarence and Marine Painter to the Prince of Wales.

As artists the Cleveleys worked within a tradition of British marine painting which could be said to date from the arrival in England of the Willem van de Veldes, father (1611–1693) and son (1633–1707) in 1672. These artists, among the foremost sea painters of the Dutch school, transplanted the principles and practices of that school to England. Patronized by Charles II and his successors, they established an enormously popular practice and employed a large studio which widely disseminated their manner and provided a training ground for the next generation.

If the pictures of sea battles and other marine subjects by Robert and his brother reflect the continuing influence of this Anglo-Dutch tradition, they also demonstrate an allegiance

to a different artistic tradition, that of the topographical watercolor, communicated to them by Paul Sandby (cat. nos. 3, 16), from whom John took lessons.

Robert's *An English Man-of-War Taking Possession of a Captured Ship* employs the standard topographical technique in its combination of detailed pen work with delicate washes of color over an underlying structure modeled with gray wash. Robert and John's watercolors are the nautical equivalents of the topographical watercolors of, say, Edward Dayes (cat. no. 21).

1. Entry for February 22, 1795; *The Diary of Joseph Farington*, ed. Kenneth Garlick and Angus Macintyre, vol. 2 (New Haven: Yale University Press, 1978), p. 308.

John Robert Cozens (1752-1797)
The Lake of Nemi, ca. 1783-85

John Robert Cozens returned from his first visit to Italy in the spring of 1779. Three years later, he made a second Italian tour, this time in the company of his father's pupil, patron, and friend William Beckford (1760–1844). Prior to their trip together, John Robert Cozens supplied Beckford with Italian views in watercolor worked up from the studies of his first visit. Back in London in 1783, he produced additional drawings of Italian subjects for Beckford based on his recent sketches, but within a year or so, the two men had a falling out.[1] Beckford continued to speak warmly of Alexander Cozens (cat. no. 1) but referred to the son as "an ungrateful scoundrel."[2]

The Lake of Nemi belongs to the years just after Cozens's second Italian visit, when, for Beckford and others, he created finished watercolors from the sketches he had made on that tour. He often produced multiple versions of his more popular compositions, and at least four versions of the present work are recorded.[3]

Known as the Speculum Dianae (Mirror of Diana), the Lake of Nemi was revered by eighteenth-century travelers for its association with the Roman goddess of the hunt. Cozens takes his view from a point near the site of an ancient temple of Diana, looking up toward the town of Nemi on the left and to Genzano on the right. Monte Circeo rises from the distant plain.

In his *Interlaken* of 1776 (cat. no. 9), Cozens used the pen for definition. Although one is aware in places of a rough pencil underdrawing in *The Lake of Nemi*, modeling in watercolor has almost completely displaced outline. The massive hills rising around Lake Nemi are given full weight and solidity by Cozens's technique of building form through the massing of delicate

touches of subdued color. While Cozens's technical achievement was considerable and influential, it was also at the service of a sensibility that John Constable (1776–1837) described as "all poetry." The sense of light and atmosphere, as well as mystery and melancholy, which Cozens created in such watercolors as this, set him apart from other contemporaries working in Italy, such as William Pars (cat. no. 6) and John "Warwick" Smith (cat. no. 19), and provided an important model for a younger generation of watercolorists, which included Thomas Girtin (cat. no. 24) and J. M. W. Turner (cat. nos. 31, 44, 56).

1. On April 10, 1805, Beckford sold his collection of ninety-four drawings by Cozens.

2. Entry for June 17, 1797; *The Diary of Joseph Farington*, ed. Kenneth Garlick and Angus Macintyre, vol. 3 (New Haven: Yale University Press, 1979), p. 855.

3. Two versions are listed in C. F. Bell and Thomas Girtin, "The Drawings and Sketches of John Robert Cozens," *Walpole Society*, vol. 23 (1934–35). One (no. 143), recorded as belonging to Mrs. Arthur Clifton, may be the drawing that was with the Leger Galleries in London in 1979; the other (no. 437) is in the Victoria and Albert Museum, London, 143–1890. In addition to the watercolor at Yale, there is another version, not recorded by Bell and Girtin, which was sold at Sotheby's on March 18, 1982 (lot 173) and appeared for sale again at Christie's on July 10, 1984 (lot 189).

13. John Robert Cozens (1752–1797)
The Lake of Nemi, ca. 1783–85
watercolor over pencil
372 x 536 mm (14⅝ x 21⅛ in.)
B1975.4.1481

Francis Towne (1739/40-1816)
Ambleside, 1786

The village of Ambleside is situated near the head of Lake Windermere in England's Lake District. From the 1750s, the area attracted writers and artists who found native natural equivalents there to the landscapes of Claude Lorrain (1600–1682), Gaspard Dughet (1615–1675), and Salvator Rosa (1615–1673). By the 1770s and 1780s it had become a focal point of Picturesque tourism.[1] The Reverend William Gilpin (1724–1804), the great popularizer of Picturesque travel, published his *Observations, Relative Chiefly to Picturesque Beauty, Made in the Year 1772, On several Parts of England; Particularly the Mountains, and Lakes of Cumberland, and Westmoreland* in 1786, the very year in which Francis Towne traveled there.

Towne toured the Lake District with John Merivale and James White, friends from Exeter where Towne earned his living as a drawing master.[2] *Ambleside* is representative of the watercolors Towne produced on the tour, a carefully numbered set of neat, precise views of lakeland scenery. The artist's inscription on the drawing's original mount (now removed) indicates that the watercolor was "drawn on the spot," but this is probably true only of the underlying pencil outlines. These outlines were later reinforced with pen and ink: a fine line in gray ink in the distant mountains, a heavier line in brown ink in the nearer trees and buildings. Over these outlines Towne has laid flat washes of soft grays, blues, greens, and ocher. The notation on the verso of the time of day and the fall of light, which commonly appears on Towne's watercolors, indicates a concern with atmospheric conditions which is not readily apparent from the formal, decorative quality of the drawing itself.

Six years before his Lake District excursion, Towne had traveled to Italy, where he worked with William Pars (cat. no. 6) and John "Warwick" Smith (cat. no. 19). In the company of

14. Francis Towne (1739/40–1816)
Ambleside, 1786
watercolor with pen and brown and gray ink over pencil
237 x 157 mm (9⁵⁄₁₆ x 6³⁄₁₆ in.)
Signed and dated, lower left: *F. Towne | delt. 1786 | No. 2*;
inscribed by the artist, verso: *Morng light from the right hand | No. 2 | Ambleside August 7th 1786*
B1977.14.4147

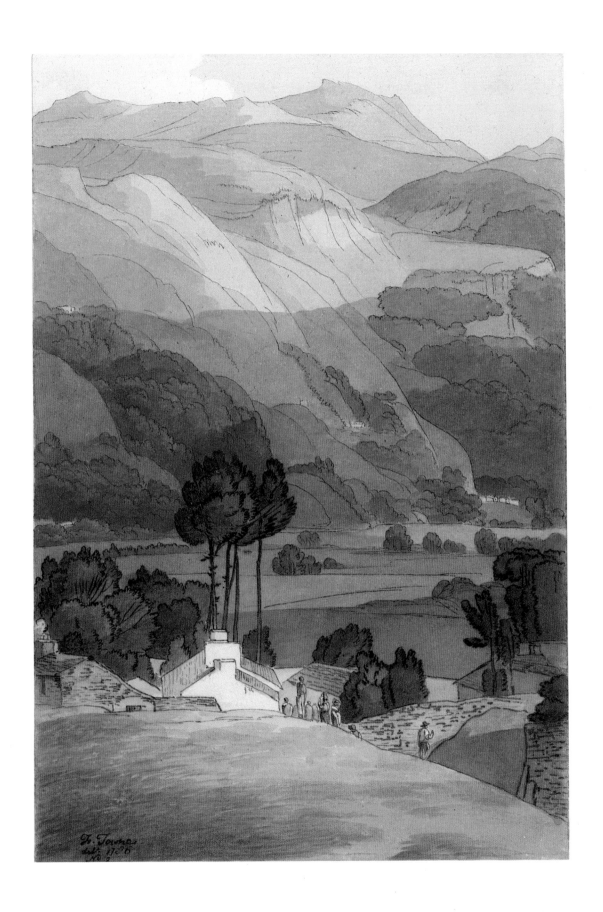

Smith, he returned to England in the autumn of 1781 by way of Switzerland. In contrast to the dense modeling and broken touches of Pars, Smith, and J. R. Cozens (cat. nos. 9, 13), Towne's Italian and Alpine watercolors rely on prominent pen outlines combined with flat planes of color. It was the old technique of the "stained" drawing subjected to an intensely individual stylization.

1. For the Picturesque response to the Lake District, see Peter Bicknell, *Beauty, Horror and Immensity: Picturesque Landscape in Britain, 1750–1850*, exhibition catalogue (Cambridge: Fitzwilliam Museum, 1981).

2. For over a century after his death, Towne was a forgotten artist. His reputation was revived by A. P. Oppé with the publication of "Francis Towne, Landscape Painter," *Walpole Society*, vol. 8 (1919–20). For the fullest account of Towne's life and art, see Adrian Bury, *Francis Towne* (London: Charles Skilton, 1962).

Julius Caesar Ibbetson (1759-1817)
Cardiff from the South, ca. 1789

In the introduction to his instructional manual *An Accidence, or Gamut, of Painting in Oil* (1803), Julius Caesar Ibbetson recounted his beginnings as an artist, ". . . having from my earliest youth had a most violent propensity, or inclination to the Art, without ever meeting with instruction, encouragement, or patronage, I at last, on making my way to London [in 1777], found myself safely moored in a Picture-dealer's garret."[1] Ibbetson's experience with dealers embittered him, and he advised artists to "avoid Picture-dealers as serpents: they are, to living artists, as hawks to singing birds."[2] Yet, his work for the dealers provided Ibbetson with a rudimentary artistic training. "It is from this period," he wrote, "I must date the first knowledge I ever acquired of the mechanical part of Painting; and it was chiefly in the Dutch and Flemish schools, to which, as Sir Joshua Reynolds observes, a student should go to learn Painting, as he should go to a grammar school to learn language."[3]

Ibbetson began exhibiting at the Royal Academy in 1785.[4] Two years later he was chosen to accompany Colonel Charles Cathcart as draftsman on the first British embassy to the Imperial Court of China. Cathcart's death en route terminated the expedition before it reached its destination. When a second embassy was dispatched in 1793, Ibbetson was again asked to participate but declined, suggesting that his place be taken by William Alexander (cat. no. 26).

Shortly after his return to England, Ibbetson became acquainted with the connoisseur and amateur etcher Captain William Baillie (1723–1810), who introduced him to a number of influential patrons. One of these was the Earl of Bute, the former prime minister, who in 1789 invited Ibbetson to be his guest at Cardiff Castle. During this visit, Ibbetson painted for his host a group portrait in oils with Lord Bute, family members, retainers, and Cardiff dignitaries

posed before the keep of the castle.[5] It was also for Lord Bute that Ibbetson executed a number of topographical watercolors of Cardiff and the surrounding countryside, including this view of the city from the south. In the long, low sweep of the view, this watercolor seems to reflect the seventeenth-century Dutch river and coastal landscapes with which Ibbetson was familiar from his days with the picture dealers.

1. Julius Ibbetson, *An Accidence, or Gamut, of Painting in Oil and Water Colours*, Part I (London: Darton and Harvey, 1803), p. 5. The second part, which would have dealt with watercolors, was never published.

2. Ibid., p. 22.

3. Ibid., p. 7.

4. For Ibbetson's life, see Rotha Mary Clay, *Julius Caesar Ibbetson, 1759–1817* (London: Country Life, 1948).

5. In the collection of the Marquess of Bute; reproduced ibid., pl. 24.

15. Julius Caesar Ibbetson (1759–1817)
Cardiff from the South, ca. 1789
watercolor with pen and gray ink over pencil
329 x 503 mm (12^{15}/$_{16}$ x 19^{13}/$_{16}$ in.)
B1975.4.1929

16. Paul Sandby (1731–1809)
The Gunpowder Magazine, Hyde Park, ca. 1790–95
watercolor with pen and gray ink and touches of black crayon over pencil
374 x 498 mm (14¾ x 19⅝ in.)
Inscribed, verso: *The Powder Magazine, Hyde Park. | by Sandby*
B1977.14.4378

Paul Sandby (1731-1809)
The Gunpowder Magazine, Hyde Park
ca. 1790-95

As a topographical drawing, *The Gunpowder Magazine, Hyde Park* is a curious work. Its ostensible subject is to a great extent obscured by a screen of trees. But then, Sandby's intention is not so much topographical as naturalistic. The real subject of the watercolor is that screen of trees and the *contre-jour* effect of looking through them into the sunlight.

Sandby was fascinated by trees. His drawings of Windsor Forest, of which his brother Thomas Sandby was deputy ranger, frequently feature majestic and fantastically gnarled beeches.[1] Such monumental trees became a cliché of his later work, regularly incorporated into a variety of non-Windsor views. By the 1790s much of his work was characterized by routine compositions and sloppy execution, but when his interest was fully engaged, as in this watercolor, he could still demonstrate a freshness of vision and fluent command of the medium.

The technique of this drawing is not appreciably different from that of Sandby's *Italianate Landscape with Travelers* (cat. no. 3) of almost thirty years earlier. The principal tones are laid in with a gray wash over which is applied local color. Outlines are strengthened and foliage characterized by pen and ink. But in the later watercolor the brushwork is freer and the pen-line looser, less tightly controlled. The technique mirrors the more casual, informal character of the composition.

1. The interest in these Windsor trees shown by Sandby and other artists beginning in the 1780s and the general artistic interest in tree forms in this period are discussed by Bruce Robertson in the catalogue of the forthcoming Sandby exhibition at the Yale Center for British Art.

Thomas Rowlandson (1756-1827)
A Review in a Marketplace, ca. 1790

Thomas Rowlandson was one of the most prolific comic draftsmen of his time, a lively and perceptive commentator on the pastimes and foibles of the age. *A Review in a Marketplace*, with its assorted market people and its line of motley recruits being inspected by a potbellied drill sergeant, is a richly comic image. Yet, in addition to the humorous activity of the figures, this drawing also presents a portrait of a particular English market square.[1]

As John Riely has noted, Rowlandson was temperamentally unsuited to the role of topographer.[2] His energetic bounding pen-line, which conveys so effortlessly a sense of life and motion, was less readily adapted to the careful delineation of architecture. It is a measure of the late-eighteenth-century taste for topographical drawings, prints, and publications that Rowlandson on a number of occasions involved himself with this rather uncongenial form. In several instances he simply contributed enlivening figures to the topographical drawings of other artists. One such drawing, with a string of Rowlandson's figures deployed before a careful rendering of Bradwell Lodge by Thomas Malton (1748–1804), is in the Yale Center.[3] The most successful and extensive of these collaborative efforts was the *Microcosm of London*, published by Ackermann between 1808 and 1810, for which Ackermann paired Rowlandson with the architectural draftsman Augustus Charles Pugin (1762–1832).

In other works, of which *A Review in a Marketplace* is an example, Rowlandson provided his own architectural setting for his figures. During the 1790s, Rowlandson produced a number of views of Continental cities as the result of several tours. These generally adopt a format similar to his view of the English marketplace: specific but loosely drawn architecture bounds a large open space that gives his comic figures plenty of room in which to maneuver. Although

17. Thomas Rowlandson (1756–1827)
A Review in a Marketplace, ca. 1790
watercolor with pen and gray ink
289 x 442 mm (11⅜ x 17⁷⁄₁₆ in.)
B1975.3.139

the figures may be quite small in proportion to the architecture, their activity is the focal point of the work. The architecture functions as a stage set.

In his insistence on the primacy of figures over setting even when the setting is a record of an actual place, Rowlandson stands apart from the topographers. He also stands apart from the contemporary developments in watercolor painting embraced and promoted by such topographical artists as Thomas Hearne (cat. no. 20), Michael "Angelo" Rooker (cat. no. 23), and Edward Dayes (cat. no. 21). The trend was toward a more atmospheric treatment in which line was downplayed and modeling with color was emphasized. Rowlandson's technique of pale washes supporting a dominant pen-line was decidedly old-fashioned, but reinvigorated by the vitality of his drawing.

1. An inscription on the drawing's mount in a later hand wrongly identified the scene as Winchester. Although no other identification of the scene has been advanced, the distinctive clock tower partially visible on the left suggests that Rowlandson is representing a specific marketplace.

2. John Riely, *Rowlandson Drawings from the Paul Mellon Collection*, exhibition catalogue (New Haven: Yale Center for British Art, 1978), p. 22.

3. *Bradwell Lodge, Bradwell Quay, Essex*, B1975.3.-148.

Richard Westall (1765-1836)
The Rosebud, 1791

Richard Westall's contemporaries were divided in their assessment of his work in watercolor. There were those who saw in his depth and richness of color a significant contribution to the development of watercolor painting comparable to painting in oils. James Northcote (1746–1831) was of the opinion that "Westall is as much intitled to share in the honour of being one of the founders of the school of painting in water-colours, as his highly-gifted contemporaries Girtin and Turner."[1] Others, like Edward Dayes (cat. no. 21), felt that Westall was only "great in little things, as his merit lies in neatness and colour." According to Dayes, "He too often sacrifices his subjects to handling."[2] Whatever shortcomings of superficial prettiness and sentimentality Westall's figure subjects may display, in a medium that was dominated by landscape painters, such subjects established an important precedent.

In his exhibition watercolors, often scenes from literature or classical mythology, or rustic genre subjects, Westall ranged from the neoclassical to the rococo. His neoclassicism, never as strenuous and severe as that of John Flaxman (1755–1826) or Henry Fuseli (1741–1825), generally contained a healthy element of rococo decorativeness, just as his more rococo watercolors, like *The Rosebud*, often reveal an underlying neoclassical armature.

Westall was a frequent and prolific contributor to the Royal Academy exhibitions from 1784 to 1836. *The Rosebud* was exhibited there in 1792 (no. 411), the year in which he became an associate. He was elected a full academician two years later. This watercolor has been known as "Rosebud, or the Judgement of Paris," but when it was exhibited at the Royal Academy, it was simply titled "The Rose-bud, after Prior." It is, in fact, an illustration to Matthew Prior's poem "A Lover's Anger." While Westall may have derived his composition

from depictions of the judgment of Paris, the celebrated choice among three beauties is unrelated to the subject of Prior's poem. A lover chides his mistress for being late (Westall shows him holding a watch in his left hand). She, seeking to deflect his anger, complains that a rosebud has fallen into her bodice and exposes her breast to exhibit the mark it has left. The lover, successfully distracted, forgets the rest of his rebuke.

1. W. H. Pyne's record of Northcote's judgment of Westall is quoted in Martin Hardie, *Water-Colour Painting in Britain* (London: Batsford, 1966–68), vol. 1, *The Eighteenth Century*, p. 150.

2. *The Works of the Late Edward Dayes Containing . . . Professional Sketches of Modern Artists* (London: Mrs. Dayes, 1805), pp. 355–56.

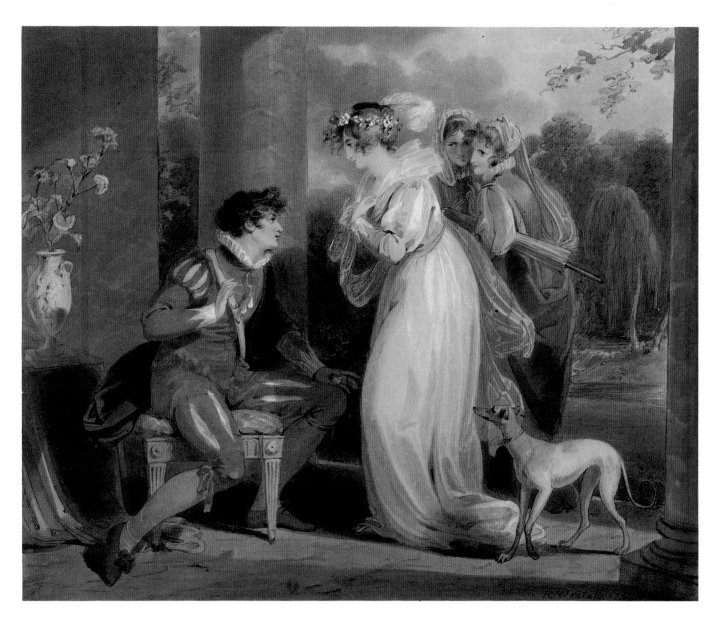

18. Richard Westall (1765–1836)
The Rosebud, 1791
watercolor and bodycolor over pencil
324 x 383 mm (12¾ x 15¹⁄₁₆ in.)
Signed and dated, lower right: *R. Westall 1791*
B1977.14.4357

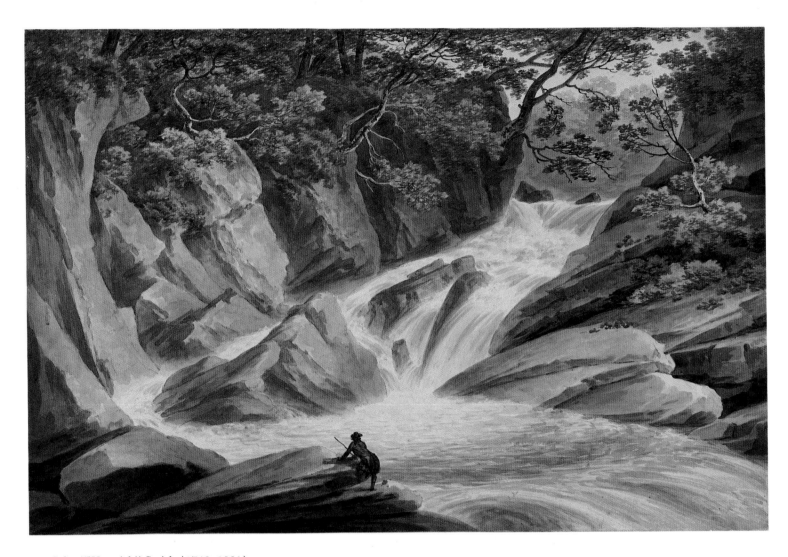

19. John "Warwick" Smith (1749–1831)
Hafod: The Upper Part of the Cascade, 1793
watercolor over pencil
346 x 512 mm (13⅝ x 20³⁄₁₆ in.)
Inscribed by the artist, verso: *Upper part of the Cascade J. Smith 1793*
B1975.4.1958

John "Warwick" Smith (1749-1831)
Hafod: The Upper Part of the Cascade, 1793

In the early nineteenth century, John Smith, known as "Warwick" Smith,[1] enjoyed a considerable reputation as one of the important innovators in watercolor technique. He was a respected member of the Society of Painters in Water-Colours, served in a number of its offices, and was its president in 1814, 1817, and 1818. By that time Smith's watercolors were decidedly conservative,[2] but during his years in Italy between 1776 and 1781 he had, together with William Pars (cat. no. 6) and Francis Towne (cat. no. 14), begun applying local color directly, creating drawings of a greater intensity and richness of color. While he seems to have been less innovative than his associates in Italy, he was the one to gain public recognition, since, as Jane Bayard has pointed out, he alone of the group had his work regularly shown in London in subsequent years.[3]

Smith's watercolor of 1793 derived from a sketching expedition through Wales in the previous year. His companions were the Honorable Robert Fulkes Greville and the artist Julius Caesar Ibbetson (cat. no. 15), who, it has been suggested, supplied the figure clambering over the rocks in this watercolor. The party visited many of the principal families of Wales and spent a considerable length of time at Hafod, the estate of Thomas Johnes, member of Parliament, lord lieutenant of Cardiganshire, and a noted bibliophile.[4]

In 1810, *A Tour to Hafod in Cardiganshire* was published with fifteen aquatint plates by J. C. Stadler (active 1780–1812) after watercolors by Smith, including this one, which appears as plate 6, *Upper Part of the Pyran Cascade.* The text by Sir James Edward Smith, botanist and president of the Linnaean Society, describes a tour through the grounds. His account of the cascade conveys the flavor of Johnes's artful presentation of natural phenomena:

After a while, the sound of a water-fall is heard, at no great distance, on the right, and a path conducts us to the Piran Cascade, so named from the brook which forms it. This, one of the most favourite water-falls, is represented in tab. VI. and VII. [The plate based on the Yale watercolor is VI.] It terminates an umbrageous glen in the most advantageous manner, opening upon the spectator by degrees, till the whole is seen in perfection, as in tab. VII. from a covered seat on the left. The Cascade consists of two distinct parts. The upper half is drawn on a larger scale in tab. VI. where it makes a natural cold bath, sufficiently secured by the ledge of slaty rocks in front, over which the stream descends to make the lower cascade. Sometimes indeed the water is so abundant and so rapid, as to render the bath inaccessible, by overflowing the smooth stones on the left.[5]

With its rushing water and angular rocks filling the entire picture space, *Hafod: The Upper Part of the Cascade* is a quintessentially Sublime image of natural power. Yet within the context of the set of views to which it belongs, it is apparent that this reflects a domesticated Sublime, part of an aesthetic experience carefully programmed by the owner of this property for the delectation of his guests.

1. The appellation "Warwick" derived from either his residence at Warwick from 1781 on, or his association with the Earl of Warwick, who was his patron for many years and sponsored his stay in Italy. See Basil S. Long, "John (Warwick) Smith," *Walker's Quarterly*, no. 24 (1927); and Iolo Williams, "John 'Warwick' Smith," *The Old Water-Colour Society's Club*, vol. 24 (1946), pp. 9–18.

2. For many, such as Sir George Beaumont, Smith's conservatism was much in his favor. Julius Caesar Ibbetson, in his *An Accidence, or Gamut, of Painting in Oil and Water Colours*, Part I (London: Darton and Harvey, 1803), p. 21, wrote: "In tinted drawings, no one, I believe, ever came so near the tint of nature as Mr. John Smith: they will always retain their value, when the dashing doubtful style has been long exploded, in which every thing appears like a confused *dream* of nature."

3. Jane Bayard, *Works of Splendor and Imagination: The Exhibition Watercolor, 1770–1870*, exhibition catalogue (New Haven: Yale Center for British Art, 1981), p. 38.

4. For a detailed account of this expedition, see Rotha Mary Clay, *Julius Caesar Ibbetson, 1759–1817* (London: Country Life, 1948), pp. 32–43.

5. James Edward Smith, *A Tour to Hafod* (London: White and Co., 1810), pp. 13–14.

Thomas Hearne (1744-1817)

Goodrich Castle on the Wye, ca. 1794

After sailing four Miles from Ross, we came to *Goodrich-castle*; where a very grand view presented itself; and we rested on our oars to examine it. A reach of the river, forming a noble bay, is spread before the eye. The bank, on the right, is steep, and covered with wood; beyond which a bold promontory shoots out, crowned with a castle, rising among the trees.

This view, which is one of the grandest on the river, I should not scruple to call *correctly picturesque*; which is seldom the character of a purely natural scene.

This description of the scene that forms the subject of Thomas Hearne's watercolor comes from the Reverend William Gilpin's *Observations on the River Wye*.[1] Published in 1782 but based on an excursion down the river in 1770, it was the first of a series of published Tours through which Gilpin popularized the Picturesque as a distinct aesthetic category, a species of beauty appropriate to pictures, but also applicable to natural scenery. In contrast to Edmund Burke's characterization of beauty as smooth and regular in his influential *Philosophical Enquiry into the Origin of Our Ideas of the Sublime and Beautiful* (1757), Gilpin counted among the properties of picturesque beauty roughness, variety, and contrast.

Gilpin's aesthetic principles were based on the landscape paintings of Claude Lorrain (1600–1682). Natural scenery was successfully picturesque to the extent that it embodied the properties of Claudian composition. In *Observations on the River Wye*, the description of the site of Goodrich Castle is followed by one of Gilpin's most famous dicta, "Nature is always great in design; but unequal in composition."

The generalized landscape compositions with which Gilpin illustrated his Tours make clear the distance between his formalist concerns and simple topography. Yet for topographers of Hearne's generation, the Picturesque exerted considerable influence on their treatment of

their subject matter. Hearne's *Goodrich Castle* not only presents a view that Gilpin declared "correctly picturesque," but also does so in a technique of broken brushstrokes which is itself an embodiment of the Picturesque attributes of roughness and variety.[2]

If Picturesque theory underlies Hearne's buildup of individual touches to represent the wooded banks of the Wye, this technique may also reflect the influence of John Robert Cozens's watercolors, such as *Lake Nemi* (cat. no. 13). Hearne was a friend of Dr. Thomas Monro (1759–1833), the art-loving physician who cared for Cozens after his mental collapse in 1794. Dr. Monro assembled a collection of drawings by Cozens and other major watercolorists (including Hearne), which he set promising young artists to copy in his so-called Academy. Many of the important figures of the next generation of watercolorists, including Girtin (cat. no. 24) and Turner (cat. nos. 31, 44, 56), worked for Monro. Although in the 1790s Hearne was an established topographical artist—not a copier in the Academy, but one of those whose work was copied—it may well have been through Dr. Monro at this period that he had the opportunity to study the watercolors of Cozens.

While Andrew Wilton has dated *Goodrich Castle* to the mid-1780s,[3] it seems more likely that it was a product of a tour down the Wye in the company of the noted connoisseur and amateur artist Sir George Beaumont (1753–1827) in 1794. The two Wye subjects—*Chepstow* and *Tintern*—that appear among the plates after Hearne in *Antiquities of Great Britain*[4] are both described in the accompanying text as deriving from sketches made in 1794. If, like them, *Goodrich Castle* was based on a sketch from the excursion with Beaumont, then Hearne's watercolor with its particular affinity to the work of J. R. Cozens would date from just the period when Hearne, through the agency of Dr. Monro, would have been most aware of Cozens's work.

1. William Gilpin, *Observations on the River Wye* (London, 1782; reprint Richmond, Surrey: Richmond Publishing Company, 1973), pp. 17–18.

2. Andrew Wilton associates Hearne's technique with Picturesque principles; see his preface in Christopher White, *English Landscape 1630–1850*, exhibition catalogue (New Haven: Yale Center for British Art, 1977), p. xvii.

3. Andrew Wilton, *The Art of Alexander and John Robert Cozens*, exhibition catalogue (New Haven: Yale Center for British Art, 1980), p. 58, notes the strong influence of Cozens in this watercolor. He gives the date as circa 1785(?), but does not discuss the reason for such a dating.

4. In 1777, Hearne joined the engraver William Byrne to begin work on *Antiquities of Great Britain: Illustrated in Views of Monasteries, Castles, and Churches, now existing*. Individual plates were published over the course of the next thirty years, the work finally appearing in two volumes of fifty-four plates in 1807.

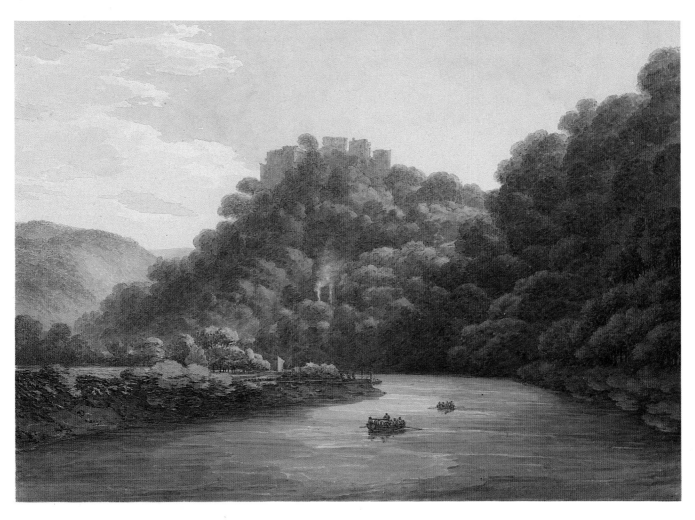

20. Thomas Hearne (1744–1817)
Goodrich Castle on the Wye, ca. 1794
watercolor over pencil
227 x 314 mm (8¹⁵⁄₁₆ x 12⅜ in.)
Inscribed on the back of the original mount: *Goodrich Castle—Hearne—No. 23*
B1975.3.1027

Edward Dayes (1763-1804)
Durham Cathedral, ca. 1790-95

Along with Michael "Angelo" Rooker (cat. no. 23) and Thomas Hearne (cat. no. 20), Edward Dayes belonged to that generation of topographers whose work was affected by Picturesque theory. The idea of the Picturesque was expanding beyond Gilpin's Claudian conception to embrace those rustic landscapes and low-life genre scenes inspired by the seventeenth-century Dutch and gaining fashionable currency in the art of Thomas Gainsborough (1727–1788) and the writings of his friend Uvedale Price (1747–1829). Dayes could not accept this interpretation, maintaining, in his *Essays on Painting*,

> By the word picturesque, the artist understands the irregular, but ever accompanied with a beautiful choice, and it stands in opposition to the simple, or grand; it does not apply to objects "rough and irregular," or such as are deformed, aged, and ugly.[1]

Dayes mounted a scathing attack on the popular notion of Picturesque subject matter:

> We must give up our understanding, if we call that landscape *fine* which represents dirty rugged grounds, scrubby bushes, poor scraggy and ill-formed trees, shapeless lumps of antiquity, and muddy pools; peopled with gipsies and vagabonds, dirty beggars, clothed with rags, their heads decorated with filthy drapery, skins like tanned leather, and their employ disgusting; and these accompanied with poor and old cattle, or nasty swine on filthy dunghills. And shall those be the objects with which we are to decorate, or rather deform, our apartments?[2]

For Dayes, first and foremost a topographer, a view had to center on some natural feature of unalloyed beauty or a noble edifice like Durham cathedral. His watercolors are populated

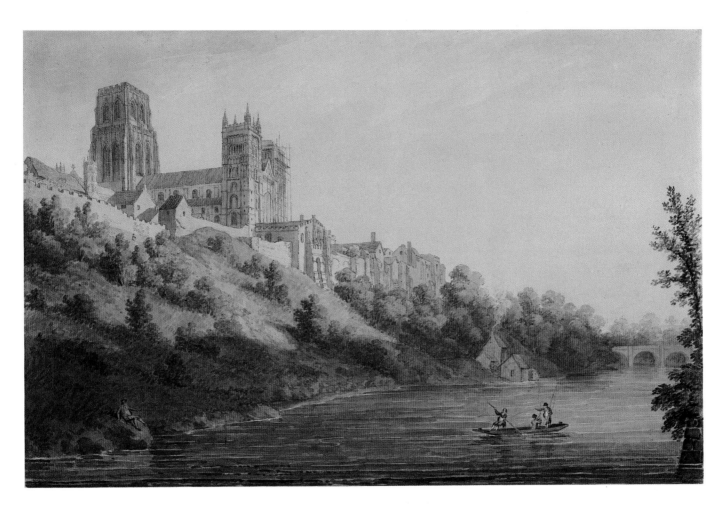

21. Edward Dayes (1763–1804)
Durham Cathedral, ca. 1790–95
watercolor with pen and gray ink over pencil
262 x 390 mm (10⁵⁄₁₆ x 15³⁄₈ in.)
B1977.14.4239

by fashionable, or at least reasonably well-dressed figures. His is a decorous art, enlivened by qualities of the Picturesque and heightened by aspects of the Sublime, but with both held in careful check.

Dayes produced a series of watercolors of Durham from the river Wear in the early 1790s, showing the southwest tower of the cathedral in scaffolding. A watercolor looking back at the cathedral from beyond the Prebends' Bridge (at the right in the Yale watercolor) is signed and dated 1791.[3] A preliminary version of the Yale composition exists, inscribed with color notes, and with the foliage beneath the cathedral given a more cursory treatment.[4]

One of Dayes's watercolors of Durham was exhibited at the Royal Academy in 1795, and it was in that year that Thomas Girtin (cat. no. 24) produced a close copy of the Yale composition.[5] Girtin was apprenticed to Dayes in 1788. The two men did not get along, and the apprenticeship was probably short-lived. Nonetheless, Girtin's early watercolor technique is closely modeled on that of Dayes, and his copy of *Durham Cathedral* indicates that through the mid-1790s Dayes continued to influence his development.

Dayes admired Girtin's work, but held a low opinion of his character. In his *Professional Sketches of Modern Artists*,[6] he chose to treat Girtin's tragically short life as a cautionary tale of the consequences of intemperance and excess of passion. His own personality was scarcely exemplary in its stability, and, within two years of Girtin's death, he took his own life.

1. *The Works of the Late Edward Dayes Containing . . . Essays on Paintings . . .* (London: Mrs. Dayes, 1805), p. 225.

2. Ibid.

3. Museum of Art, Rhode Island School of Design, Providence, 71.153.47.

4. With Andrew Wyld, London; *Autumn Catalogue* (1982), no. 10, ill.

5. In the Laing Art Gallery, Newcastle upon Tyne, 31–41.

6. *The Works of the Late Edward Dayes*, pp. 315–59.

Thomas Richard Underwood (1772–1835)
The Chapel on Wakefield Bridge, Yorkshire, 1794

Thomas Richard Underwood is one of the lesser-known topographical watercolorists of the late eighteenth century, yet examples of his work, such as *The Chapel on Wakefield Bridge*, merit comparison with the best drawings of the more noted topographers Thomas Malton, Jr. (1748–1804) and Thomas Hearne (cat. no. 20). If Underwood's watercolors immediately bring to mind those of Malton and Hearne, this places Underwood in the wrong generation. He was, in fact, only three years older than Thomas Girtin (cat. no. 24) and J. M. W. Turner (cat. nos. 31, 44, 56), and in many respects his early career parallels theirs.

At the age of seventeen he began exhibiting at the Royal Academy, and he continued to exhibit there until 1801. This watercolor appeared at the Royal Academy in 1795 (no. 530). Like Girtin and Turner, he worked for Dr. Thomas Monro (1759–1833), and he was among the original members of Girtin's Sketching Club (see cat. no. 27). Taking advantage of the Treaty of Amiens in 1802, he traveled to the Continent, as did Girtin and Turner. On his return trip from Italy in 1803, he was taken prisoner by the French. After his release, he remained in France and ceased to play any further role in the story of British watercolor painting.

The Bridge and St. Mary's Chapel in Wakefield, both dating from the middle of the fourteenth century, were well-known antiquarian attractions in Yorkshire. In the Yorkshire volume of *The Beauties of England and Wales*, John Bigland praised the beauty of the chapel's façade: "The buttresses, finials, traceries, &c. form an assemblage of Gothic embellishments, which for richness and delicacy can scarcely be excelled." Bigland noted, however, that "This superb relic of antiquity was of late years used as a warehouse, and its beautiful embellish-

ments have received considerable damage. But it is to be hoped that the good taste of the inhabitants of Wakefield, will preserve from destruction this noble monument of past ages, which is so great an ornament to their town, and so intimately connected with a most interesting part of our national history."[1] Underwood's depiction of the play of light and shade on the carefully delineated brickwork and ornate stone façade of the chapel shows a sophisticated employment of the conventional tinted drawing technique comparable to that of Turner and Girtin in the mid-1790s.

1. *The Beauties of England and Wales*, vol. 16, *Yorkshire*, by John Bigland (London: J. Harris, 1812), p. 805.

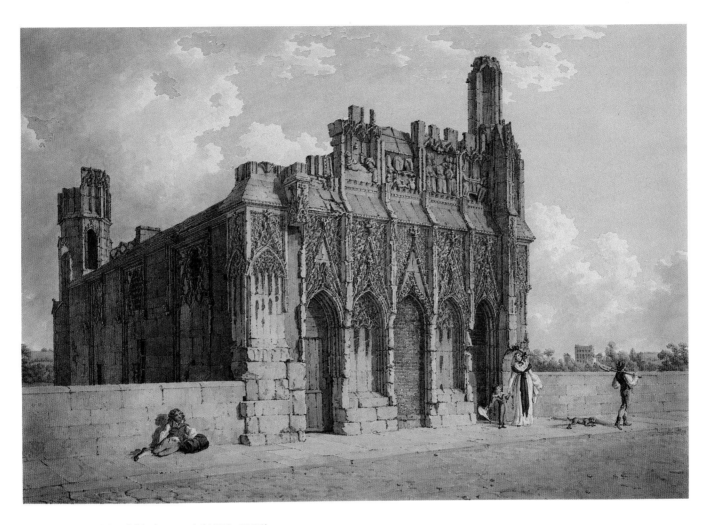

22. Thomas Richard Underwood (1772–1835)
The Chapel on Wakefield Bridge, Yorkshire, 1794
watercolor over pencil
254 x 356 mm (10 x 14 in.)
Inscribed on verso of contemporary mount: *T. R. Underwood / Novr. 1794 / 55*
B1975.3.1079

23. Michael "Angelo" Rooker (1743–1801)
Alms House in St. Cuthbert's Churchyard, Wells, ca. 1795–1800
watercolor over pencil
226 x 279 mm (8⅞ x 11 in.)
Signed, lower left: *M A* [in monogram] *Rooker*
B1975.3.975

Michael "Angelo" Rooker (1743–1801)
Alms House in St. Cuthbert's Churchyard, Wells
ca. 1795–1800

For Edward Dayes (cat. no. 21), writing his *Professional Sketches of Modern Artists*, the life of his fellow topographer Michael Rooker conformed to a standard literary type—the tragedy of the unappreciated artist. Dayes began his account:

> Poor Michael! dejected and broken in spirit, for want of due encouragement, drooped into eternity the last day of February, 1801, aged about fifty-seven. The ingratitude of a friend, to whom he had lent a sum of money, and the neglect of an undiscerning public, broke the heart of this highly deserving and meritorious artist.[1]

Dayes's overstatement aside, Rooker's career was not successful, even though he was one of the foremost topographers of the generation that followed Paul Sandby (cat. nos. 3, 16).

Like his father, Rooker was an engraver, and as engravers both father and son worked with Sandby. Michael Rooker may also have been Sandby's pupil, and it was Sandby who gave him the nickname "Michael Angelo" by which he was widely known and which he himself adopted. He eventually gave up engraving to work as a scene-painter in a London theater, and to pursue his primary interest in view painting. He became an associate of the newly formed Royal Academy in 1769 and exhibited his topographical works at the Academy exhibitions from that year until his death. In 1788, he began a series of summer walking tours, sketching in various parts of England and Wales. The drawings he produced on these tours remained in his possession.

If Rooker suffered from public indifference, he was also hurt by his own lack of business acumen and his roughness of manner.[2] This brusqueness, which may have cost him patrons,

seems strangely at odds with the delicacy and charm conveyed by his watercolor style. To a compositional sense shaped, or at least sharpened, by Sandby, Rooker added a technique for creating texture and flickering light through the repeated application of small touches of color.

Alms House in St. Cuthbert's Churchyard, Wells, with the elaborate Gothic porch sandwiched between the broad blocklike building on the left and the avenue of trees on the right, shows Rooker's eye for effective and unusual compositions. The watercolor also shows the delicate precision of his brushwork and his cool, attractive color. While none of his exhibited works was of Wells, other Somersetshire scenes did appear among his contributions to the Royal Academy exhibitions between 1795 and 1799, which suggests an approximate dating for this watercolor.

1. *The Works of the Late Edward Dayes . . . Professional Sketches of Modern Artists* (London: Mrs. Dayes, 1805), p. 347.

2. Edward Edwards, *Anecdotes of Painting* (London, 1808; reprint London: Cornmarket, 1970), p. 266, concludes his account of Rooker, "It ought to be observed, that though something rough in his manners, he was a man of integrity and honesty."

Thomas Girtin (1775-1802)
The New Walk, York, ca. 1798

Although in his *Anecdotes of Painting,* Edward Edwards (1738–1806) dismissed Thomas Girtin's landscapes as being "in a loose, free manner, with more of effect than truth,"[1] Girtin was, even before his untimely death, celebrated as a great master of landscape and an innovator in the art of watercolor. From an early date his name was coupled with Turner's as the artists most responsible for the elevation of watercolor to the status of a major art form. Even more than Turner (cat. nos. 31, 44, 56), Girtin in his brief career created a style that would shape the achievements of the succeeding generation of watercolorists.[2]

Girtin began as a topographical draftsman in the manner of his master Edward Dayes (cat. no. 21). While his art always retained a strong topographical basis, from the mid-1790s Girtin introduced a new breadth of handling and deep-toned expressiveness which set his works apart from the topographical tradition in which he had been trained. *The New Walk, York,* less broad in handling, less sweeping in composition, and less moodily evocative in feeling than the great watercolors of his last years, looks both backward and ahead. The treatment of the wedge-shaped foreground is conventional, recalling, for example, the foreground of Julius Caesar Ibbetson's *Cardiff* (cat. no. 15), but the color is denser and richer and the atmospheric handling of the city beyond the bridge subtler.

Girtin's watercolor shows the old Ouse Bridge with St. William's Chapel, a York landmark which Girtin made the subject of a number of other watercolors (fig. 1). Stretching to the right is the New Walk, an elm-lined promenade which extended nearly a mile along the river Ouse. The walk was laid out and trees planted in 1733 and 1734 at the expense of the Lord Mayor and the corporation. It was raised and improved in 1782 and became the city's

most fashionable resort on summer evenings. With tiny dots and dashes Girtin has indicated some of the fashionable promenaders beneath the elms. The rather stocky foreground figures on the opposite bank are decidedly not people of fashion.

Girtin's first visit to York was probably in 1796, during his tour of Scotland and the north of England. Five of the ten watercolors he sent to the Royal Academy exhibition the following spring were views of the city. From 1798 to 1801 Girtin seems to have paid yearly visits to Harewood House, the Yorkshire home of his patron Edward Lascelles. These Harewood visits were sometimes combined with further touring of Yorkshire.

In their catalogue of Girtin's drawings, Girtin and Loshak suggest a date of 1798 for this watercolor. This date accords well with the strong, dark color, the use of bodycolor, and the prominent left-hand repoussoir. But there is another more lightly handled version of this composition which is signed and dated 1801[3]; this watercolor, with its less solid and weighty treatment of form and its less pronounced effect of light filtering beneath the trees of the New Walk, would seem to be preliminary to Yale's example. The actual relationship of the two watercolors remains problematic.

1. Edward Edwards, *Anecdotes of Painting* (London, 1808; reprint London: Cornmarket, 1970), p. 279.

2. The major work on Girtin is Thomas Girtin and David Loshak, *The Art of Thomas Girtin* (London: Adam and Charles Black, 1954), which includes a full catalogue of the artist's work. See also Francis Hawcroft, *Watercolours by Thomas Girtin*, exhibition catalogue (Manchester: Whitworth Art Gallery; London: Victoria and Albert Museum, 1975).

3. Victoria and Albert Museum, London, 1091–1884.

24. Thomas Girtin (1775–1802)
The New Walk, York, ca. 1798
watercolor over pencil with bodycolor
311 x 554 mm (12¼ x 21¹³⁄₁₆ in.)
Signed, lower left: *Girtin*
B1977.14.4906

25. Francis Wheatley (1747–1801)
A Traveling Potter with His Wares outside a Cottage, 1798
watercolor over pencil with touches of bodycolor
390 x 489 mm (15⅜ x 19¼ in.)
Signed and dated, lower right: *F. Wheatley, delt. 1798*
B1977.14.4360

Francis Wheatley (1747-1801)

A Traveling Potter with His Wares outside a Cottage, 1798

The decade of the 1790s started auspiciously for Francis Wheatley.[1] On November 1, 1790, he became an associate of the Royal Academy and within just a few months he was voted full academician. His art was both respected and widely popular. Yet, years of extravagant living and chronic debt soon took their toll. He was forced to declare bankruptcy in 1794, and he spent the following years, despite financial assistance from the Royal Academy, in and out of prison for debt. Meanwhile his health deteriorated, so that by 1800 he could no longer mix his paints himself.

It was against this darkening background that Wheatley produced such pastoral confections as *A Traveling Potter with His Wares outside a Cottage*. These works are clearly indebted to the landscapes and fancy pictures of Thomas Gainsborough (1727–1788). As such works were for Gainsborough an escape from the pressures of his career as a portraitist, so Wheatley may have found a refuge from his manifold difficulties in these images of an idyllic rural world. Yet Wheatley's picturesque subjects, for all their charm, have neither the poetry nor the personal intensity of Gainsborough's.

Wheatley was not primarily a watercolorist, but throughout his career he produced numerous watercolors which he found to be highly saleable. His early works in the medium were generally topographical views and less sentimental scenes of rural life, rather similar to Paul Sandby's work in character (cat. nos. 3, 16), and executed in the conventional technique of tinted pen outlines. In the 1790s, Wheatley developed a more painterly approach to watercolor, as can be seen in this example, but the change had as much to do with financial as artistic considerations. His friend Joseph Farington (1747–1821) noted that he "does not outline with a Pen as the Collectors call all such *Sketches* and will not pay so much for them."[2]

1. For Wheatley's life and art, see Mary Webster, *Francis Wheatley* (London: Paul Mellon Foundation for British Art and Routledge and Kegan Paul, 1970).

2. Entry for October 9, 1797; *The Diary of Joseph Farington*, ed. Kenneth Garlick and Angus Macintyre, vol. 3 (New Haven: Yale University Press, 1979), p. 904.

William Alexander (1767–1816)
View near the City of Tientsin, 1800

From 1792 to 1794, William Alexander accompanied Lord Macartney's embassy to the Emperor of China as its official draftsman.[1] Alexander owed his appointment to Julius Caesar Ibbetson (cat. no. 15), who had been his teacher when he moved to London from his native Maidstone in 1782. Ibbetson had been the draftsman on an earlier, aborted embassy to China; when offered the post of draftsman with Lord Macartney's embassy, he declined, suggesting that Alexander replace him.

Although the embassy failed in its ostensible mission of opening up a Chinese market for British goods, it engendered in the British public a considerable interest in China. The long-standing taste for chinoiserie received a transfusion of new enthusiasm. With his virtual monopoly on accurate visual information about China, Alexander was strategically situated to take advantage of this interest. Throughout the rest of his life he produced finished water-colors from his Chinese sketches and provided illustrations to a number of books on China. His first published Chinese views appeared in 1797 illustrating Sir George Staunton's *An Authentic Account of an Embassy from the King of Great Britain to the Emperor of China*. In the same year he began producing the aquatints that would be published in 1805 as *The Costume of China*. Another collection of his aquatints, *Picturesque Representations of the Dress and Manners of the Chinese*, appeared in 1814.

View near the City of Tientsin is not a repetition of one of the compositions engraved for Staunton's *Authentic Account*, as many of his later finished Chinese watercolors were. It does, however, depict a scene that Staunton, the secretary to the embassy, described. The embassy

26. William Alexander (1767–1816)
View near the City of Tientsin, 1800
watercolor over pencil
230 x 364 mm (9¹⁄₁₆ x 14⁵⁄₁₆ in.)
Signed and dated, lower right: *W. Alexander 1800*
B1975.3.1083

passed through the commercial city of Tientsin on August 11, 1793, on its way to Peking. It returned through Tientsin on October 13. Staunton recorded the appearance of the city:

> It . . . is built at the confluence of two rivers, from which it rises in a gentle slope. The palace of the governor stands on a projecting point, from whence it commands the prospect of a broad bason, or expanse of water, produced by the union of the rivers, and which is almost covered with vessels of different sizes.[2]

The style of *View near the City of Tientsin* is essentially that of Hearne and Dayes, with some reflections of the contemporary watercolors of Girtin (cat. no. 24). As a part of Dr. Thomas Monro's circle (see cat. no. 20) and a member of Girtin's Sketching Club (see cat. no. 27), Alexander was exposed to the work of Hearne, Dayes, J. R. Cozens (cat. nos. 9, 13), and Girtin. In Dayes's *Durham Cathedral* (cat. no. 21) or Hearne's *Goodrich Castle on the Wye* (cat. no. 20), parallels with Alexander's striated treatment of the water, his delicate pencil outlines, his modeling of form through the layering of small touches of the brush, and his limited color range may be found. These same stylistic features were being developed by Girtin at the same period into a more personally distinctive and influential style. If Alexander did not advance the art of watercolor as much as Girtin did, he nevertheless, in his Chinese watercolors, employed the topographical style with great sensitivity and finesse.

1. Alexander's trip to China and the watercolors he produced as a result of the trip are admirably treated in Patrick Connor, *William Alexander: An English Artist in Imperial China*, exhibition catalogue (Brighton: Royal Pavilion, Art Gallery and Museums; Nottingham: University Art Gallery, 1981).

2. Sir George Staunton, *An Authentic Account of an Embassy from the King of Great Britain to the Emperor of China* (London: G. Nicol, 1797), vol. 2, pp. 23–24.

Robert Hills (1769-1844)
Tree Study, ca. 1800-1805

In the half-dozen years before the foundation of the Society of Painters in Water-Colours in 1804 (see cat. no. 29), artists working in watercolor joined together in less formal associations. The most famous of these was the one known as "the Brothers," or Girtin's Sketching Club, whose membership included Thomas Girtin (cat. no. 24), François Louis Thomas Francia (cat. no. 50), and later, after Girtin's death, John Varley (cat. no. 37) and John Sell Cotman (cat. no. 51).[1] Girtin's Sketching Club was undoubtedly an influential force in the development of watercolor at the time, but it was less directly connected with the establishment of a formal association of watercolor artists than was a similar sketching club, of which Robert Hills was a member. Of the five members of this club, four—Hills, Samuel Shelley (1756-1808), William H. Pyne (1769-1843), and John Claude Nattes (ca. 1765-1822)— joined William Frederick Wells (cat. no. 29) as founding members of the Society of Painters in Water-Colours. James Ward (1769-1859), the fifth member of this club, told Joseph Farington (1747-1821) in 1804 that it had been in existence for four years. It met "once a week during the winter Season at each others Houses *alternately*, to *sketch* & converse upon Art."[2] Although membership was limited to the five, the meetings were popular and guests often numbered thirty to forty.

A series of watercolor sketches by Hills of gnarled trees, of which this drawing is an example, dates from the years of his involvement in the sketching club and may be related to its activities. These sketches are definitely works of close observation rather than the imaginative creations of a convivial evening; however, in addition to its winter evening meetings, the club also engaged in sketching excursions, meeting afterward to examine one another's

productions.[3] Many of Hills's sketches are annotated with a form of shorthand, as are sketches by James Ward. It is possible that both artists began the practice during their years in the sketching club.

Hills became the first secretary of the Society of Painters in Water-Colours. To the Society's exhibitions he contributed landscapes and animal pictures painted in a fine stipple technique that derives from the long tradition of British miniature painting and anticipates the elaborate and precise watercolor techniques of William Henry Hunt (cat. nos. 38, 43) and J. M. W. Turner (cat. nos. 31, 44, 56) later in the century. Even in so slight a sketch as this tree study, Hills has reproduced with remarkable fidelity the texture of the bark.

Like William Wells, Hills refused to continue as a member of the Society when it was reorganized in 1812 as the Society of Painters in Oil and Water-Colours. Unlike Wells, however, he continued to contribute to the Society's exhibitions. When, in 1820, the Society reverted to its exclusively watercolor policy, he rejoined.

1. Girtin's Sketching Club and the major sketching clubs that followed it are discussed in Jean Hamilton, *The Sketching Society 1799–1851* (London: Victoria and Albert Museum, 1971).

2. Entry for March 22, 1804; *The Diary of Joseph Farington*, ed. Kenneth Garlick and Angus Macintyre, vol. 6 (New Haven: Yale University Press, 1979), p. 2271.

3. Basil S. Long, "Robert Hills, Water-Colour Painter and Etcher," *Walker's Quarterly*, no. 12 (1923), p. 6.

27. Robert Hills (1769–1844)
Tree Study, ca. 1800–1805
watercolor over pencil
305 x 226 mm (12 x 8⅞ in.)
Inscribed by the artist, lower right: *July 11th 180[?]*
B1981.25.2634

28. John Augustus Atkinson (ca. 1775–ca. 1833)
Fishermen Putting out to Sea, ca. 1800–1810
watercolor and pen and gray ink over pencil
266 x 365 mm (10½ x 14⅜ in.)
B1975.4.999

John Augustus Atkinson (ca. 1775-ca. 1833)

Fishermen Putting out to Sea, ca. 1800-1810

John Augustus Atkinson's *Fishermen Putting out to Sea* continued in the early 1800s a type of Picturesque coastal scene that Thomas Gainsborough (1727–1788) had formulated in a small group of paintings in the early 1780s and George Morland (1763–1804) had more extensively employed in a series of paintings in the 1790s. These are low-key cousins of the theatrical storm and shipwreck paintings of the French artist Claude Joseph Vernet (1714–1789) and the Alsatian emigré in England, Philip Jacques de Loutherbourg (1740–1812). In the first decade of the nineteenth century, Turner (cat. nos. 31, 44, 56) also produced versions of the Picturesque coastal scene, but it is the eighteenth century rather than the contemporary works of Turner that Atkinson's pen-and-wash drawing recalls.

Although Atkinson was a Londoner by birth, the crucial years of his artistic coming of age were spent in Russia, where he had been taken by an uncle at the age of nine. He returned to England in 1801; in 1803 and 1804 he capitalized on his Russian experience by producing the illustrations to *A Picturesque Representation of the Manners, Amusements, and Customs of the Russians* (published in 1807). He soon established a place for himself among the respected practitioners of watercolor art in that crucial decade. He was elected an associate of the Society of Painters in Water-Colours in 1808, becoming a full member later in the same year.

Whatever the nature of his artistic training in Russia, he showed himself on his return to England to be responsive to certain stylistic trends in English watercolor. These were not, however, the more progressive developments; the achievements of Turner, Girtin (cat. no. 24), and the Varleys (cat. nos. 37, 40) left little imprint on Atkinson's modest art. It was in the more retardataire drawing style of de Loutherbourg that he found his primary model. In *Fisher-*

men Putting out to Sea, the active character of the pen-line, the quality of the figure drawing, the use of wash, and the composition with its dark repoussoir in the lower right are particularly close to the drawings of de Loutherbourg.

Through much of the first two decades of the century, Atkinson's detailed and lively drawings of costume and military subjects enjoyed a considerable popularity, but his eighteenth-century manner of draftsmanship soon appeared outmoded. After about 1820 he and his work virtually disappear from view.

William Frederick Wells (1764-1836)

A Distant View of the City of London from St. John's Wood, ca. 1805-10

By the beginning of the nineteenth century, a sizable number of British artists were working in watercolor and exhibiting their watercolors at the Royal Academy. Dissatisfaction among these artists with the second-class status accorded their work by the establishment was inevitable, and in 1801 or 1802, William Frederick Wells, a landscape painter in watercolor who had been exhibiting since 1795, printed and circulated a letter urging the formation of a society devoted exclusively to the promotion and exhibition of watercolors. He took his motto from Shakespeare's *Measure for Measure*, "We oftimes lose the good we else might gain by fearing to attempt."[1]

Wells was able to bring together a group of nine of his fellow watercolorists, who, in a meeting on November 30, 1804, established themselves as the Society of Painters in Water-Colours. Another ten members were added before the Society held its first exhibition in April of the following year. Although not its first president—William Sawrey Gilpin (1762–1843) had that honor—Wells did serve in that office in 1806 and 1807.[2] While its initial exhibitions were extremely popular, by 1812 the Society was experiencing difficulties. It disbanded, reconstituting itself shortly thereafter under new rules, which included the admission of oil paintings in its exhibitions. To Wells, who had been instrumental in its creation solely as a watercolor society, this development was unacceptable. He resigned, and though he was vindicated in 1820 when the Society resumed its original character, he showed no further interest in its doings.

Among the watercolors Wells exhibited with the Society from 1805 to 1812, Scandinavian views (he visited Norway, Sweden, and Denmark in 1804) and views of his native Kent pre-

dominate. *A Distant View of the City of London from St. John's Wood* was not exhibited. But it is typical of the attractive finished watercolors Wells produced and represents a type of simply constructed landscape that was a staple of such early Society exhibitors as George Barret, Jr. (1767–1842), John Glover (1767–1849), and William Havell (1782–1857). The composition adheres to a formula that Wells often employed. A stand of trees bounds a view on one side with a winding diagonal path leading into the distance. The color is cool and decorative; the touch is delicate, but schematized and regular.

While the charm of Wells's watercolors cannot be denied, it is easy to see how his role as founder of the Society of Painters in Water-Colours could overshadow his own rather conventional work in the medium. He is perhaps even better known for his association with another of his contemporaries, J. M. W. Turner. According to his daughter, it was Wells who suggested to Turner the idea for his set of mezzotints, the *Liber Studiorum* (see cat. no. 31).

1. This is not an accurate quotation of Shakespeare's line (act 1, sc. 4), but it is the form in which Clara Wheeler, the artist's daughter, recorded it in "A Sketch of the Original Formation of the Old Water-Colour Society," *The Old Water-Colour Society's Club*, vol. 11 (1933–34), p. 53. No extant copy of the actual letter is known.

2. For the founding of the Society of Painters in Water-Colours, see Wheeler, pp. 53–55; and John Lewis Roget, *History of the "Old Water-Colour" Society* (London: Longmans, Green, 1891), vol. 1, pp. 175–76. For Wells, see Basil S. Long, "William Frederick Wells," *The Old Water-Colour Society's Club*, vol. 13 (1935–36), pp. 1–11; and J. M. Wheeler, "William Frederick Wells," ibid., vol. 46 (1971), pp. 9–24.

29. William Frederick Wells (1764–1836)
A Distant View of the City of London from St. John's Wood, ca. 1805–10
watercolor over pencil with wiping out
verso: watercolor study of clouds
287 x 395 mm (11�5⁄₁₆ x 15⁹⁄₁₆ in.)
Inscribed, verso: *London from St. Johns Wood*
B1977.14.4351

Samuel Owen (1768-1857)
Margate Harbor, 1806

The marine tradition, established by the van de Veldes and carried on by native English artists such as the Cleveleys (cat. no. 12), balanced precision and fidelity of nautical detail with an atmospheric evocativeness. While the decades on either side of 1800 saw a virtual revolution in watercolor painting, the inherent conservativeness of such a closely defined genre as marine painting insulated its practitioners from these developments. Yet to the open-minded marine artist working in watercolor, the achievements of Turner (cat. nos. 31, 44, 56) and Girtin (cat. no. 24) revealed new potential for both their genre and their medium. The works of many of the outstanding nineteenth-century marine watercolorists from William Joy (cat. no. 64) to Edward Duncan (cat. no. 67) to Henry Moore (cat. no. 75) showed a primary concern with light and atmosphere that was unthinkable without the liberating influence of Turner.

Little is known of Samuel Owen's life and training, but his *Margate Harbor* makes clear that the lessons of Girtin's watercolors were not lost on him. In its combination of broad washes and dotlike touches of color and in its movement of light and shadow through the composition, *Margate Harbor* shows its debt; and the line of quayside buildings to the right recalls in particular Girtin's views of Paris which were published posthumously in 1803.

Owen exhibited marine subjects at the Royal Academy from 1794 to 1807. He was a member of the short-lived Associated Artists in Water-Colours from 1808. A rival to the Society of Painters in Water-Colours with a more open exhibition policy, the Associated Artists was formed in 1807 and collapsed in 1812. Among its members were David Cox (cat. nos. 45, 69), John Sell Cotman (cat. no. 51), Peter DeWint (cat. nos. 35, 48), and Samuel Prout (cat. no. 39). Owen resigned from the Associated Artists in 1810. Although he lived on until 1857, he stopped painting long before his death.

30. Samuel Owen (1768–1857)
Margate Harbor, 1806
brown wash over pencil
310 x 486 mm (12³⁄₁₆ x 19⅛ in.)
Signed and dated, lower left: *S O[we]n 1806*
B1975.3.971

31. Joseph Mallord William Turner (1775–1851)
Shipping Scene, ca. 1810
pen and brown wash with scraping out
219 x 294 mm (8⅝ x 11⁹⁄₁₆ in.)
B1978.43.171

Joseph Mallord William Turner (1775-1851)

Shipping Scene, ca. 1810

In October 1806, J. M. W. Turner in conversation with his friend William Frederick Wells (cat. no. 29) devised a scheme for publishing a collection of landscape prints modeled on the *Liber Veritatis* of Claude Lorrain (1600–1682). Claude's book of drawings, recording the compositions of his painted works, had been published in 1777 in two folio volumes of mezzotints by Richard Earlom (1743–1822). From 1803, Earlom was at work on a third volume, reproducing other Claude drawings. It may have been this third volume that provided Wells and Turner with the idea of assembling copies of Turner's paintings, together with original studies, into a volume of landscape mezzotints.

Turner's *Liber Studiorum: Illustrative of Landscape Compositions, Viz. Historical, Mountainous, Pastoral, Marine and Architectural* was published between 1807 and 1819, appearing in fourteen parts, each of which contained five plates.[1] As the title suggests, the plates represent different landscape types, and each plate bears an engraved letter indicating to which category it belongs. The *Liber Studiorum* was probably intended by Turner as a demonstration of his range and versatility as a landscape artist, but also, and perhaps more importantly, as a wordless treatise on landscape art.

For Charles Turner (1774–1857) and the other engravers who worked on the *Liber* plates under the artist's supervision, J. M. W. Turner provided drawings in pen and brown wash as the basis for their mezzotints. This small marine subject is one of these drawings, the majority of which are in the Turner Bequest in the British Museum. Some of these drawings reinterpret for the engraver Turner's oil paintings; others, like this one, were invented specially for the *Liber*. This particular drawing was never actually engraved. It is similar to marine subjects which did appear in parts 2 and 4 and is close in type to the marine oils Turner exhibited in his own gallery in 1808 and 1809.

1. For the origin and nature of the *Liber Studiorum*, see John Lewis Roget, ed., *Notes and Memoranda Respecting the Liber Studiorum of J. M. W. Turner, R.A., Written and Collected by the Late John Pye* (London: John van Voorst, 1879); and Gerald Wilkinson, *Turner on Landscapes: The Liber Studiorum* (London: Barrie & Jenkins, 1982).

Hugh William Williams (1773–1829)
Castle in a Landscape, ca. 1810

The central event of Hugh William Williams's life was undoubtedly his journey to Greece in 1816 and 1817.[1] On his return, he produced a detailed account of the trip, published in 1820 as *Travels in Italy, Greece, and the Ionian Islands*. In 1822 in his native Edinburgh, he exhibited a set of finished watercolors worked up from his Greek sketches. The exhibition was a great success. These strongly Turner-influenced watercolors were engraved and published in 1829, titled *Select Views in Greece*. The artist has been known ever since as "Grecian Williams."

If the period of his Greek sojourn marked a major turning point, the years around 1810 seem to have been another crucial period in his development as an artist. In 1808 he joined the Associated Artists in Water-Colours, which had come into being the previous year. He exhibited with them until their demise in 1812. It was also in these years that he began painting in oils. He was never to have any real success as an oil painter, though he did incorporate oils in some of his popular, large watercolors of Greece. The experience of handling oil paints does seem to have affected his watercolor technique. It was presumably about this time too that he first came under the spell of the seventeenth-century masters, Claude Lorrain (1600–1682), Gaspard Dughet (1615–1675), and Salvator Rosa (1615–1673), whose influence on his work was consolidated during the time he spent in Italy on his way to Greece.

Williams's early watercolors are dry, conventional views of Scottish scenery, with strong outlines and formulaic color schemes. *Castle in a Landscape* demonstrates the increasing breadth of handling and depth of subtle color that were Williams's response to both the exhibition style in watercolors and his own work in oils. The subject and composition reflect his growing awareness of the art of Dughet and Claude. In its evocative treatment of light and its mood of twilit melancholy, *Castle in a Landscape* may also owe something to John Robert Cozens (cat. nos. 9, 13), that eighteenth-century master of the poetic landscape.

1. See the account of Williams in David Irwin and Francina Irwin, *Scottish Painters at Home and Abroad* *1700–1900* (London: Faber and Faber, 1975), pp. 228–31.

32. Hugh William Williams (1773–1829)
Castle in a Landscape, ca. 1810
watercolor over pencil
275 x 403 mm (10¹³⁄₁₆ x 15⅞ in.)
B1975.4.1444

Joshua Cristall (1768-1847)
A Girl Peeling Vegetables, ca. 1810-15

Joshua Cristall was a contributor to the first exhibition of the Society of Painters in Water-Colours in 1805 and remained an active member until his death.[1] Although *A Girl Peeling Vegetables* cannot be positively identified with any of the titles Cristall exhibited, it represents a type of rustic figure subject that comprised fully a third of his exhibition work. While such figures occur throughout his career, the warm, muted color and breadth of treatment in this example argue for an early date.

Cristall's country figures have antecedents in the rustic subjects of Thomas Gainsborough (1727–1788), Francis Wheatley (cat. no. 25), and George Morland (1763–1804), yet the grand simplicity with which Cristall endows them sets them apart from their more picturesque brethren. In his depictions of country girls spinning, knitting, drawing water, or shelling peas, Cristall substitutes a classical stateliness for rococo prettiness, and it is surely no coincidence that classical pastoral subjects drawn from Virgil, Theocritus, and Ovid formed another major category of Cristall's work.

His rustic figures often have a stiff, formal quality, as if his gods and goddesses were not quite comfortable donning contemporary garments. *A Girl Peeling Vegetables*, on the other hand, remains completely natural while conveying the monumentality of a Michelangelo Sybil.

W. H. Pyne wrote of Cristall's watercolors in 1824:

We never recur to the works of this classic genius but we regret that he did not originally direct his fine talent for composition to the profession of sculpture or to painting in oil. There

33. Joshua Cristall (1768–1847)
A Girl Peeling Vegetables, ca. 1810–15
watercolor over pencil
449 x 358 mm (17¹¹⁄₁₆ x 14⅛ in.)
B1975.4.1483

was perceptible in his early designs a largeness of parts a greatness of execution that called for more powerful space for the display of such rare excellences than the scope of watercolour could afford.[2]

Pyne's comment is noteworthy not so much for its condescending view of the limits of watercolor, as it is for acknowledging a sculptural quality and a sense of scale in Cristall's work, which seemed to demand some larger, more substantial format.

1. The only extended treatment of Cristall's life and art is Basil Taylor, *Joshua Cristall (1768–1847)*, exhibition catalogue (London: Victoria and Albert Museum, 1975).

2. *Somerset House Gazette*, no. 13 (January 3, 1824), p. 195.

John Foster (ca. 1787-1846)

The East End and South Side of the Parthenon
ca. 1811-12

When the young architect John Foster went abroad in 1809, London was astir over the recently exhibited Elgin marbles. These sculptures from the Parthenon, which had begun arriving in London in 1802, were put on display in 1807, engendering great public interest and aesthetic debate. As Foster left England, Lord Elgin was about to begin negotiations to place the sculptures in the British Museum.[1] The popular interest in the Elgin marbles, and by extension in ancient Greek art generally, was to color Foster's travels.

In Constantinople, he met Charles Robert Cockerell (1788–1863), another young architect with a decidedly archaeological bent. The two traveled together to Greece. In a letter of January 19, 1811, Cockerell wrote of his traveling companion and their present accommodations, "Foster . . . is an excellent tempered fellow & as our style of life is entirely different we never clash, we have a house looking over the plain of Athens on one side & the Acropolis on the other."[2] Over the next few years Foster and Cockerell traveled around Greece and the eastern Mediterranean, visiting archaeological sites, excavating, and making notes and drawings. Foster produced a series of sensitively drawn and delicately colored views of classical ruins; *The East End and South Side of the Parthenon* is a particularly striking example.[3]

In April 1811, Cockerell and Foster, together with the German architect and archaeologist Carl Haller von Hallerstein (1774–1817) and the German painter Jacob Linkh (1786–1841), visited the island of Aegina. At the Temple of Jupiter Panhellenius (Temple of Aphaea) they discovered and excavated an important group of Late Archaic sculptures. With the possible disposition of Lord Elgin's Parthenon sculptures clearly in mind, Cockerell and Foster intended that the Aegina group be given to the British Museum; however, the Germans in-

sisted on a public sale. The group was purchased on behalf of Crown Prince Ludwig of Bavaria and was installed in the Glyptothek in Munich. Cockerell and Foster went on to excavate the frieze of the Temple of Apollo Epicurius at Bassae[4] in the following year, and this important sculpture group was purchased for the British Museum.

Cockerell was undoubtedly more serious-minded than Foster in his approach to the art and architecture of classical Greece. It is clear from Cockerell's journal that Foster, apart from producing such drawings as the *Parthenon*, spent much of his time in romantic entanglements.[5] After his return to England, Cockerell combined a successful architectural practice with a continuing interest in Greek archaeology, exhibiting a series of finished drawings of antiquities at the Royal Academy and publishing a number of scholarly works on Greek architecture and sculpture. Foster, back in England after 1816, seems to have made little use of his archaeological experience. It is reflected only in the Greek Revival style of the public buildings he designed for his native Liverpool.

1. The Elgin marbles were finally purchased for the British Museum in 1816 on the recommendation of a select committee of the House of Commons.

2. Quoted by David Watkin, *The Life and Work of C. R. Cockerell* (London: A. Zwemmer, 1974), p. 8.

3. This is one of seven examples in the Yale Center for British Art. There is a collection of Foster's Greek drawings in the Walker Art Gallery, Liverpool.

4. Two of Foster's drawings of the site are in the Yale Center for British Art, B1977.14.4317 and B1977.14.-4318.

5. *Travels in Southern Europe and the Levant, 1810–1817: The Journal of C. R. Cockerell, R.A.*, ed. Samuel Pepys Cockerell (London: Longmans, Green, 1903).

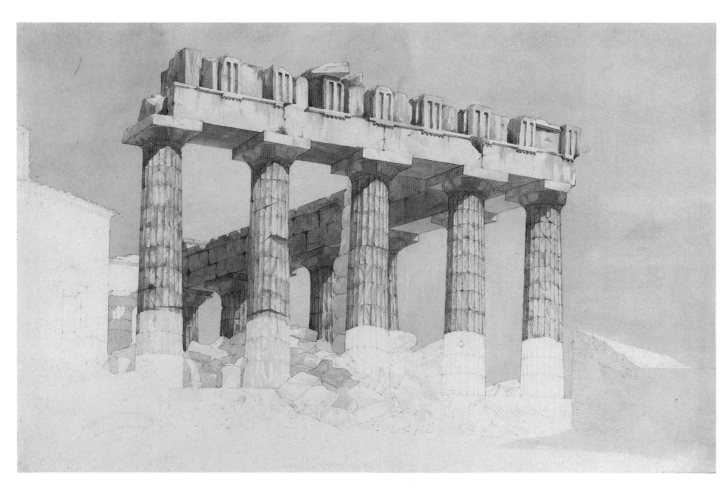

34. John Foster (ca. 1787–1846)
The East End and South Side of the Parthenon, ca. 1811–12
watercolor over pencil
298 x 464 mm (11¾ x 18¼ in.)
B1977.14.4321

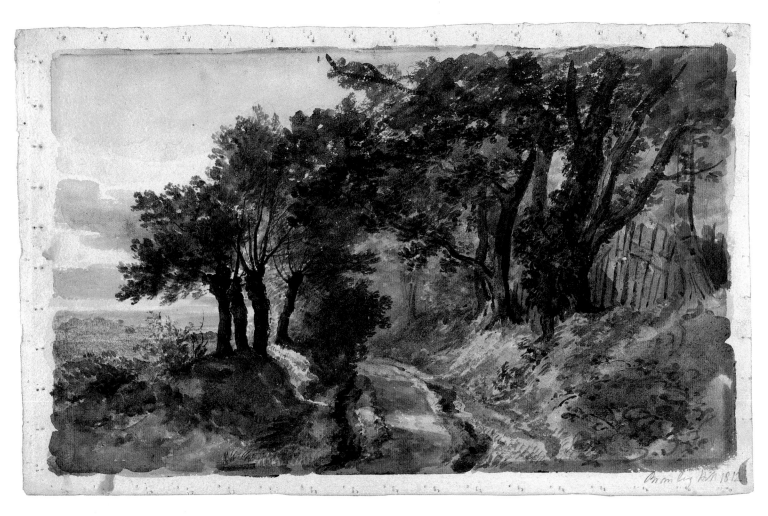

35. Peter DeWint (1784–1849)
Bromley Hill, 1812
watercolor over pencil
327 x 505 mm (12⅞ x 19⅞ in.)
Inscribed by the artist, lower right: *Bromley Hill 1812*
B1977.14.6148

Peter DeWint (1784-1849)

Bromley Hill, 1812

In 1802, Peter DeWint was apprenticed to the portraitist and mezzotint engraver John Raphael Smith (1752–1812).[1] After four years, Smith let him out of the remainder of his apprenticeship in exchange for eighteen oil paintings which DeWint promised to produce over the next two years. With his friend the painter William Hilton (1786–1839), DeWint engaged lodgings in Golden Square, where they were neighbors of John Varley (cat. no. 37). DeWint took instruction from Varley and became part of the circle of Dr. Thomas Monro (see cat. no. 20). It was probably under their influence that he turned to watercolor. Although he continued to paint in oils, it was as a watercolorist that DeWint made his reputation.

He exhibited three drawings at the Royal Academy in 1807, and in the following two years he exhibited with the Associated Artists in Water-Colours. In 1809 he entered the Royal Academy school. The following year he became an associate of the Society of Painters in Water-Colours and began exhibiting with them, becoming a full member of the Society in 1811.

This watercolor of a woodland lane near London, unusual in DeWint's work for being inscribed and dated, shows the artist still under the influence of Varley, particularly that aspect of Varley's art and teaching which valued simple, unpretentious scenes and study from nature. The wet and bold application of color, however, announces a basic element of DeWint's mature style. The color itself has the somber richness that one associates with DeWint, although the original color would have been somewhat cooler, as can be seen along the edges of the drawing which an earlier mat has shielded from the damaging effects of light.

The sheet conveys a particularly strong impression of the artist at work. In part this is the effect of the freedom of DeWint's brushwork. But it is enhanced by the nature of the sheet itself, which has not been trimmed to the image as would generally have been the case in preparation for sale or exhibition. Around the border of the drawing one can still see the holes made by the tacks that attached the sheet to a drawing board.

1. For DeWint, see Hammond Smith, *Peter DeWint, 1784–1849* (London: F. Lewis, 1982).

John Linnell (1792–1882)
Landscape in North Wales, 1813

From the time of his apprenticeship to John Varley during 1804–5, John Linnell worked frequently out of doors, sketching in pencil, chalk, watercolor, or oil in the environs of London. His sketching companions were William Henry Hunt (cat. nos. 38, 43) and William Mulready (1786–1863), also pupils of Varley. Not only did Varley encourage his students to sketch from nature, but his own work encompassed, along with grander landscape compositions, a strand of less formally composed views of everyday London. These watercolors, of which *The Thames near the Penitentiary* (cat. no. 37) is a somewhat later example, provided a general model for the remarkably fresh and direct watercolor studies of Kensington and Bayswater and other locations on London's outskirts which Linnell produced in 1811 and 1812.

Linnell's visit to North Wales in August 1813 was his first major sketching expedition outside the London area. From the time of the Welsh landscape paintings of Richard Wilson (1713?–1782) and the Welsh aquatints of Paul Sandby (cat. nos. 3, 16), Wales had been a mecca for seekers of the Picturesque. To the founding members of the Society of Painters in Water-Colours and other watercolor artists making a name for themselves in the first decade of the nineteenth century, a sketching excursion through Wales was almost de rigueur. Linnell became a member of the Society in 1812 when it reconstituted itself as the Society of Painters in Oil and Water-Colours. In the following year he was off to Wales, accompanied by George R. Lewis (1782–1871), a former member of Girtin's Sketching Club (see cat. no. 27).

The drama of Welsh mountain scenery, exploited by so many of the early members of the Society, plays no part in Linnell's sensitive but low-key studies of Wales. Eschewing the conventions of the Sublime and the Picturesque, he applied to the Welsh landscape the same

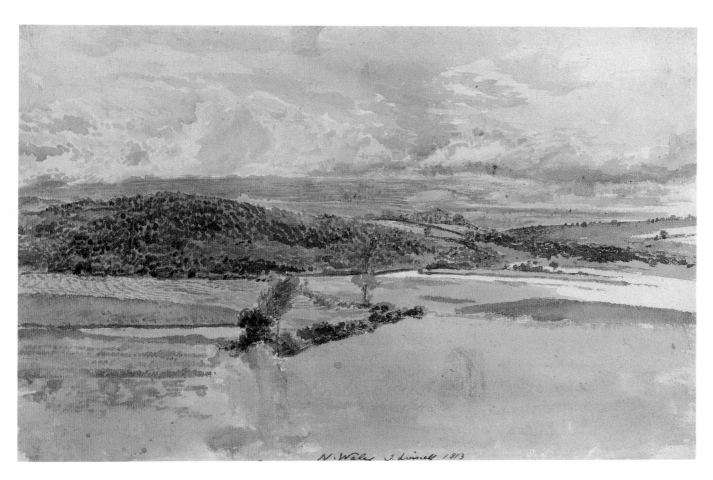

36. John Linnell (1792–1882)
Landscape in North Wales, 1813
watercolor over pencil
238 x 371 mm (9⅜ x 14⅝ in.)
Inscribed by the artist, lower center: *N. Wales J. Linnell 1813*
B1975.4.1875

straightforward, unemphatic treatment as in his sketches of Bayswater and Kensington. On the one hand, Varley's teaching and example lay behind this direct response to nature; on the other, Varley's art in its more formal manifestations represented for Linnell the formulaic approach to landscape which deadened perception and masked artistic ineptitude. He wrote, "The Varley school of Welsh landscape I found to be conventional and the refuge of those who had no powers in figure drawing or individualisation."[1]

Landscape in North Wales is typical of Linnell's watercolor studies from his Welsh tour. The color, largely greens and blues, is cool and delicate, the handling of the watercolor free but sensitive. Density of color and touch is concentrated in a band across the center of the sheet, the foreground left free of detail as in the earlier Welsh mountain studies of Cornelius Varley (cat. no. 40). The simple beauty of Linnell's Welsh watercolors demonstrates his affinity with the medium, yet his interests and ambitions lay in oil painting. When in 1820 the Society returned to an exclusive commitment to works in watercolor, he resigned.

Despite the uncompromising directness of these studies from nature and his rejection of the conventionally Picturesque, Linnell felt, as Samuel Palmer (cat. no. 46) and Francis Oliver Finch (cat. no. 61) would later feel, that simple naturalism was an insufficient basis for great landscape art. Each in his own way was devoted to a "poetical landscape." It was only after 1846 that Linnell was able to turn his attention from the portrait painting, by which he had until then made his living, to the "poetical landscape," which it had been his ambition to paint from his earliest days as an artist. The oil sketches, watercolors, and drawings that he produced in the years around 1813 he would have valued only as the raw material for more substantial landscape paintings. This is not to say that he did not value these Welsh watercolors highly. He said of the Welsh tour of 1813, "One month's study supplied me with material for life."[2]

1. "Autobiographical Notes"; quoted by Katharine Crouan, *John Linnell: A Centennial Exhibition*, catalogue (Cambridge: Fitzwilliam Museum, 1982; New Haven: Yale Center for British Art, 1983), p. 9.

2. Quoted in *A Loan Exhibition of Drawings, Watercolours and Paintings by John Linnell and His Circle*, catalogue (London: P. & D. Colnaghi, 1973).

John Varley (1778-1842)
The Thames near the Penitentiary, 1816

If the watercolor style of Thomas Girtin (cat. no. 24) was the crucial influence on the great generation of British watercolorists who came to maturity in the first two decades of the nineteenth century, an early death prevented his exerting this influence personally as teacher and colleague. The man who was most instrumental in transmitting the Girtin style was John Varley, an associate of the circle of Dr. Thomas Monro (see cat. no. 20) from about 1800 and a member of the sketching club Girtin had founded (see cat. no. 27).[1] Although by the time Varley joined, Girtin was dead and John Sell Cotman (cat. no. 51) had succeeded him as the club's leading member, the former's influence was still strongly felt. From Girtin, Varley derived a technique based on broad washes of deep, full color and a penchant for sweeping, simple compositions. Both as a tireless and popular teacher and as a prolific exhibitor with the Society of Painters in Water-Colours (of which he was one of the original members), Varley passed on these principles to younger artists. Among his pupils were John Linnell (cat. no. 36), William Turner of Oxford (cat. no. 47), William Henry Hunt (cat. nos. 38, 43), and Francis Oliver Finch (cat. no. 61). David Cox (cat. nos. 45, 69) and Peter DeWint (cat. nos. 35, 48) also went to Varley for lessons and advice.

In the light of his extensive teaching activity, it is not surprising that Varley's own work could and, as he grew older, increasingly did degenerate into a reliance on formula. Yet, in *A Treatise on the Principles of Landscape Design*, the first installment of which appeared the same year in which he painted *The Thames near the Penitentiary*, he argued for spontaneity in watercolor, "While the deliberate progression of the painter in oil may be compared to philosophy, the practise of landscape in water-colour must assimilate to wit, which loses more

by deliberation than is gained by truth."[2] The study of nature was a central tenet of his teaching, and he encouraged his pupils to sketch outdoors.

The Thames near the Penitentiary is one of a group of Thames-side subjects that embody the naturalistic approach he sought to impart to his students. While it is unlikely to have been painted on the spot, this watercolor retains something of the informal, offhand quality of a sketch.

1. For John Varley's life and work, see Randall Davies, "John Varley," *The Old Water-Colour Society's Club*, vol. 2 (1924–25), pp. 9–27; and Adrian Bury, *John Varley of the Old Society* (Leigh-on-Sea: F. Lewis, 1946).

2. John Varley, *A Treatise on the Principles of Landscape Design* (London: J. Varley, 1816–18), introduction.

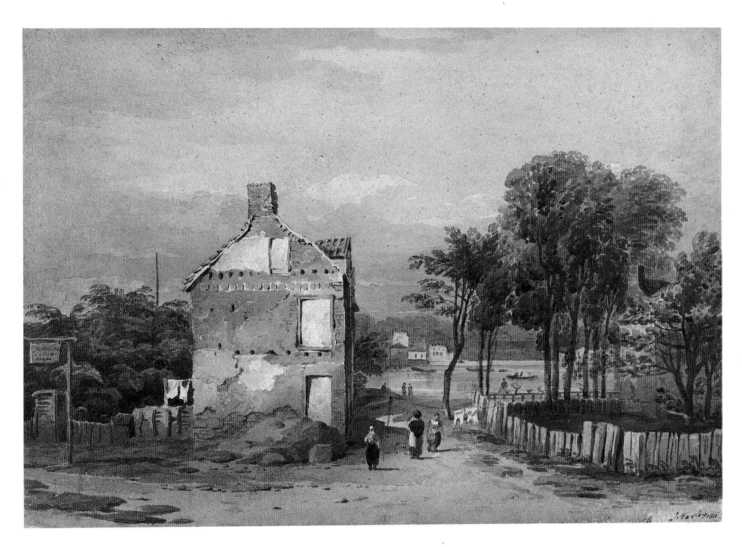

37. John Varley (1778–1842)
The Thames near the Penitentiary, 1816
watercolor over pencil
292 x 409 mm (11½ x 16⅛ in.)
Signed and dated, lower right: *J. Varley 1816*
B1975.3.1080

William Henry Hunt (1790-1864)
Old Farm Buildings, ca. 1815-20

At the age of sixteen, William Henry Hunt was apprenticed to John Varley (cat. no. 37). It was shortly after entering Varley's studio that Hunt became a part of the Academy of Dr. Thomas Monro (see cat. no. 20). His fellow pupil John Linnell (cat. no. 36) recalled that he and Hunt would work for two or three hours in the evening copying drawings by Thomas Girtin (cat. no. 24), J. M. W. Turner (cat. nos. 31, 44, 56), and Thomas Gainsborough (1727–1788) in the doctor's collection.[1]

From 1808, Dr. Monro spent his summers at Bushey in Hertfordshire, retiring there permanently in 1820. Many of his artist friends and protégés were houseguests at Bushey. By 1815, if not earlier, Hunt was a frequent visitor.[2] *Old Farm Buildings* is one of the large number of views of the neighborhood of Bushey which Hunt produced on these visits. Many of these works were done for Monro, and the sale of Monro's collection after his death included one hundred sixty-eight works by Hunt.

The buildings in this watercolor have been identified by John Witt as the back of cottages along Bushey High Street, which Hunt made the subject of another watercolor.[3] Many of Hunt's Bushey drawings are in his distinctive early style which features prominent outlines in brown ink. The style derives from drawings by Antonio Canaletto (1697–1768), copies of which Hunt made for Dr. Monro. In *Old Farm Buildings*, however, he is working in the manner of Henry Edridge (1769–1821). Edridge was a close friend of Dr. Monro, a frequent visitor to Bushey, and sketcher of its environs. Another Bushey subject by Hunt, *Singer's Farm*,[4] is in fact a close copy of a watercolor by Edridge.[5]

1. "Autobiographical Notes"; quoted in John Witt, *William Henry Hunt (1790–1864), Life and Work* (London: Barrie & Jenkins, 1982), p. 36.

2. The first mention of Hunt at Bushey occurs in the diaries of E. T. Monro, the doctor's son, entry for August 1815; Witt, *William Henry Hunt*, pp. 36–37.

3. Now in the Cecil Higgins Art Gallery, Bedford, P.110/P.100; Witt, *William Henry Hunt*, p. 164 and no. 241.

4. Yale Center for British Art, B1975.3.964.

5. British Museum, London, 1845.8.18.7.

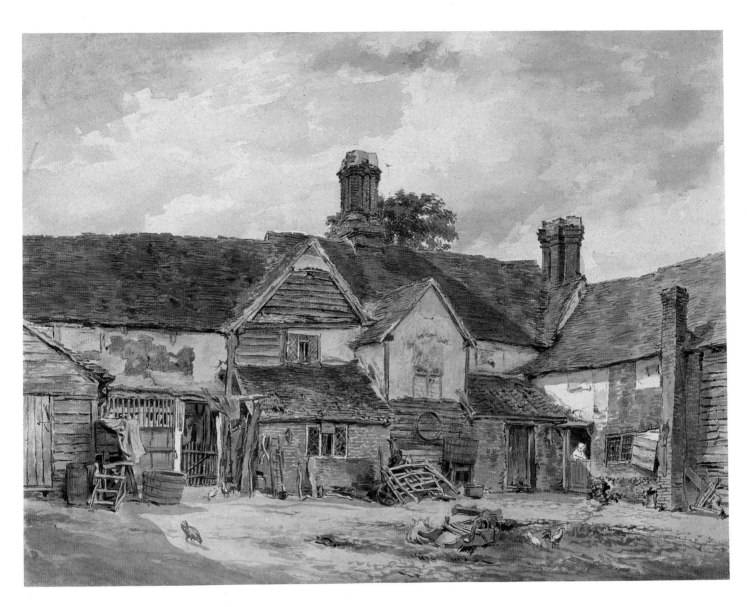

38. William Henry Hunt (1790–1864)
Old Farm Buildings, ca. 1815–20
watercolor over pencil
333 x 426 mm (13⅛ x 16¾ in.)
B1975.3.1046

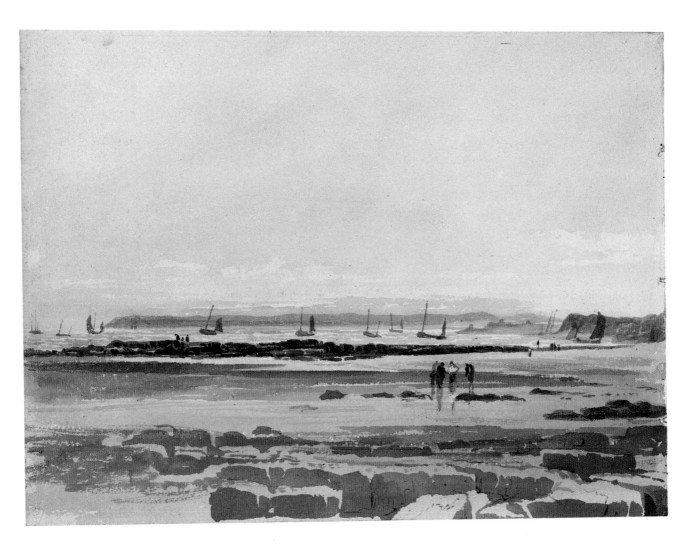

39. Samuel Prout (1783–1852)
The Beach at Hastings, ca. 1815–20
watercolor over pencil
verso: beach scene in watercolor
193 x 252 mm (7⅝ x 9¹⁵⁄₁₆ in.)
Inscribed, possibly by the artist, verso: *From the Whale Rock*
B1975.4.1359

Samuel Prout (1783-1852)
The Beach at Hastings, ca. 1815-20

Samuel Prout was known in his time and is remembered today for his picturesque delineations of Continental architecture.[1] From 1820 to the year before his death in 1852, he annually supplied the Society of Painters in Water-Colours with decorative views of the streets, churches, and palaces of European cities. In such publications as his *Illustrations of the Rhine* of 1824, *Facsimiles of Sketches Made in Flanders and Germany* of 1833, and *Sketches in France, Switzerland, and Italy* of 1839 his Continental drawings reached an even larger public through the medium of lithography. Prout was first and foremost a topographer and in both style and attitude was closely aligned with his eighteenth-century predecessors.

Yet it was not until 1819, when the artist was thirty-six, that he made his first trip abroad. Up to that point his work consisted largely of marine subjects and views of coastal England treated in a broad wash technique that he probably derived from John Varley (cat. no. 37). Not yet in evidence is the distinctive flickering pen outline that characterizes his Continental drawings. The European visit of 1819 marked a radical shift in Prout's art which, within a decade, became exclusively devoted to European architecture; but through the 1820s, occasional seacoast scenes, particularly with fishing boats and dismasted Indiamen, continued to appear with the works he sent to the Society of Painters in Water-Colours.

Among his exhibited coastal watercolors are a handful of Hastings subjects all shown between 1816 and 1820. This sketchbook page with its views of the beach at Hastings on both recto and verso probably dates from this period or slightly earlier. The side of the sheet shown

here formed the basis for the upper left quadrant of a large, finished watercolor of Hastings which shows (to the right) the town nestling amid the cliffs.[2]

From his childhood, Prout was dogged by poor health. In 1836 illness caused him to move from London to Hastings. By this time, however, he seems to have shown little interest in his surroundings, at least as material for finished watercolors. None of the exhibited works of these years had other than a Continental subject.

1. John Ruskin wrote an appreciation of Prout's work; see his *Notes on Samuel Prout and William Hunt* (1879–80), in *The Works of John Ruskin*, ed. E. T. Cook and Alexander Wedderburn, vol. 14 (London: George Allen, 1904), pp. 384–439. See also C. E. Hughes, "Samuel Prout," *The Old Water-Colour Society's Club*, vol. 6 (1928–29), pp. 1–30.

2. Now in the Victoria and Albert Museum, London, 3023–1976.

Cornelius Varley (1781-1873)
Remains of Parton Hall, 1820

In this 1820 watercolor of Parton Hall, Cornelius Varley has inscribed the letters "P.G.T." along the wall that runs in front of the house. These letters stand for Patent Graphic Telescope, an optical device for taking views and portraits which Cornelius Varley had developed about a decade earlier and patented on April 5, 1811. Varley's invention was an advance on the camera lucida, devised by Dr. William Wollaston in 1807, which was itself a lighter and more easily portable alternative to the camera obscura, used by artists since the seventeenth century. The Patent Graphic Telescope was employed by a number of Cornelius Varley's contemporaries, including his brother John Varley (cat. no. 37), John Sell Cotman (cat. no. 51), and the sculptor Sir Francis Chantrey (1781–1841).[1] In an 1814 drawing manual, Samuel Prout (cat. no. 39) recommended it in addition to the camera lucida:

> A similar invention, or rather an improvement thereof, has been made by Mr. Cornelius Varley, who has added the power of a reflecting telescope to this most ingenius instrument, by which views of objects at a considerable distance may be drawn, which affords a vast scope for the study of landscape composition.[2]

Cornelius Varley was raised by his uncle Samuel Varley, an instrument maker and amateur scientist, from whom he gained the expertise to produce the Graphic Telescope and imbided a general interest in scientific pursuits. Under the influence of his older brother, John, he began to draw around 1800. Both brothers became part of Dr. Thomas Monro's circle (see cat. no. 20) and both were among the initial members of the Society of Painters in Water-Colours. Cornelius seems to have taken his brother's exhortation to his pupils to "go to nature for everything" very much to heart, and Cornelius's watercolors are, together with those of

John Linnell (cat. no. 36) and William Henry Hunt (cat. nos. 38, 43), outstanding examples of naturalistic landscape in the first decades of the nineteenth century.

The unfinished character of so many of his watercolors suggests that the impulse behind his work was as much scientific curiosity as artistic feeling. Having captured the essential elements of a scene or a particularly interesting effect of light, he had no desire to bring the whole watercolor to a uniform degree of finish. His interest in science, particularly in optics, gradually came to displace his artistic concerns. Although he continued to exhibit watercolors occasionally, even after his resignation from the Society of Painters in Water-Colours in 1820, most of his energy was devoted to developing improved forms of the microscope.

With his interests in both art and optics, it is not surprising that he was in his later years an advocate of photography as an aid to art. He undoubtedly viewed the photographic process as an improvement on his own optical device for recording nature. In 1853 he wrote to Linnell claiming that he could see the beneficial influence of photography on the works in the Royal Academy exhibition of that year and calling photography "the most glorious associate the arts have ever had."[3]

1. For a more complete account of the Patent Graphic Telescope and its inventor, see Michael Pidgley, "Cornelius Varley, Cotman, and the Graphic Telescope," *Burlington Magazine*, vol. 114 (November 1972), pp. 781–86; and Michael Pidgley, *Exhibition of Drawings and Watercolours by Cornelius Varley*, catalogue (London: P. & D. Colnaghi, 1973), introduction.

2. Samuel Prout, *Rudiments of Landscape: In Progressive Studies* (London: R. Ackermann, 1814), p. 16.

3. Alfred Thomas Story, *The Life of John Linnell* (London: Bentley and Son, 1892), vol. 2, p. 222.

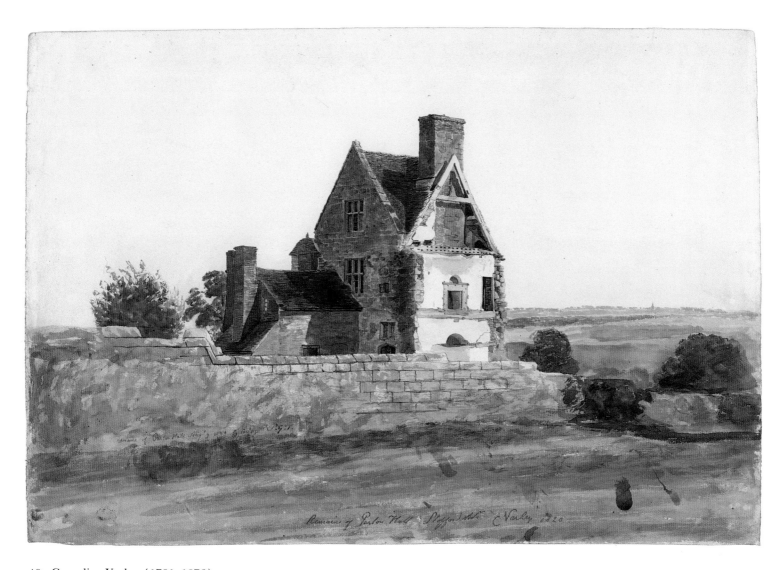

40. Cornelius Varley (1781–1873)
Remains of Parton Hall, 1820
watercolor over pencil
383 x 542 mm (15¹⁄₁₆ x 21⅜ in.)
Inscribed by the artist, along wall at lower left:
remains of Parton Hall Aug 9 1820 C Varley P.G.T.;
and lower center: *Remains of Parton Hall Staffordshr C Varley 1820*
B1977.14.4338

41. Edward Francis Burney (1760–1848)
The Triumph of Music, ca. 1820
watercolor with pen and gray ink over pencil
308 x 459 mm (12⅛ x 18¹⁄₁₆ in.)
B1975.4.1467

Edward Francis Burney (1760-1848)
The Triumph of Music, ca. 1820

Although he is remembered primarily as a comic master, Edward Francis Burney's output as a professional artist consisted largely of book illustrations, which are charming and graceful in the manner of Thomas Stothard (cat. no. 42), but neither humorous nor satirical in intention. He studied at the Royal Academy Schools, and from 1780 to 1803 he sent portraits and literary subjects to their exhibitions. It was only after 1810 that he began to work in a comic mode, culminating in the years around 1820 in his series of four great comic masterpieces, one of which is *The Triumph of Music*.[1] Although they have every appearance of exhibition works, these large, elaborate watercolors were neither exhibited nor engraved. They seem to have been purely personal creations intended for his own enjoyment and that of his family and friends.

The Burneys were a musical family. Edward's uncle was the famous musicologist Dr. Charles Burney, his father and two of his brothers were dancing masters, and an elder brother, with whom Edward lived from 1783 to 1798, was a noted harpsichordist and music teacher. Edward himself played the violin and frequently joined in trios and quartets with the celebrated musicians, among them Franz Josef Haydn, who were guests in his brother's house. Therefore, it is not surprising that musical subjects form the basis for his comic quartet of watercolors, *The Triumph of Music*, *Amateurs of Tye-Wig Music*, *The Waltz*, and *The Elegant Establishment for Young Ladies*.[2]

The Triumph of Music takes aim at the late-eighteenth-and early-nineteenth-century fashion for glee clubs. Among these clubs devoted to the collection and performance of glees, part-songs, catches, and canons were the Anacreonic Society, the Ad Libitum Society, and the Catch Club (satirized here by a picture of a group of cats in the portfolio on the floor). Titles

of famous glees appear in inscriptions throughout the composition, many forming the subjects of visual puns. Presiding over all is the bust of "Glorious Apollo," the title of one of the best-known glees.

The pun at the center of the picture—a group of men with backsides turned to the viewer huddle over a piece of music entitled "Life's a Bum per"—is already present in the preliminary pen and wash drawing in the British Museum. At this stage, Burney had established the composition in all its essentials. In the finished watercolor, his basic comic ideas have been amplified through a proliferation of detail and humorous reference.[3]

Burney's distinctively pneumatic figures have something of Rowlandson's rounded, flowing forms, but the precise neoclassical outline has more in common with John Flaxman (1755–1826) or Thomas Stothard. Burney's large comic machines have been labeled his "neo-Hogarth group"[4] and certainly *The Triumph of Music* is Hogarthian in its complexity, its intricate structure of allusion, verbal and visual puns, and densely packed incident. The underlying framework of the composition, however, is in its symmetry once again neoclassical.

1. The dating of circa 1820 is suggested by Patricia Crown in her discussion of these works in *Edward F. Burney: An Historical Study in English Romantic Art* (Ph.D. diss., University of California, Los Angeles; Ann Arbor, Mich.: University Microfilms, 1979), pp. 130–31; and in her subsequent article, "Visual Music: E. F. Burney and a Hogarth Revival," *Bulletin of Research in the Humanities*, vol. 83 (Winter 1980), pp. 435–72. The present discussion draws heavily on Crown's research and observations.

2. *Amateurs of Tye-Wig Music* is also in the Yale Center for British Art, B1975.3.155. Both *The Waltz* and *The Elegant Establishment for Young Ladies* are in the Victoria and Albert Museum, London, P.129–1931 and P.50–1930, respectively; preliminary drawings for both are at Yale, B1975.4.1045 and B1975.4.1896, respectively.

3. Crown, *Edward F. Burney*, pp. 166–68, and "Visual Music," pp. 461–62, 466–67, analyzes closely the comic details of the watercolor and the relation between its structure and musical forms.

4. Crown, *Edward F. Burney*, p. 130.

Thomas Stothard (1755-1834)
The Tenth Day of the Decameron, ca. 1825

This watercolor is one of ten illustrations Thomas Stothard provided for an edition of Boccaccio's *Decameron*, published by William Pickering in 1825.[1] Rather than represent the tales themselves, Stothard chose to depict the settings in which the tales were told, providing one illustration for each of the ten days of storytelling. In this drawing, Stothard represents the tenth day, with the young Florentine aristocrats, who have fled the plague-ravaged city, drinking and conversing within the loggia of their country retreat.

Stothard's watercolors for Pickering's edition were the culmination of over a decade's interest in illustrating Boccaccio. As early as 1811, he exhibited at the Royal Academy *The Scene of Boccaccio's Tales*. In 1819, he exhibited two more scenes from the *Decameron*, and in the following year he showed a suite of six pictures illustrating the *Decameron*. Like the Pickering watercolors, these concentrated on the scenes of storytelling.

The *fêtes galantes* of Antoine Watteau (1684–1721) provided an obvious model for the depiction of aristocratic youth disporting themselves in elegant parkland settings, and Stothard's Boccaccio subjects rely heavily on the French artist's graceful paintings. The manner came naturally to Stothard, whose drawing style had been formed in the rococo tradition introduced into England by the French book illustrator and engraver Hubert Gravelot (1699–1773). Like Richard Westall (cat. no. 18), Stothard combined this rococo style with elements of neoclassicism into a fashionable hybrid which he employed in numerous book illustrations, oil paintings, and designs for a variety of decorative schemes.

A visit to Paris in 1815 sparked in Stothard a renewed interest in the works of Watteau. At the Royal Academy in 1817, he exhibited *Sans Souci*, an imitation of a Watteau *fête galante*.

In 1818 and again in 1826, he exhibited works with the title *Fête champêtre*. Thus, his Boccaccio subjects can be seen as part of a broader concern with re-creating the mood and style of Watteau's masterpieces.

The Boccaccio illustrations have undeniable charm, but they fail to capture the poignancy of the Watteau images they ape, or the character of Boccaccio's *Decameron*. Thomas Griffiths Wainwright, writing of the *Decameron* pictures that Stothard exhibited in 1820, criticized their lack of authentic feeling:

> There is not a grain of vivacity. They are only good little English boys and girls, in masquerade. Indeed, lately, Stothard never condescends to make out a set of features at all. The only spirit his figures have, lies entirely in their attitudes, which have really a good deal of nature,—(we are only speaking of his imitations of Watteau, in more homely subjects he is unrivalled)—that is, they are elegant portraitures of flaxen-headed boys and girls, unitiated [*sic*] in the mysteries of fashionable boarding-schools. And, truly, the sight of their innocent recreations is very touching to an amiable mind, and would be so to us, were they so intended; but, unfortunately, Mr. Stothard fancies, that, in their "simple Cheeks sincere," he has embodied the souls of the "noble and amorous dames" in Boccaccio, or the queen of Navarre's licentious "Heptameron!" Taken in that point of view, they present nothing but the lamentable spectacle of mawkish do-me-good insipidity.[2]

While Stothard's imitations of Watteau had their detractors, they were influential works. Stothard was by no means alone in his admiration of Watteau. As unlikely an artist as David Cox (cat. nos. 45, 69) tried his hand at a *fête galante*.[3] In 1831, J. M. W. Turner (cat. nos. 31, 44, 56) exhibited at the Royal Academy an oil painting entitled *Watteau Study by Fresnoy's Rules*. A *fête galante* that Turner exhibited a few years earlier, *Boccaccio Relating the Tale of the Birdcage*,[4] makes clear that it was through Stothard's Boccaccio series that Turner approached Watteau. Charles Leslie (1794–1859) recorded that Turner, retouching his *Boccaccio* on varnishing day at the Royal Academy, commented, "If I thought he [Stothard] liked my pictures half as well as I like his, I should be satisfied."[5]

1. The major sources for Stothard's life and art are Anna Eliza Bray [Stothard's daughter], *Life of Thomas Stothard, R.A.* (London: J. Murray, 1851), and A. C. Coxhead, *Thomas Stothard, R.A.* (London: A. W. Bulen, 1906).

2. Janus Weathercock [Thomas Griffiths Wainwright], "Sentimentalities on the Fine Arts," *The London Magazine*, vol. 1 (1820), p. 288; quoted by Pauline Grace King, "Thomas Stothard and the Development toward Victorian Romanticism" (Ph.D. diss., University of Chicago, 1950), pp. 181–82.

3. Now in the Lady Lever Art Gallery, Port Sunlight, England.

4. Both these Turner oils are in the Tate Gallery, London.

5. Charles P. Leslie, *Autobiographical Recollections*, ed. Tom Taylor (London: John Murray, 1860; reprint London: EP Publishing, 1978), vol. 1, p. 130.

42. Thomas Stothard (1755–1834)
The Tenth Day of the Decameron, ca. 1825
watercolor over pencil
270 x 204 mm (10⅝ x 8 in.)
B1975.4.1757

[43]

William Henry Hunt (1790–1864)
Still Life with a Ginger Jar, ca. 1825

In 1824, William Henry Hunt became an associate of the Society of Painters in Water-Colours. Two years later he was elected a full member. It was at this time that his art began to shift from such landscapes as *Old Farm Buildings* (cat. no. 38) to genre subjects and still lifes. As John Witt has remarked, Hunt's early still lifes with their subdued color and simple arrangements of everyday kitchen utensils bring to mind the eighteenth-century master-pieces of Jean Siméon Chardin (1699–1779).[1] Despite their comparable qualities, the still lifes of Chardin are a highly unlikely source for those of Hunt. After Chardin's death, his work slipped into obscurity from which it was retrieved only in the middle of the nineteenth century.

Neither was there any ongoing tradition of British still-life painting. Although both Peter DeWint (cat. nos. 35, 48) and David Cox (cat. nos. 45, 69) produced fine watercolor still lifes that have much in common with Hunt's of the late 1820s and early 1830s, still life was never more than a small and insignificant aspect of their work. For Hunt, on the other hand, it came to form the core of his art and the basis for his large popular following.

Already evident in *Still Life with a Ginger Jar* is Hunt's technique of describing form through hatching with fine brushstrokes. In his later still lifes, the touches of the brush be-come more precise and minute, the color brightens to include vivid greens, yellows, and purples, and the subjects change from jugs and pots to fruit, sprays of delicate flowers, and birds' nests (fig. 4). It was his frequent employment of nests with eggs in his still lifes that earned him the nickname "Bird's Nest" Hunt.

While Hunt's later still lifes were celebrated for their truthfulness, their technical virtu-osity did draw attention to itself and thus laid Hunt open to the criticism that his "manner"

43. William Henry Hunt (1790–1864)
Still Life with a Ginger Jar, ca. 1825
watercolor over pencil
190 x 254 mm (7½ x 11 in.)
Signed, lower right: *W. Hunt*
B1975.3.1038

was obtrusive. The *Spectator*'s critic, devoting the final paragraph of his review of the Society of Painters in Water-Colours exhibition of 1847 to a consideration of the problem of Hunt's "manner," maintained that, "Hunt is, among living artists, in whatsoever medium working, one of those who possess the keenest conception of truth and the greatest command over materials." The review went on to note that, "Hunt's manner is naturally devised, powerful for his purpose, but occasionally somewhat too powerful—not quite under command."[2]

1. John Witt, *William Henry Hunt (1790–1864), Life and Work* (London: Barrie & Jenkins, 1982), p. 28 and no. 773.

2. *Spectator* (May 1, 1847), p. 426.

Joseph Mallord William Turner (1775-1851)
Rhodes, ca. 1825-30

Rhodes is one of twenty-six designs Turner produced to illustrate editions of Byron's works published by John Murray in the 1820s and 1830s.[1] Turner often turned to literary sources for the subjects of his oil paintings, and from 1798 his exhibited pictures at the Royal Academy often carried quotations from Milton, Shakespeare, James Thomson, and contemporary and classical poets. Frequently the poetic tags were his own, fragments from that amorphous poem he called *The Fallacies of Hope*. The Byron watercolors were, however, among Turner's earliest work as a book illustrator.[2] Through the next decade and a half he was involved in a number of similar but often more extensive projects, illustrating editions of contemporary poets Walter Scott, Samuel Rogers, Thomas Campbell, and Thomas Moore.[3]

Since Turner had not visited a number of the Mediterranean locales, including Rhodes, depicted in his Byron illustrations, these watercolors were based on the drawings of other artists. *Rhodes* was engraved by William Finden (1787–1852) and included in a succession of illustrated Murray editions of Byron's works. The plate was also used for Finden's *Landscape and Portrait Illustrations to the Life and Works of Lord Byron* published 1833–34.

In the 1820s, Turner was involved in a number of projects for which he produced watercolors to be engraved. In addition to his illustrations to literary works, there were the various series of topographical views, the most ambitious being *Picturesque Views in England and Wales*, begun in 1826. Working with the engraver in mind, Turner adapted his watercolor technique accordingly. As a response to the small scale of book illustration, he developed a miniaturist technique of hatching and stippling, of which *Rhodes* is a virtuoso example. He was also preoccupied with the problems of translating color into the black and white of line

engraving, supervising closely his engravers in this process of translation. Rather than produce monochrome drawings, as he had for the *Liber Studiorum* (see cat. no. 31), he tended to heighten his color and accentuate color contrasts. As Andrew Wilton has noted, "The whole progress of his approach to colour in the 1820s may be seen as a paradoxical corollary to his activities in black and white."[4]

1. According to Mordechai Omer, *Turner and the Poets*, catalogue of a traveling exhibition (London: Greater London Council, 1975), Turner's first seven designs were used in an eleven-volume edition, titled *Lord Byron's Works*, which appeared in 1825. John Murray's ledgers record no such edition. Andrew Wilton, in *J. M. W. Turner: His Art and Life* (New York: Rizzoli, 1979), pp. 444–45, placed *Rhodes* within that first group but now doubts the existence of such an early edition and has suggested in conversation that a date of the later 1820s for this watercolor is more appropriate stylistically.

2. In 1818, Turner had been commissioned to provide a series of illustrations for Walter Scott's *The Provincial Antiquities of Scotland*. Several other artists, including Hugh William Williams (cat. no. 32), provided further illustrations for the publication.

3. For a full discussion of these works, see Omer, *Turner and the Poets*.

4. Wilton, *J. M. W. Turner*, p. 166.

44. Joseph Mallord William Turner (1775–1851)
Rhodes, ca. 1825–30
watercolor with bodycolor and scraping out
135 x 225 mm (5⁵⁄₁₆ x 8⅞ in.)
B1977.14.153

David Cox, Sr. (1783-1859)

A French Marketplace, ca. 1829

When a friend suggested to David Cox that his son might benefit from travel on the Continent, Cox replied, "Wales, Yorkshire, and Derbyshire have been good enough for me, and I quite believe they may yet do for him."[1] While such artists as Samuel Prout (cat. no. 39), David Roberts (cat. no. 62), and William Callow (cat. no. 63) built reputations on the depiction of foreign locales, Cox's standing as one of the major watercolor artists of the nineteenth century rests largely on his fresh and atmospheric treatments of British meadows and hayfields, moorlands and mountains.

Nonetheless, for a period of six years in the middle of his career, Cox did turn his attention to the Continent, visiting the Low Countries in 1826, Calais, Amiens, Beauvais, and Paris in 1829, and coastal France in 1832. *A French Marketplace*, probably a product of the 1829 trip, is typical of the sketches that Cox produced on his Continental excursions. These are fundamentally outline drawings in pencil to which Cox has added washes to establish the color of a detail or the pattern of light and shadow.

In the same year that Cox first crossed the Channel, the young expatriate artist Richard Parkes Bonington (1802–1828) began exhibiting in London. With its technical facility and bright vibrant color, Bonington's art had a considerable impact on a whole generation of English artists. Cox, though of an older generation, responded strongly to his work, and many of Cox's watercolors of the late 1820s and early 1830s show an indebtedness to his style.

It is likely that the visits to France in 1829 and 1832 were undertaken with the recently deceased Anglo-French artist very much in mind, and Cox's sketches from these trips recall Bonington both in their subjects and in the liveliness of their treatment. Yet Cox's pencil line

45. David Cox, Sr. (1783–1859)
A French Marketplace, ca. 1829
watercolor over pencil
251 x 314 mm (9⅞ x 12⅜ in.)
Inscribed by the artist, upper right: *slate* and *not quite high enough* [?]
B1981.25.2420

has a roughness and a vigor that distinguish it from Bonington's suave manner. In fact, closer parallels to Cox's sketching style can be found in the freer sketches of other, younger followers of Bonington, such as William Callow and James Holland (cat. no. 68).

For all the freshness and verve of his Continental sketches, Cox seems to have been reluctant to capitalize on the material he collected on his three tours. Apart from a series of French coastal scenes, which has the character of an homage to Bonington, few Continental subjects appeared among his yearly contributions to the exhibitions of the Society of Painters in Water-Colours. His primary allegiance remained with the landscape of his native Britain.

1. Nathaniel Neal Solly, *Memoir of the Life of David Cox* (London: Chapman and Hall, 1873; reprint London: Rodart Reproductions, 1973), p. 72. Solly's biography of Cox is one of two written by men who knew him; the other is William Hall, *A Biography of David Cox* (London: Cassell, Petter, Galpin, 1881). These remain the fullest, most reliable accounts of the artist's life.

Samuel Palmer (1805-1881)

A Cow Lodge with a Mossy Roof, ca. 1829

The major thrust and central achievement of British landscape painting in the first decades of the nineteenth century was naturalism. Although, as the diverse watercolors in this exhibition demonstrate, naturalism can take many forms, it provided a common ground for many of the landscape painters working in both oils and watercolors. There were, however, artists who chose to follow another path. Of these, Samuel Palmer is one of the most highly valued today.[1]

Palmer met William Blake (1757–1827) in 1824. Inspired by Blake's wood engravings for Dr. Robert Thornton's *The Pastorals of Virgil* and by the style of the early Flemish and German masters, Palmer, over the course of the next few years, produced a series of intensely personal pastoral visions in a uniquely archaizing style. In 1826, Palmer moved to the village of Shoreham in Kent where he became the leader of a group of young artists, self-styled the "Ancients," who were devoted to Blake and to a mystical celebration of nature.

Into this pastoral idyll, the pressures of naturalism intruded in the person of Palmer's future father-in-law, John Linnell (cat. no. 36). It was Linnell who had introduced Palmer to Blake, and through Linnell that Palmer had become aware of the art of Albrecht Dürer (1471–1528) and Lucas van Leyden (1494?–1533). Yet at the same time, Linnell encouraged Palmer in a more literal-minded approach to nature. As early as September 1824 Palmer was writing to Linnell, "I may safely boast that I have not entertain'd a single imaginative thought these six weeks, while I am drawing from Nature vision seems foolishness to me." Clearly Palmer found compliance with Linnell's dicta a struggle. Later in the same letter he pointedly confessed that he found Michelangelo's *Night* more fascinating than "most exhibitions of clover and beans and parsly and mushrooms and cow dung and the innumerable etceteras of a fore-

ground."[2] In the wake of Linnell's visit to Shoreham in 1828 Palmer set about making studies from nature to please the older artist, although he had reservations about the value of such work. He wrote to his fellow Ancient George Richmond (1809–1896) in the autumn, "Tho' I am making studies for M. Linnell, I will, God help me, never be a naturalist by profession."[3]

A Cow Lodge with a Mossy Roof is one of a group of studies of farm buildings at Shoreham from the period after Linnell's visit. While Palmer's intention was presumably straight-forward natural observation, the drawing with its flowing, organic lines and almost obsessive preoccupation with the texture of the moss is hardly simple naturalism. The brilliant pinks and yellows also contribute to the drawing's strange intensity, but the strip of color along the upper edge of the sheet, where it was protected from exposure by an earlier mat, shows the blue that has disappeared from the rest of the drawing. Originally the color would have been cooler, as it is in another very similar watercolor from this same group, also at Yale, *A Barn with a Mossy Roof*.[4]

By the middle of the 1830s, Palmer had adopted a precise, detailed naturalism. Although he continued to produce watercolors of great beauty and delicacy, the visionary fervor of his early work was gone. The triumph of naturalism in his art was, however, not permanent. In the 1860s he began a series of watercolors and etchings illustrating Milton and Virgil, in which he again gave eloquent form to the pastoral dream that had been his earliest inspiration.

1. The major accounts of Palmer are A. H. Palmer, *The Life and Letters of Samuel Palmer* (London: Seeley, 1892); Geoffrey Grigson, *Samuel Palmer: The Visionary Years* (London: Kegan Paul, 1947); and Raymond Lister, *Samuel Palmer: A Biography* (London: Faber and Faber, 1974).

2. *The Letters of Samuel Palmer*, vol. 1, *1814–1859*, ed. Raymond Lister (Oxford: Clarendon Press, 1974), pp. 8–9.

3. Ibid., p. 36.

4. B1977.14.5968.

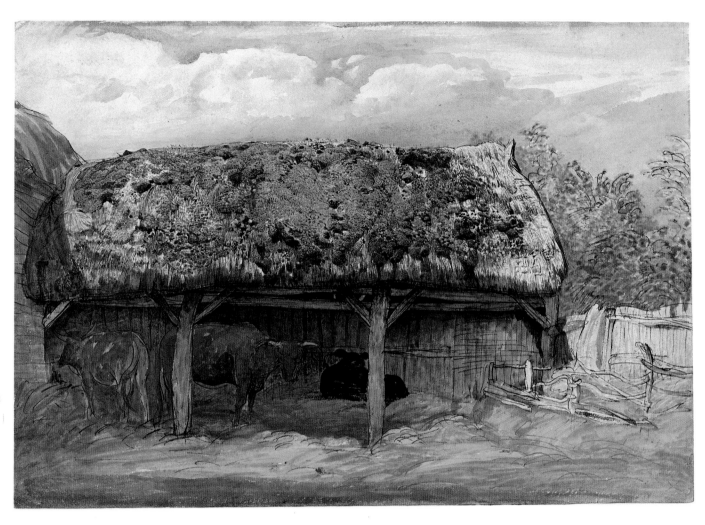

46. Samuel Palmer (1805–1881)
A Cow Lodge with a Mossy Roof, ca. 1829
watercolor, pen and black ink, with bodycolor and gum arabic
267 x 375 mm (10½ x 14¾ in.)
B1975.4.1876

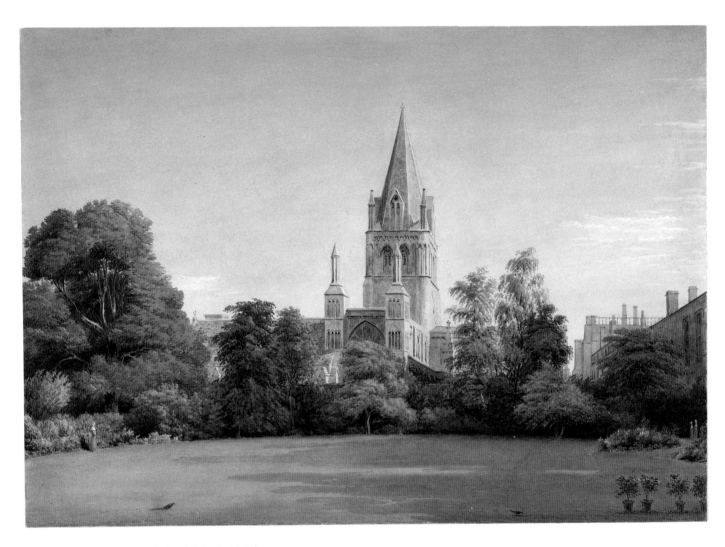

47. William Turner of Oxford (1789–1862)
View from the Dean's Garden, Christ Church, Oxford, ca. 1829–30?
watercolor with bodycolor
275 x 378 mm (10¹³⁄₁₆ x 14⅞ in.)
Inscribed by the artist, verso: *View from the Dean's Garden*
Christ Church, Oxford | painted on the spot | W. Turner.
B1975.4.1861

William Turner of Oxford (1789–1862)

View from the Dean's Garden, Christ Church, Oxford, ca. 1829-30?

On the evening of January 27, 1808, Joseph Farington (1747–1821) attended a conversazione at which John Varley (cat. no. 37) and Ramsay Richard Reinagle (1775–1862) were also present. Farington recorded in his diary, "Varley spoke violently of the merit of a young man who has been His pupil in learning to draw in water colour & Reinagle said 'He had never before seen drawings equal to them.' His name Turner."[1]

William Turner came to London from his native Oxfordshire around 1804 and was apprenticed to John Varley. Shortly after Farington recorded Varley and Reinagle's strong advocacy of the young artist, Turner was elected an associate of the Society of Painters in Water-Colours. He became a full member later that same year.[2]

Turner seemed destined to play a leading role in London's developing watercolor school, but in 1811 he returned to Oxford, where he resided for the rest of his life, teaching drawing. He did, however, remain a regular contributor to the Society's exhibitions right up to his death, not missing a single year. John Ruskin (cat. no. 70), in the 1850s, described him as a "patient and unassuming master" whose contributions were not sufficiently appreciated by the Society.[3]

Although *View from the Dean's Garden, Christ Church, Oxford* was not exhibited at the Society of Painters in Water-Colours, it may have formed part of a group of Oxford views of which two were exhibited, *The Old Gateway of Magdalen College* in 1829 (no. 243) and *High Street* in 1830 (no. 101). Both of these works are described in the Society's catalogues as "painted on the spot," which corresponds to the inscription on the verso of this drawing.

While Oxfordshire scenes formed a staple of Turner's exhibition watercolors, such views of Oxford's streets and colleges were much less common than distant views of the city and its environs. From the eighteenth century, views of the Oxford colleges engraved after such artists as Edward Dayes (cat. no. 21), Michael "Angelo" Rooker (cat. no. 23), J. M. W. Turner (cat. nos. 31, 44, 56), and Peter DeWint (cat. nos. 35, 48) had appeared yearly in the Oxford *Almanack*.[4] William Turner's view of Christ Church Cathedral from the Dean's Garden is, in fact, similar to one by Rooker which illustrated the *Almanack* for 1782. Turner supplied none of the *Almanack* views during his lifetime. It was only at the end of the nineteenth and early in the twentieth century that collotypes of a few of his watercolors were used to illustrate the *Almanack*.[5]

Turner's watercolor landscapes share with those of George Fennel Robson (1788–1833) and Francis Danby (cat. no. 55) a combination of smooth, meticulous technique, which can at times become stiff and dry, intensity of color, and an almost supernatural stillness. Though very different in character from the open landscapes Turner frequently made the subjects of his watercolors, this enclosed garden view possesses those same qualities.

1. Entry for January 27, 1808; *The Diary of Joseph Farington*, ed. Kathryn Cave, vol. 9 (New Haven: Yale University Press, 1982), p. 3209.

2. The most complete accounts of Turner of Oxford are A. L. Baldry, "William Turner of Oxford, Watercolour Painter," *Walker's Quarterly*, no. 11 (April 1923); and Martin Hardie, "William Turner of Oxford," *The Old Water-Colour Society's Club*, vol. 9 (1931–32), pp. 1–23.

3. Ruskin added this note to the fifth edition of *Modern Painters*, vol. 1, published in 1851; see *The Works of John Ruskin*, ed. E. T. Cook and Alexander Wedderburn, vol. 3 (London: George Allen, 1903), p. 472.

4. The *Oxford Almanack* was first published in 1674. Its earlier illustrations tended to be allegorical in nature; only in the mid-1760s did the series of picturesque topographical views of Oxford and its colleges begin; see Helen Mary Petter, *The Oxford Almanacks* (Oxford: Clarendon Press, 1974).

5. In 1896, 1919, and 1928.

Peter DeWint (1784-1849)
A Yorkshire Road, ca. 1830-35

Of all the artists who were affected by the example of Thomas Girtin's watercolor style (cat. no. 24), Peter DeWint was perhaps his truest heir. This was recognized by DeWint's contemporaries. A critic, writing in *Fraser's Magazine* in 1830, remarked:

> What Girtin would have produced had he lived, can, of course, be but [a] matter of speculation; but his drawings were decidedly grander than even those of Turner at the same period; and his effects have never, to this moment, been surpassed by any artist in the same line. The man who comes nearest to him in this respect is DeWint, and who, on the whole, must be allowed to be the more perfect artist.[1]

Through his acquaintance with Dr. Thomas Monro (see cat. no. 20) and John Varley (cat. no. 37), DeWint had opportunity to study and absorb Girtin's style. *A Yorkshire Road*, with its warm color, broad, fluid brushwork, and low, sweeping composition, is both typical of much of DeWint's work and reminiscent of Girtin's. If DeWint's color is warmer, his strokes freer and more vigorous, and his compositions simpler and more forthright, these are only the logical extensions of tendencies inherent in Girtin's watercolor style.

To the poet John Clare, an agricultural laborer's son whose poetry spoke of the English countryside with a similar directness and unaffected pleasure, DeWint was "the only artist that produces real English scenery." Clare appreciated the absence of Sublime and Picturesque formulas from DeWint's work. "There are no mountains lifting up the very plains with their extravagant attitudes and ruins with their worn and moss claptrap."[2] Clare knew DeWint,

and in 1829 he wrote to the artist asking for "one of those rough sketches taken in the fields that breathes with the living freshness of open air and sunshine."[3]

1. *Fraser's Magazine* (June 1830), p. 535.

2. From unpublished notes for *An Essay on Landscape Painting* in J. W. Tibble and Anne Tibble, eds., *The Prose of John Clare* (London: Routledge & Kegan Paul, 1951), p. 211.

3. Letter of December 19, 1829; in J. W. Tibble and Anne Tibble, eds., *The Letters of John Clare* (London: Routledge & Kegan Paul, 1951), p. 238.

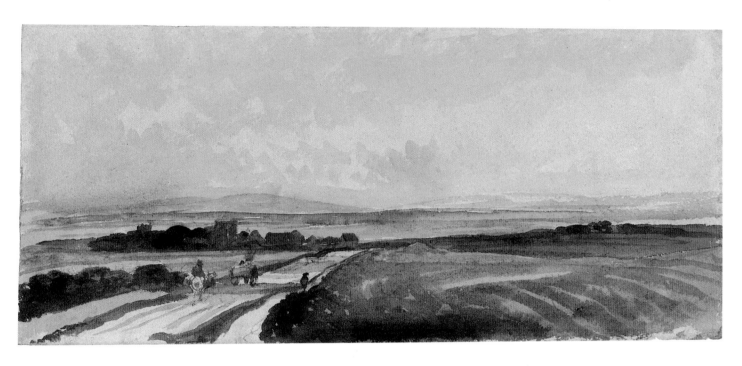

48. Peter DeWint (1784–1849)
A Yorkshire Road, ca. 1830–35
watercolor over pencil
195 x 428 mm (7⅝ x 16⅞ in.)
B1977.14.4241

George Scharf, Sr. (1788–1860)
St. Paul's, Deptford, ca. 1830–40

In addition to a partiality for views of picturesque corners of the British Isles and exotic scenes from foreign lands, Londoners of the early nineteenth century also showed a taste for artistic representations of their own streets and public buildings. The late 1820s and early 1830s saw the publication of a number of topographical volumes that appealed to this taste, including John Britton and Augustus Charles Pugin's *Illustrations of the Public Buildings of London* (1825–28) and Thomas Hosmer Shepherd's *Metropolitan Improvements* (1827–30) and *London in the Nineteenth Century* (1830–31). It was this interest in London scenes that shaped the art of Bavarian-born George Scharf after his arrival in London.

Scharf studied in Munich and worked there as a drawing master and miniaturist until 1810. In Belgium in 1814, he joined the British army, serving at Waterloo and in Paris after the occupation. Settling in London in 1816, he gained a reputation as a lithographer. He also produced numerous sketches and finished drawings of London architecture and the varied life of the London streets.[1] He sent his watercolors to the exhibitions of the Royal Academy and the Society of British Artists, and from 1833 to 1836 he was a member of the New Water-Colour Society.

Scharf's background as a miniaturist is apparent in the fine detail and jewellike color of his finished architectural watercolors, such as this interior of St. Paul's in Deptford. The church was designed by the architect Thomas Archer in 1713 and was completed in 1730. It has been described as "one of the most moving [eighteenth-century] churches in London: large, sombre, and virile."[2] The plasterwork of the ceiling and cornices, so carefully delineated by Scharf, was by James Hands.

1. A large collection of sketches by Scharf was bequeathed to the British Museum by his son, Sir George Scharf, in 1900.

2. Bridget Cherry and Nikolaus Pevsner, *London,* vol. 2, *South,* in *The Buildings of England* (Harmondsworth: Penguin Books, 1983), p. 403.

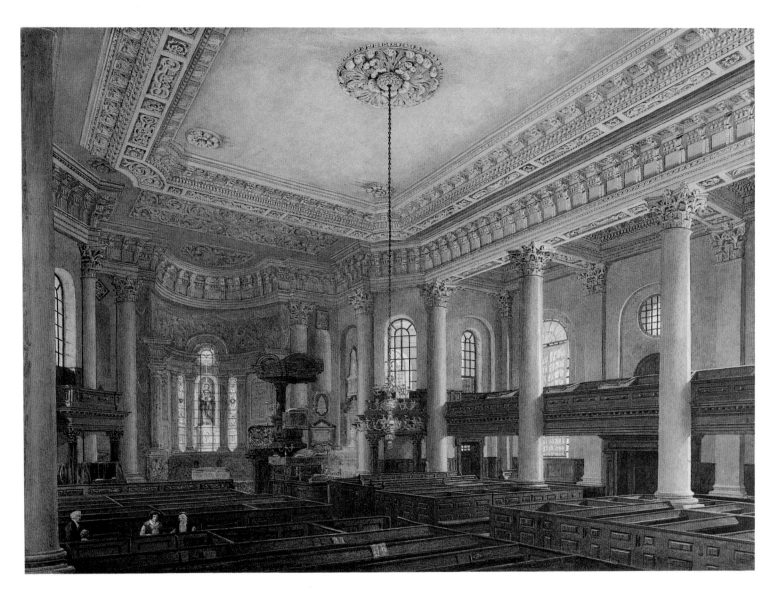

49. George Scharf, Sr. (1788–1860)
St. Paul's, Deptford, ca. 1830–40
watercolor with bodycolor
377 x 505 mm (14⅞ x 19⅞ in.)
B1977.14.4379

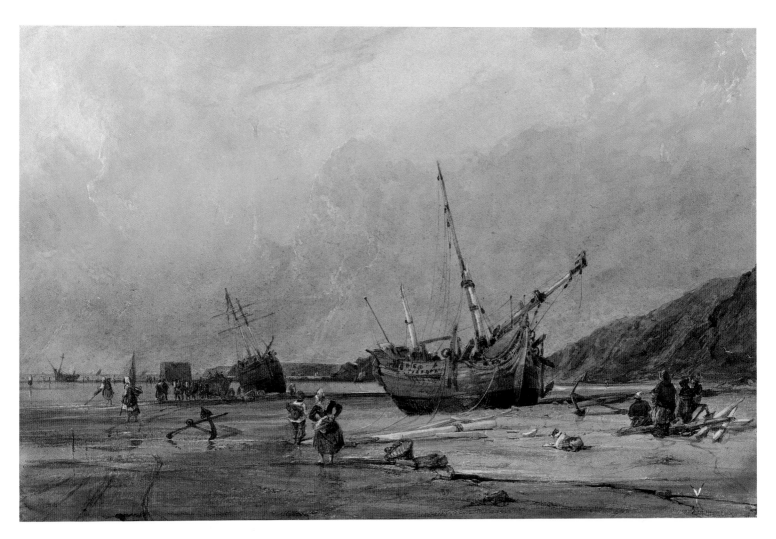

50. François Louis Thomas Francia (1772–1839)
Calais Sands, 1831
watercolor over pencil with bodycolor and scraping out
340 x 509 mm (13⅜ x 20 in.)
Signed and dated, lower center: *L Francia. 1831*
B1975.3.958

François Louis Thomas Francia (1772–1839)

Calais Sands, 1831

The connections between the British watercolor tradition, French art, and British artists working in France form a significant but still imperfectly understood chapter in the history of nineteenth-century watercolor painting. The closeness of the Frenchman François Louis Thomas Francia's association first with Thomas Girtin (cat. no. 24) and later with Richard Parkes Bonington (1802–1828) has ensured him a place of honor in that chapter but has, at the same time, obscured the nature of his own achievement as a watercolorist. While he has been relegated to the role of follower and transmitter of the ideas of his more brilliant colleagues, the actual exchange of influence among these artists has yet to be properly mapped out.

Francia fled to England as a youthful refugee from the French Revolution. Coming into contact with Girtin through the Academy of Dr. Thomas Monro (see cat. no. 20) and Girtin's Sketching Club (see cat. no. 27), of which he was the secretary in 1799, he developed a broad, deep-toned watercolor style which had much in common with Girtin's. From 1810 to 1812 he was a member of the Associated Artists in Water-Colours, again serving as secretary to the organization. His failure to gain election to the Royal Academy, coupled with the changed political situation in France, led to his return to his native Calais in 1817.

It was shortly after his return that he met the young Bonington, who had emigrated from England with his parents in the same year. Francia instructed Bonington in the principles of watercolor painting he had imbibed in England. Starting from a basis in a Girtin-derived, or at least Girtin-related, watercolor technique, both Francia and Bonington developed over the next few years a brighter, more dashing style (see fig. 3). By the mid-1820s, Bonington had

surpassed his former instructor in this regard, but it is not clear from the evidence of their works which artist took the initial steps in this direction.

Calais Sands, painted three years after Bonington's death, shows Francia taking a subject from his own home ground, yet it is the type of coastal scene Bonington had made very much his own. The crisp, incisive brushwork with which the activities of the beach are delineated also recalls Bonington. On the other hand, the amount of activity, together with the glowing sky and its dramatically piled-up clouds, points to the influence of another master of coastal landscapes—J. M. W. Turner (cat. nos. 31, 44, 56).

While Francia sent one work to the Royal Academy exhibition of 1822 and did have contact with David Cox (cat. nos. 45, 69) and other British artists who passed through Calais on their Continental tours, it is uncertain to what extent he kept in touch with artists in England, or with those English artists, such as Thomas Shotter Boys (1803–1874) and William Callow (cat. no. 63), who were working in Paris. This watercolor suggests that he was at least aware of Turner's work in watercolor, experiencing it either at firsthand or through the many series of engravings after it, such as *The Picturesque Views on the Southern Coast of England*, published between 1814 and 1826.

John Sell Cotman (1782–1842)
A Summer Day, ca. 1832

For a period of eight years after his arrival in London in 1798, John Sell Cotman seemed to be moving steadily toward a brilliant and successful career as a watercolorist.[1] He was taken up by Dr. Thomas Monro (see cat. no. 20), he exhibited at the Royal Academy, and he became the leading figure in the Sketching Club that Girtin had founded (see cat. no. 27). His watercolors progressed from highly competent imitations of Girtin's manner to the thoroughly individual works that resulted from his visits to Yorkshire in 1803, 1804, and 1805—works that are unique in British watercolor for their sophisticated sense of abstract design. However, the promising young artist was blackballed by the recently formed Society of Painters in Water-Colours, for reasons that remain a mystery,[2] and he returned to his native Norwich in 1806.

Norwich was home to a flourishing school of landscape painting centered around John Crome (1768–1821). Cotman joined the Norwich Society of Artists, becoming its vice-president in 1810 and its president in 1811, and seemed destined to occupy the kind of position in the smaller sphere of the Norwich art world that had been denied him in London. But in 1812, at the insistence of his patron Dawson Turner (1775–1858) he moved to Yarmouth to devote himself more fully to Turner's antiquarian projects. Cotman's absence from both the London and Norwich exhibitions deprived him of the recognition that was his due as one of the most original exponents of watercolor painting. With much of his energies sapped by the burdens of teaching and of producing architectural illustrations for Turner, and with his mental state swinging through cycles of depression and manic activity, Cotman's years in Norwich and Yarmouth were difficult.

A Summer Day, which has been identified as a view of Postwick Grove on the river Wensum near Norwich,[3] dates from one of his happier periods. Back in Norwich, in the early

1830s, Cotman was once again taking a leading role in the Norwich Society of Artists. He served as vice-president in 1831 and 1832, and as president in 1833.

A Summer Day exhibits the changes that Cotman's watercolor style underwent in those years. In the later 1820s he had begun employing a brighter palette, emphasizing strong contrasts of primary colors, markedly different from the subdued colors of his early Yorkshire drawings. This heightening of color reflects a general trend in watercolor of the period, but it was an aspect of Cotman's work that attracted criticism. After seeing drawings from the Spanish tour of John Frederick Lewis (cat. no. 59), Cotman lamented, "My poor *Reds*, *Blues* and *Yellows*—for which I have, in Norwich, been so much abused and broken-hearted about are *faded fades* to what I saw there."[4]

Cotman's experimenting with the manipulation of the medium is also evident in *A Summer Day*. He has scraped away large areas of the surface and then applied further washes, giving the work a rough, soft appearance. The contrast with the crisp, precise washes of his earlier works is dramatic. Cotman was seeking greater richness and body from the medium, and this technique of scraping was followed by his experiments with adding paste to his watercolors to give them a more oillike consistency.

As president of the Norwich Society of Artists, Cotman presided over its demise in 1833. The following year he moved to London, but the necessity of teaching and the frequent bouts of depression continued. Although from 1823 he had been exhibiting with the Society of Painters in Water-Colours, little notice was taken of his work by the critics, and his passing in 1842 went virtually unobserved.

1. The fullest account of Cotman's life and work is Sydney D. Kitson, *The Life of John Sell Cotman* (London: Faber and Faber, 1937). The catalogue of the exhibition *John Sell Cotman 1782–1842* (London: Victoria and Albert Museum, 1982), organized by the Arts Council of Great Britain, includes several good introductory essays and an up-to-date bibliography. Specific periods of Cotman's life are documented in Miklos Rajni and Marjorie Allthorpe-Guyton, *John Sell Cotman: Drawings of Normandy in Norwich Castle Museum*, exhibition catalogue (Norfolk Museums Service, 1975), and idem, *John Sell Cotman, 1782–1842: Early Drawings (1798–1812) in Norwich Castle Museum*, exhibition catalogue (Norfolk Museums Service, 1979).

2. That Cotman's failure to be admitted as a member of the Society was the result of his being blackballed appears in a letter of 1806 by his patron Mrs. Cholmeley; see Rajni and Allthorpe-Guyton, *Early Drawings*, p. 16.

3. *Selected Paintings, Drawings & Books* (New Haven: Yale Center for British Art, 1977), p. 81.

4. Kitson, *Life*, p. 306.

51. John Sell Cotman (1782–1842)
A Summer Day, ca. 1832
watercolor over pencil with scraping out
318 x 467 mm (12½ x 18⅜ in.)
Signed, lower left: *J S Cotman*
B1977.14.4104

52. William Burgess of Dover (1805–1861)
Interior of a Stable with Two Horses Feeding, ca. 1835–40
brown wash with bodycolor over pencil
239 x 339 mm (9⅜ x 13⁵⁄₁₆ in.)
Signed, lower left: *W Burgess*
B1975.14.1690

William Burgess of Dover (1805-1861)

Interior of a Stable with Two Horses Feeding
ca. 1835-40

William Burgess was born in Canterbury, where he was a schoolfriend of the popular animal painter Thomas Sidney Cooper (1803–1902). Apprenticed to an uncle who was a coach builder and painter, Burgess followed the trade of coach painting for a time. Cooper encouraged his artistic pursuits, and in 1827 Burgess and Cooper made a sketching expedition into Belgium.

While Burgess traded his artisan status for the somewhat higher one of watercolor artist, teaching drawing in Dover and exhibiting with the Royal Academy and Society of British Artists in London from 1838 to 1856, the world of coaching and horses remained at the center of his art. An album of his drawings in the British Museum contains a number of scenes of races, markets, carthorses, and related subjects, bearing dates from the mid- to the late 1830s. Most are in pencil, but some are in brown wash and watercolor and are similar in character to *Interior of a Stable with Two Horses Feeding*. A watercolor entitled *Old Post, Salisbury*, signed and dated 1837,[1] is a more elaborate and highly finished version of this type of interior.

1. British Museum, London, 1907.10.18.45.

Thomas Creswick (1811–1869)
Quarry with a Windmill, ca. 1835–45

The windmills that appear so frequently in British landscapes of the first half of the nineteenth century strike a quaint, nostalgic note for modern viewers. For the artists themselves, windmills were a common feature of the working rural scene. They did, however, represent an older technology, picturesque in form, linked to the natural forces of wind and weather, and with important artistic precedents for their representation in the seventeenth-century Dutch paintings of Jacob van Ruisdael (1628/9–1682) and Rembrandt (1606–1669).[1] The presence of the windmill, here associated with a stone quarry, contributes a certain picturesque interest to Thomas Creswick's straightforward depiction of a common bit of landscape.

Creswick, one of the most popular landscape painters of the mid-nineteenth century, worked mainly in oils. His range of subject matter was largely restricted to Welsh glens and English woodlands. An article on Creswick in the *Art Journal* in 1856 asserted that "he paints facts; at least, he always seems to do so, for his works are full of what appears strict truth." The author went on to state that "at the same time, he always contrives to make a poem of a picture, no matter how insignificant may be the scene."[2] It is this sometimes feeble poeticizing of the landscape that can make his oils seem conventional and contrived. Yet Creswick was noted for working out of doors before his subject. John Ruskin (cat. no. 70), while criticizing his color, commended him for being "one of the very few artists who *do* draw from nature and try for nature."[3] This watercolor sketch has the fresh, natural character of a drawing done on the spot.

1. Rembrandt's *Mill* (now in the National Gallery of Art, Washington, D.C.) was in England in the early nineteenth century, where it inspired careful study by J. M. W. Turner and copies by Thomas Girtin, Benjamin West, John Crome, and James Ward.

2. "British Artists: Their Style and Character, No. XIV. Thomas Creswick, R.A.," *Art Journal* (May 1, 1856), p. 142.

3. *Modern Painters*, vol. 1; in *The Works of John Ruskin*, ed. E. T. Cook and Alexander Wedderburn, vol. 3 (London: George Allen, 1903), p. 604.

53. Thomas Creswick (1811–1869)
Quarry with a Windmill, ca. 1835–45
watercolor over pencil
210 x 369 mm (8¼ x 14½ in.)
B1975.4.1692

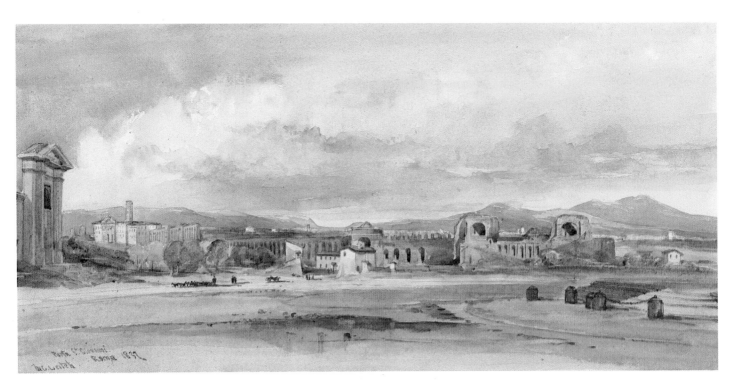

54. William Leighton Leitch (1804–1883)
Porta San Giovanni, Rome, 1837
watercolor over pencil with scraping out
226 x 457 mm (8¹⁵⁄₁₆ x 18 in.)
Inscribed by the artist, lower left:
Porta St. Giovanni. | Roma 1837 | W. L. Leitch
B1978.2.2

William Leighton Leitch (1804-1883)
Porta San Giovanni, Rome, 1837

In 1833, William Leighton Leitch traveled to Italy, where he remained until 1837, studying the Old Masters, sketching from nature, and teaching drawing to English residents. Those four years were crucial in transforming Leitch from a provincial scene painter into one of the most popular drawing masters and landscape painters in watercolor of the Victorian period.

In several respects Leitch's career is the epitome of the popular Victorian artist. His progression from scene painter to highly regarded member of the artistic community followed the pattern of other popular Victorian painters like David Roberts (cat. no. 62) and Clarkson Stanfield (1793–1867). The combination of teaching and a productive artistic career, which Leitch achieved rather more felicitously than most, was a necessity for many nineteenth-century watercolorists. For artists such as John Sell Cotman (cat. no. 51) and David Cox (cat. nos. 45, 69), teaching was a financially necessary but particularly irksome drain on their artistic ambitions.

Leitch started on the very lowest rung of artistic endeavor, as a decorator and sign painter in his native Glasgow. In 1824 he became a scene painter at the Glasgow Theatre Royal, where he had been preceded by Alexander Nasmyth (1758–1840) and David Roberts. Examples of the latters' stage scenery, which were still in use at the theater, formed the school in which Leitch learned the principles of his art.

Following an interval of several years in which Leitch traded the grand scale of scene painting for the minute work of decorating snuffboxes, he went to London in 1830 with an introduction to David Roberts. He returned to scene painting but also began to turn his atten-

tion to producing watercolors and oil paintings. In 1832, he exhibited two works at the Society of British Artists.

Funded by a stockbroker who admired his work, Leitch set off for Italy late in the summer of 1833. Traveling to Rotterdam, up the Rhine, and across Switzerland, he arrived in Venice three months later, his money exhausted. He soon procured several jobs teaching drawing, and it was by this means that he supported himself throughout his extended Italian sojourn. From Venice he moved on to Rome, where he resided until July 1835. The rest of 1835 and much of 1836 were spent in Naples and Sicily, but he was back in Rome from January to June of 1837. The watercolor sketch of the sixteenth-century Porta San Giovanni and the adjoining classical ruin of the Porta Asinaria was made during this second Roman period. Leitch later referred to these years abroad as "the most interesting part of all my artistic life."[1]

He returned to London with a large collection of sketches and finished watercolors, extensive teaching experience, and a number of introductions to aristocratic families. He rapidly gained a reputation as a clear and thorough teacher, and in 1842 he became the drawing master to Queen Victoria and other members of the royal family.

Recognition from the artists' societies was longer in coming. After being an unsuccessful candidate for admission to the Society of Painters in Water-Colours, Leitch was invited by the officers of the New Water-Colour Society to join them. He was unanimously elected to that body in 1862 and was from that date one of the most prominent contributors to their annual exhibitions. From 1873 until his death he served as their vice-president.

In artistic matters, Leitch was a thoroughgoing conservative. He had no time for John Ruskin (cat. no.70) and the Pre-Raphaelites. Although he was a great admirer of Turner's early work—he felt that the Carthaginian pictures and *Crossing the Brook* were "wonderfully fine, and immeasurably beyond anything that had been done in modern times"[2]—he was totally out of sympathy with Turner's later works. His own exhibited landscapes, which were generally of Italian subjects or scenes from his native Scotland, employ the well-worn formulas of classical and Sublime landscape. There is frequently a deadening artificiality about these finished watercolors which is far removed from the freshness and fluency of the earlier Italian sketches like *Porta San Giovanni*.

1. Quoted in A. MacGeorge, *Wm. Leighton Leitch, Landscape Painter: A Memoir* (London: Blackie & Son, 1884), p. 57. MacGeorge remains the best source on Leitch.

2. Quoted ibid., p. 84.

Francis Danby (1793–1861)
Sunset over a River Landscape, ca. 1840–45

The first half of the nineteenth century witnessed an explosion of provincial artistic activity.[1] Local exhibitions and artists' societies proliferated. Distinctive local schools grew up, most notably the Norwich School, which included such masters of English naturalism as John Crome (1768–1821), James Stark (1794–1859), and John Sell Cotman (cat. no. 51). The Bristol School was a less cohesive unit than the Norwich group, but among those who can be associated with it are Samuel Jackson (1794–1869), William James Müller (cat. no. 58), and Francis Danby.[2]

Far from encouraging the arts as a source of civic pride, Bristol had a reputation for failing to support artistic endeavor. In the mid-1820s there were promising developments: the privately sponsored Gallery of Art offered a showplace for local artists and traveling exhibitions, and the newly formed Bristol Institution began its public exhibitions in 1824. Yet, a local newspaper disputed the claim that real advances were being made and concluded, "No artist of any consequence will settle here; and, should one spring up, he will soon be compelled to fly."[3]

One artist who did settle in Bristol was the young Francis Danby, who, stopping there on the way back to his native Ireland after a visit to London in 1813, decided to take up residence. Whether his decision was based on an appreciation of the dramatic scenery around Bristol or on a lack of funds to continue his journey is uncertain. In any event, he remained in Bristol until 1824, painting the scenery of the Avon and Clifton Gorge, and becoming a prominent figure in the fledgling group of artists who would evolve into the Bristol School.

A clear-eyed, brightly colored naturalism characterizes the Bristol landscapes of Danby, as it does those of Jackson and other Bristol artists of the period. While Danby himself moved

away from topographical views to poetic, idealized landscapes and images of the apocalyptic Sublime and ceased after 1824 to be part of this Bristol School, the bright, precise style of those years continued to be apparent in later works such as *Sunset over a River Landscape* of the early 1840s.[4]

Danby began exhibiting work in London in 1820, and four years later he moved there. While he enjoyed some success with his poetic landscapes, debt and personal scandal caused him to leave London for Paris in 1829. He remained abroad for nearly a decade. *Sunset over a River Landscape* is presumably a work from the years shortly after his return to London. The view has not been identified and is most likely imaginary. It may, however, recall something of the character of the scenery of the Avon near Bristol. It may also reflect the mountainous landscape of Norway, which Danby visited in 1825.

1. The various manifestations of this phenomenon are documented in Trevor Fawcett, *The Rise of English Provincial Art: Artists, Patrons, and Institutions outside London, 1800–1830* (Oxford: Clarendon Press, 1974).

2. For the Bristol School, see Francis Greenacre, *The Bristol School of Artists: Francis Danby and Painting in Bristol, 1810–1840*, exhibition catalogue (Bristol: City Art Gallery, 1973).

3. *Bristol Mercury*, February 28, 1825; quoted in Fawcett, *Rise of English Provincial Art*, p. 15.

4. This watercolor appears as no. 143 under the title *Lake Landscape* in the catalogue of Danby's works in Eric Adams, *Francis Danby: Varieties of Poetic Landscape* (New Haven: Yale University Press, 1973). Adams dates the watercolor to the early 1840s, noting that its classically balanced and generalized composition is typical of Danby's work at that period.

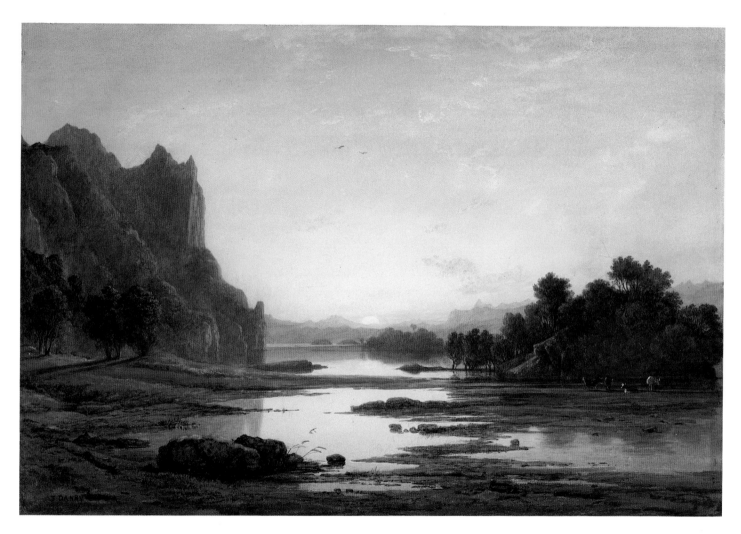

55. Francis Danby (1793–1861)
Sunset over a River Landscape, ca. 1840–45
watercolor and bodycolor over pencil with scraping out
311 x 445 mm (12¼ x 17½ in.)
Signed, lower left: *F Danby*
B1975.4.1487

Joseph Mallord William Turner (1775-1851)

On the Moselle, near Traben Trarbach
1841 or 1844?

Turner generally carried with him on his travels small pocket sketchbooks in which he would record in pencil whatever caught his attention. The contents of over two hundred sixty of these notebooks are preserved in the Turner Bequest in the British Museum. For much of his career, Turner used watercolor in outdoor sketching infrequently. He is recorded as stating during his first Italian visit of 1819 that "It would take up too much time to colour in the open air—he could make 15 or 16 pencil sketches to one coloured."[1] Nevertheless, in the 1830s Turner began to take with him soft-bound sketchbooks which he could roll up and carry in his pocket. These roll sketchbooks provided him with relatively large sheets on which he could make watercolor studies.

This sheet with its overlapping veils of freely washed-in color is typical of the roll sketchbook watercolors Turner produced on his Continental tours of the early 1840s. While the drawing has been known as *On the Moselle, near Traben Trarbach,* no journey along the Moselle is recorded for the 1840s. A group of sheets from a roll sketchbook showing Moselle subjects indicates that such a journey was made, and the year 1844 has been proposed as its probable date.[2] The traditional identification of the Yale watercolor would place it with that group of drawings, but Andrew Wilton has suggested that the work may be misidentified and that stylistically it belongs with the roll sketchbook drawings Turner produced during his Swiss tour of 1841.[3]

1. A. J. Finberg, *The Life of J. M. W. Turner, R.A.,* 2d ed. (Oxford: Clarendon Press, 1961), p. 262.

2. The watercolors presumed to be from this tour appear as nos. 1326–1348 in the catalogue of Turner's watercolors in Andrew Wilton, *J. M. W. Turner: His Art and Life* (New York: Rizzoli, 1979), pp. 459–62.

3. Ibid., no. 1325, p. 459.

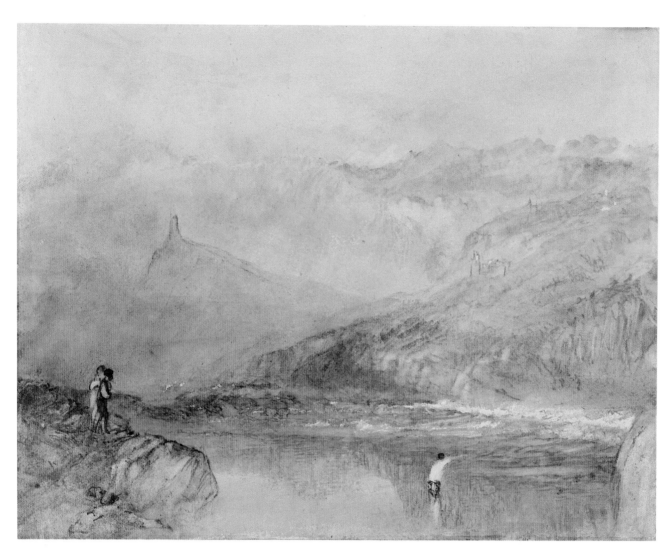

56. Joseph Mallord William Turner (1775–1851)
On the Moselle, near Traben Trarbach, 1841 or 1844?
watercolor over pencil with scraping out
230 x 287 mm (9¹/₁₆ x 11⁵/₁₆ in.)
B1975.4.1421

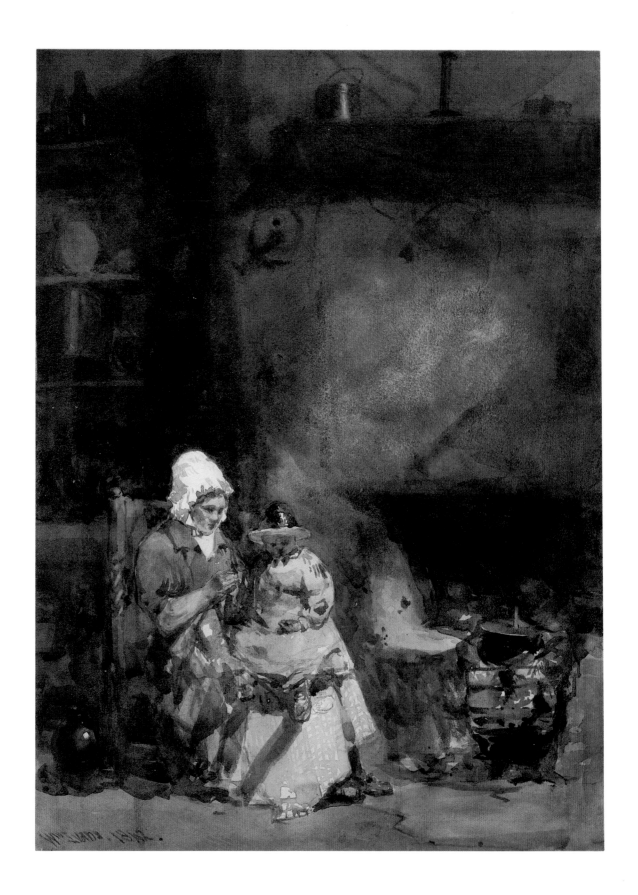

William Evans of Eton (1798–1877)

Woman with a Child by a Hearth, 1842

William Evans's *Woman with a Child by a Hearth* represents a tradition of painting simple cottage interiors which has its roots in the peasant-genre paintings of the seventeenth-century Dutch. David Wilkie (1785–1841) was perhaps the best-known and most influential British exponent of this Dutch tradition, but there are other examples closer to Evans's watercolor by artists less readily associated with this tradition. In the early 1840s David Cox (cat. nos. 45, 69) and William James Müller (cat. no. 58) produced a number of sketches in both oil and watercolor of Welsh cottage interiors.[1] Evans's style in his watercolor landscapes owes much to Cox, and possibly also to Müller. This hearthside scene may be further evidence of a connection between these artists in the early 1840s. In the broad, wet handling of Evans's dark interior and in the treatment of its various still-life elements, the watercolor also evinces something of the style of Peter DeWint (cat. nos. 35, 48), who was, in fact, Evans's teacher.

Evans was the son of an Eton drawing master whom he followed in that position in 1818. At his death, Evans was in turn succeeded by his son. Educated at Eton, Evans had originally studied medicine but gave it up for art, taking lessons with DeWint and William Collins (1788–1847). Through his long tenure as drawing master, he took an active role in the affairs of the school and was instrumental in a number of reforms. He was also a prominent member of an Eton society known as the Psychrolutes, dedicated to the practice of outdoor bathing during the winter months.[2]

1. One example, with a similarly capped woman sitting by a large fireplace, is David Cox's oil sketch *Cottage Interior, Trossavon, near Bettws-y-Coed*, Birmingham Museum and Art Gallery, 2494.85.

2. John Lewis Roget, *History of the "Old Water-Colour" Society* (London: Longmans, Green, 1891), vol. 2, pp. 210–11.

57. William Evans of Eton (1798–1877)
Woman with a Child by a Hearth, 1842
watercolor over pencil
337 x 240 mm (13¼ x 9⁷⁄₁₆ in.)
Signed and dated, lower left: *Wm Evans. 1842.*
B1975.4.1172

58. William James Müller (1812–1845)
A Mountain Torrent, ca. 1841–42
watercolor over pencil with touches of bodycolor and scraping out
270 x 384 mm (10⅝ x 15⅛ in.)
B1975.4.1349

William James Müller (1812-1845)
A Mountain Torrent, ca. 1841-42

William James Müller established a reputation within his own short lifetime as a brilliant sketcher.[1] He grew up as part of the Bristol art scene. His father, a German immigrant, was the curator of the Bristol Institution. Müller himself was instrumental in founding the Bristol Sketching Society in 1832. Yet, as an artist Müller was closer to David Roberts (cat. no. 62) or David Cox (cat. nos. 45, 69) than he was to such Bristol compatriots as Francis Danby (cat. no. 55) or Samuel Jackson (1794–1869). Müller's bravura watercolor sketching style was in the Bonington tradition carried on by William Callow (cat. no. 63) and James Holland (cat. no. 68).

In 1833, Müller made the first of a number of sketching tours in Wales. The following year he traveled through Germany and Switzerland into Italy. In 1838 and 1839, he made his first journey to the Middle East, visiting Greece and Egypt. This was also the time when David Roberts was in Egypt, and Müller's Middle Eastern works done in a limited range of colored washes on a colored paper with bodycolor highlights are frequently quite close to Roberts in style. In 1840, he worked in France on the illustrations for a Bonington-influenced volume entitled *The Age of Francis I of France*. This was followed by a second trip to the Middle East, in 1843, as part of Sir Charles Fellows's expedition to Lycia. He returned to England in 1844. The following year his health deteriorated rapidly, and early in September he died.

This watercolor probably represents a scene in the Welsh mountains, sketched on one of Müller's trips through Wales in 1841 and 1842. From Roe-Ty-Gwyn near Conway he wrote to a friend in September 1842:

I am more than ever convinced in the *actual necessity* of looking at nature with a more observant eye than the mass of young artists do, and in particular at skies. These are generally neglected. Could you but see some of the effects I have witnessed within the last few weeks, I am sure you would join with me in laughing at our imperfect attempts to imitate.[2]

Müller's technique combines broad, flat washes in the mountains with hard-edged touches of the brush to define the rocks—what John Harrison, Müller's physician and frequent sketching companion, referred to as his "sharpening out"—and the use of a dry brush dragged across the paper to achieve an effect of spray and turbulent water. Müller advised Harrison, "Keep to dry colours, shun the bottle white, and leave your lights to the paper,"[3] but here Müller has added tiny specks of bodycolor to the white of the paper to increase the effect of spray.

1. The most complete account of Müller's life and art is, still, Nathaniel Neal Solly, *Memoir of the Life of William James Müller* (London: Chapman and Hall, 1875).

2. Letter to James Chisholm Gooden, September 13, 1842; quoted ibid., p. 150.

3. Quoted ibid., p. 251.

John Frederick Lewis (1805-1876)

Sheik Hussein of Gebel Tor and His Son, ca. 1842

From 1841 to 1851, John Frederick Lewis resided in Cairo.[1] His contributions to the exhibitions of the Society of Painters in Water-Colours in the previous decade had established him as one of the Society's leading lights, and the absence of his work from the Society's exhibitions after 1841 was conspicuous. When, in 1850, the year before he himself returned to England, he resumed sending works to the Society's exhibitions, his watercolors of Eastern subjects with their brilliant color and meticulous detail created a sensation.

His pièce de résistance was a large watercolor exhibited in 1856 titled *A Frank Encampment in the Desert of Mount Sinai, 1842—The Convent of St. Catherine's in the Distance. The Picture Comprises Portraits of an English Nobleman and His Suite, Mahmoud, the Dragoman, etc. etc. etc., Hussein, Scheikh of Gebel Tor, etc. etc.* It is now in the Yale Center for British Art (fig. 5). In his lengthy, laudatory review of this picture, John Ruskin (cat. no. 70) wrote, "I have no hesitation in ranking it among the most *wonderful* pictures in the world."[2]

The English nobleman of the picture is Frederick Stewart, Viscount Castlereagh. His guide, Sheik Hussein, who stands at the center of *A Frank Encampment*, is also the subject of this drawing. Although the Sheik's pose in the finished watercolor differs from this study and his son no longer appears beside him, the study was presumably drawn as a preliminary for the elaborate portrait group of Lord Castlereagh and his entourage.

Lewis was not actually with Castlereagh's party on that journey, which left Cairo for the Convent of Saint Catherine's in the Sinai on May 12, 1842. Just two days earlier, Castlereagh wrote to the artist:

My Dear Lewis, According to our Convention [*sic*], I hope you will accept a commission to paint a picture for me of ourselves, & party . . . you will exercise your discretion as to place, persons & details. The price 200 Gs. I am pleased beyond measure at what you have done. . . .[3]

For Lewis, who had just returned from his own visit to the Sinai a month earlier, an encampment beneath the Convent of Saint Catherine's was a logical choice for the portrait's setting. Even before Castlereagh's letter of May 10, Lewis may have begun assembling elements for the composition. On May 8 Castlereagh wrote: "The Sheikh has been sitting for his picture, much against his will, as it is forbidden by the Koran, and this has evidently weighed heavily on Hussein's mind. So that it is only by the gift of a pair of pistols, that he has been prevailed upon to allow himself to be immortalized by Lewis."[4] The portrait of the sheik to which Castlereagh refers may well be this drawing.[5]

1. For Lewis, see [Richard Green], *John Frederick Lewis, R.A., 1805–1876*, exhibition catalogue (Newcastle upon Tyne: Laing Art Gallery, 1971); and Major-General Michael Lewis, C.B.E., *John Frederick Lewis, R.A., 1805–1876* (Leigh-on-Sea: F. Lewis, 1978). For this drawing, see Patrick J. Noon, *English Portrait Drawings & Miniatures*, exhibition catalogue (New Haven: Yale Center for British Art, 1979), cat. no. 119.

2. *Academy Notes*; in *The Works of John Ruskin*, ed. E. T. Cook and Alexander Wedderburn, vol. 14 (London: George Allen, 1904), p. 74.

3. Quoted in Rodney Searight, "An Anonymous Traveller Rediscovered," *Country Life*, vol. 163 (May 4, 1978), p. 1259. It was this article that first identified the English nobleman as Castlereagh.

4. Viscount Castlereagh [Frederick William Robert Stewart, 4th Marquis of Londonderry], *A Journey to Damascus* . . . (London, 1847), vol. 1, p. 260; quoted in Noon, *English Portrait Drawings & Miniatures*, p. 114.

5. A replica of the composition is in the National Gallery of Canada, Ottawa, 6151.

59. John Frederick Lewis (1805–1876)
Sheik Hussein of Gebel Tor and His Son, ca. 1842
watercolor, bodycolor, red and black chalks, and pencil on tan paper
512 x 369 mm (20⅛ x 14½ in.)
B1975.4.1937

Frederick Catherwood (1799-1854)
The Well at Bolonchen, Yucatan, 1843

Trained as an architect, Frederick Catherwood joined Robert Haig's expedition up the Nile Valley in 1831 as archaeological draftsman.[1] Following his travels through Egypt and the Middle East, he returned to London and supplied Robert Burford, the proprietor of the Leicester Square Panorama, with drawings for panoramas of Jerusalem, Thebes, Karnac, and the ruins of Baalbek.[2]

In 1836, Catherwood moved to New York, bringing with him the panorama of Jerusalem, and opened his own panorama rotunda. With his panorama established in New York, Catherwood turned his attention to Central America. In company with John Lloyd Stephens, an American lawyer and amateur archaeologist, he made expeditions to Central America in 1839–40 and 1841–42. Stephens published an account of the first trip (illustrated with eighty engravings by Catherwood) in 1841 under the title *Incidents of Travel in Central America, Chiapas and Yucatan.*

The following year fire destroyed Catherwood's panorama and, along with it, his collection of Mayan relics and a set of large watercolors of Mayan ruins that were on exhibit at the rotunda. Catherwood set to work on a new, more lavishly illustrated edition of Stephens's book, and the two men planned a monumental folio work of one hundred to one hundred twenty plates on the archaeology of Central America. When they were unable to find a publisher for this great undertaking either in New York or London, Stephens withdrew from the project. Catherwood, back in London, employed his own lithographers and in 1844 published privately an abbreviated version of their original plan.

The work, reduced to twenty-five plates, was titled *Views of Ancient Monuments in Central America, Chiapas and Yucatan.* With their combination of archaeological accuracy and Piranesi-

60. Frederick Catherwood (1799–1854)
The Well at Bolonchen, Yucatan, 1843
brown wash over pencil with scraping out
464 x 340 mm (18¼ x 13⅜ in.)
Signed and dated, lower right: *F. Catherwood | 1843*
B1979.12.688

like grandeur, Catherwood's images were a great success. When the famous German naturalist Alexander von Humboldt sent Prince Albert a copy of his book *Kosmos*, Albert reciprocated by sending Humboldt a copy of Catherwood's *Views*.

The Well at Bolonchen, Yucatan, is one of the drawings that Catherwood prepared in London for the team of lithographers hired to produce his volume.[3] The lithograph by Henry Warren after this drawing appeared as plate XX. In the book's introduction, Catherwood noted:

> Though the rains are very abundant in the rainy season, the soil absorbs the whole quantity which falls, and prevents the waters from uniting and forming water-courses or springs. . . . The country would become unfit for the residence of man or beast, if it were not for the existence of an extraordinary species of natural wells, occurring as caverns in the limestone rock, and forming a succession of passages and chambers of very great depth, at the bottom of which are usually found sources of clear and pure water from ten to twenty feet deep. They are descended by rude ladders, and the whole supply of water has to be brought up by human labour from these subterranean recesses. One of the most singular that we met with, at Bolonchen, is drawn in Plate XX., which will give a better idea of these remarkable places than any description can do.[4]

Catherwood, however, did describe his visit to the well vividly in the text accompanying the plate. The name Bolonchen, he wrote, was derived from the Mayan words for "nine wells." These nine wells in the plaza of the village supplied water for only seven or eight months of the year. When they failed, the Indians resorted to the well depicted in his drawing, which lay at a distance from the village. Catherwood recounted his torchlight passage through a cavern to "the brink of a great perpendicular descent, to the very bottom of which a strong body of light was thrown from a hole in the surface." The ladder was "very steep, seemed precarious and insecure, and confirmed the worst accounts we had heard of the descent into this extraordinary well." His drawing represents the view from the foot of the ladder—a view he described as "the wildest that can be conceived."[5]

1. Victor Wolfgang von Hagen, *Frederick Catherwood Archt.* (New York: Oxford University Press, 1950), provides a full account of Catherwood's varied and interesting career.

2. The panorama was a popular nineteenth-century form of scenic entertainment consisting of a large circular painting depicting a 360-degree view. For the panorama, see Richard Altick, *The Shows of London* (Cambridge, Mass.: Belknap Press, 1978).

3. This drawing was included in the exhibition *The European Vision of America*; see the catalogue by Hugh Honour (Cleveland Museum of Art, 1976), no. 259.

4. Frederick Catherwood, *Views of Ancient Monuments in Central America, Chiapas and Yucatan* (London, 1844), p. 2.

5. Ibid., pp. 20–21.

Francis Oliver Finch (1802-1862)

The Shepherd: Evening, Buckinghamshire, 1845

Like Samuel Palmer (cat. no. 46), Francis Oliver Finch was an "Ancient." Indeed, he was the first of the group to meet William Blake (1757–1827), to whom he was introduced by his teacher John Varley (cat. no. 37). After Finch's death, Palmer, calling him "my earliest friend," wrote of Finch's place among the followers of Blake:

> This is remarkable, that if, among Blake's deceased friends, we were suddenly asked to point to one without passion or prejudice, with the calmest judgement, with the most equable *balance* of faculties, and those of a very refined order, Finch would probably be the man; and yet he, of all the circle perhaps, was most inclined to believe in Blake's spiritual intercourse. I do not state this as giving myself any opinion on the subject, but simply as a curious fact.[1]

Finch was intensely religious in an unorthodox way, becoming an active member of the Swedenborgian Church. His art, however, lacks the intensity and the visionary fervor of Blake or of Palmer and the other "Ancients." Finch's art, like his personality as presented to us by Palmer, is calm, balanced, and without passion. The stillness of *The Shepherd: Evening, Buckinghamshire* is typical of the prevalent mood of serenity in his work. His friend and fellow "Ancient" Edward Calvert (1799–1883) wrote of his repugnance to "turbulence of every kind, even when of nature's producing, as in a steep waterfall, or in a storm of wind or rain."[2]

There is a poetic quality to Finch's landscapes, and it is perhaps more than coincidence that he was an amateur poet and musician.[3] The poetical element in his watercolors most often took the form of an evocation of the world of the classical pastoral. In this he was following the lead of John Varley and of George Barret, Jr. (1767–1842). Finch's classical landscape compositions are particularly close to those of Barret. It was in this role as perpetuator of this

tradition of formal pastoral landscape that Palmer referred to Finch as "the last representative of the old school of watercolour landscape-painting."[4] Varley, in addition to his elaborate classical compositions, produced unpretentious Thames-side scenes such as *Thames near the Penitentiary* (cat. no. 37). Likewise Finch produced less overtly "poetical" rustic scenes of contemporary England, of which *The Shepherd* is an example. It is by no means devoid of poetry, sharing something of Palmer's lyrical response to the rural landscape transposed into a lower, less emphatic key.

Finch would certainly have objected to any categorization of this watercolor as fundamentally naturalistic. In a lecture on the fine arts delivered to a Swedenborgian meeting in 1854, he deplored simple naturalism, insisting that "the grand end of all art is to produce certain sensations and emotions [preferably of a moral or religious character] in the human mind." He spoke of a "law of analogy whereby mental conditions are translatable (so to speak) into outward forms."[5] Thus, for Finch, it was the mood of serenity rather than any merely descriptive concern which lay at the heart of *The Shepherd*, and that serenity was undoubtedly meant to be read as exemplary. If, in his quiet rustic scenes, he intended to point a moral, it was one which such artists as David Cox (cat. nos. 45, 69) or Peter DeWint (cat. nos. 35, 48) less consciously embodied in their work—rural landscape as an antidote to the frenetic pace of industrialized Britain in the 1840s.[6]

1. Letter to Mrs. Anne Gilchrist, January 1863; in *The Letters of Samuel Palmer*, ed. Raymond Lister, vol. 2, *1860–1881* (Oxford: Clarendon Press, 1974), p. 674.

2. "On the Late Francis Oliver Finch as a Painter," in [Mrs. Eliza Finch], *Memorials of the Late Francis Oliver Finch, Member of the Society of Painters in Water-Colours, with Selections from His Writings* (London: Longman, Green, Longman, Roberts and Green, 1865), p. 346.

3. In a letter of February 23, 1863, to Finch's widow thanking her for a copy of a privately published volume of her husband's sonnets, the watercolor artist Carl Haag wrote, "I did not know that Mr. Finch wrote verses, although I knew distinctly that he was a Poet in painting, for his pictures are all painted Poetry." Ibid., p. 130.

4. *Letters*, p. 674.

5. "On the Fine Arts"; in *Memorials*, p. 245.

6. *The Shepherd* has been dated 1845 on the basis of a note that reads, "Inscribed on the face Buckinghamshire 1845." This note seems to have been attached to the drawing or its mat at some point and presumably records an inscription on the original mount.

61. Francis Oliver Finch (1802–1862)
The Shepherd: Evening, Buckinghamshire, 1845
watercolor over pencil
204 x 324 mm (8 x 12¾ in.)
Signed, lower right: *F O Finch*
B1975.4.1178

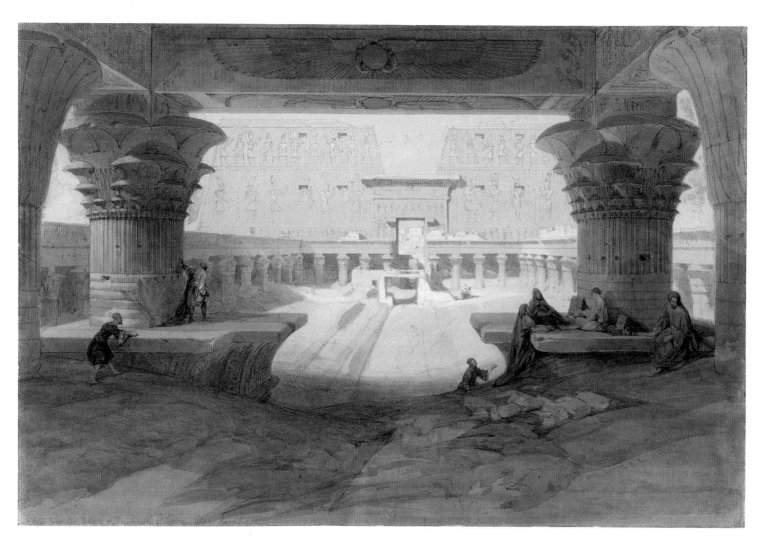

62. David Roberts (1796–1864)
From under the Portico of the Temple of Edfu, Upper Egypt, 1846
watercolor and bodycolor over pencil
348 x 502 mm (13¹¹⁄₁₆ x 19¾ in.)
Signed, lower right: *David Roberts. R.A. 1846*;
inscribed, lower left: *from Under the Portico of The Temple of Edfou, Upper Egypt*
B1977.14.4377

David Roberts (1796-1864)

From under the Portico of the Temple of Edfu, Upper Egypt, 1846

Among the proliferation of lavishly illustrated travel books in the nineteenth century, David Roberts's *The Holy Land, Syria, Idumea, Arabia, Egypt and Nubia* stands out as one of the most ambitious and elaborate productions. Published in parts from 1842 to 1849, this monumental work consisted of two hundred forty-eight tinted lithographs by Louis Haghe after watercolors by Roberts.[1]

An earlier volume of lithographs, *Picturesque Sketches in Spain during the Years 1832 and 1833*, had won Roberts a large popular following on its publication in 1837. When he traveled east to Palestine and Egypt the following year, it was with the intention of producing another such volume. Roberts was at Edfu in Egypt in November of 1838. He recorded in his journal: "I made two large drawings of the Portico, and, from it, looking across the Dromos towards the Propyla. To do the first I was compelled to sit with my umbrella in the sun which today must have been 100 in the shade. I fear I did very wrong. I hope in God there may be no bad effects from it—but the Portico is so beautiful in itself I could not resist it."[2]

He returned from the Middle East in 1839. To the Royal Academy Exhibition of 1840, he contributed a number of oil paintings based on his Eastern sketches, including a version of this view of the outer court of the Temple of Edfu (no. 292).[3] The *Art-Union* commended the paintings as "all pictures of high merit, and of great interest, as introducing us to scenes comparatively new to art."[4] At the same time, a selection of his watercolors of Eastern subjects was exhibited in Regent's Street as a promotion for his forthcoming publication.

The separate parts of the first section, *The Holy Land and Palestine*, appeared between 1842 and 1845. It was in the summer of 1846 that Roberts, staying on the Isle of Wight with

his daughter and son-in-law, prepared the finished drawings for the second section, *Egypt and Nubia*. *From under the Portico of the Temple of Edfu* is one of the watercolors he produced that summer for Louis Haghe to work from. Haghe's lithograph after the drawing appears as plate 32 in *Egypt and Nubia*.

At the outset of his career, Roberts had worked as a scene painter in his native Scotland and in the London theaters. Therefore, a certain theatricality of effect might well be expected in his Egyptian views. Yet, his images of ancient Egypt were admired specifically for their accuracy and lack of sensationalism, John Ruskin (cat. no. 70) referring to him as a "grey mirror."[5] Nonetheless, Roberts did recognize and exploit a certain Piranesian grandeur in his Egyptian subjects. Of the Portico at Edfu, he wrote, "Though half buried it is more beautiful than if laid open and reminds me of Piranesi Etchings of the Forum of Rome."[6]

1. For a full account of the complicated publication history of this work, see *Travel in Aquatint and Lithography, 1770–1860, from the Library of J. R. Abbey: A Bibliographical Catalogue*, vol. 2 (London: Privately printed at the Curwen Press, 1957), pp. 334–41.

2. Quoted in Helen Guiterman, *David Roberts, R.A., 1796–1864*, rev. ed. (London, 1981), p. 9. The most complete account of Roberts's life remains James Ballantine, *The Life of David Roberts, R.A., Compiled from His Journals and Other Sources* (Edinburgh: Adam and Charles Black, 1866).

3. In the collection of the artist's family; see *David Roberts, Artist Adventurer, 1796–1864*, catalogue (A Scottish Arts Council Touring Exhibition, 1981–82), cat. no. 16, ill. p. 25.

4. *Art-Union* (May 15, 1840), p. 75.

5. *Praeterita*; in *The Works of John Ruskin*, ed. E. T. Cook and Alexander Wedderburn, vol. 35 (London: George Allen, 1908), p. 404.

6. Quoted in *Artist Adventurer*, p. 27.

William Callow (1812-1908)
The Rialto, 1846

On July 2, 1846, William Callow married one of his pupils, Harriet Anne Smart. The following day they embarked on a ten-week honeymoon tour up the Rhine and across the Alps, reaching Venice in mid-August, where they spent several days.[1] Callow produced a number of vivacious watercolor sketches, of which *The Rialto* is a striking example. He had visited the city once before, in 1840, and Venetian subjects had appeared regularly among his contributions to the exhibitions of the Society of Painters in Water-Colours from 1841. In the exhibition in the spring prior to his honeymoon trip, he had shown a watercolor titled *The Rialto, Venice*. Thus his Venetian sketches, and particularly this view of the Rialto, represent a firsthand revision and renewal of those 1840 impressions on which he had been basing exhibition watercolors for a half dozen years.

With its bold pencil drawing, crisp washes, and accents of vivid color added with a dry brush, the sketch of the Rialto bears testimony to the continuing influence of Richard Parkes Bonington (1802–1828). Its dashing execution and brilliant color recall Bonington's own Venetian watercolors produced during his Italian visit of 1826.

It was in Paris in the early 1830s that Callow, under the influence of Thomas Shotter Boys (1803–1874), absorbed the virtuoso style of the recently deceased Bonington. Callow shared a studio with Boys, who had been an associate of Bonington in the mid-1820s and was one of the foremost exponents of the popular and influential Bonington style. Working in this style, Callow achieved considerable success in Paris, exhibiting at the Paris Salon and winning several gold medals.

In the 1840s, after his return to England, Callow's Boningtonesque manner was tempered by the demands of producing suitably finished exhibition watercolors for the Society of Painters in Water-Colours. Yet in such sketches as *The Rialto* he continued to demonstrate that freshness and vivacity which characterize his best work of the 1830s.

1. See Callow's *Autobiography*, ed. H. M. Cundall (London: Adam and Charles Black, 1908), and Jan Reynolds, *William Callow, R.W.S.* (London: B. T. Batsford, 1980).

63. William Callow (1812–1908)
The Rialto, 1846
watercolor over pencil with bodycolor
366 x 265 mm (14⅜ x 10⁷⁄₁₆ in.)
Signed, lower left: *Wm Callow*;
inscribed by the artist, lower right: *Rialto, Venice / Aug. 18.46*
B1975.4.1054

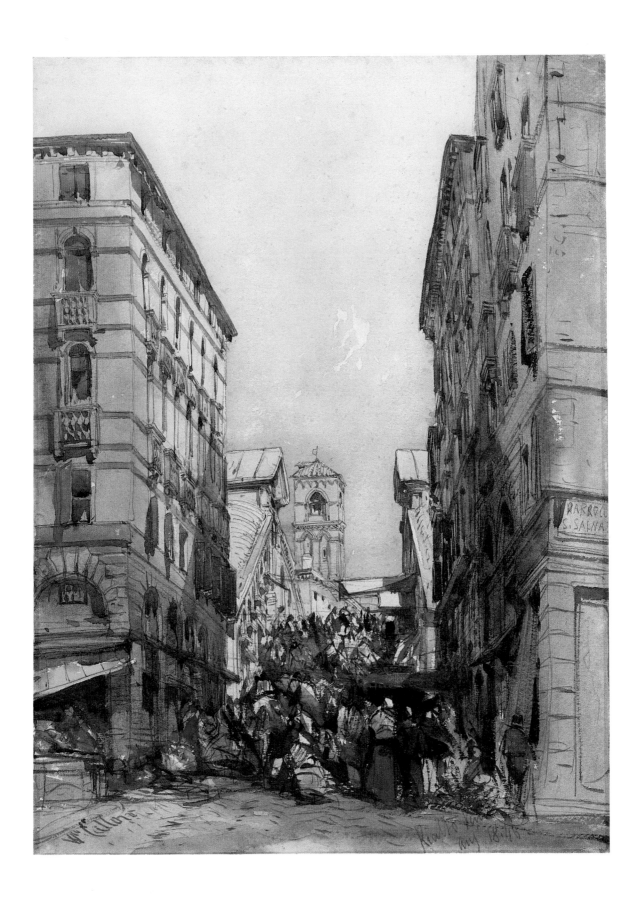

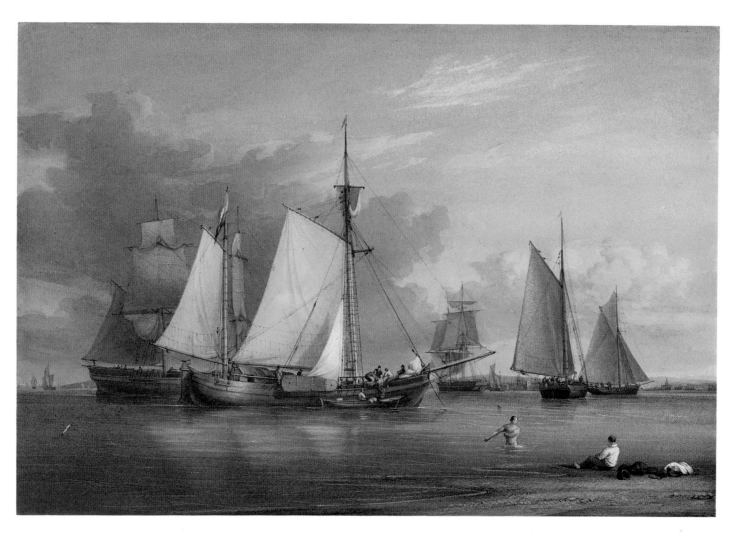

64. William Joy (1803–1867)
Dutch Fishing Boats at Anchor in an Estuary, ca. 1850–60
watercolor over pencil with scraping out
291 x 413 mm (11⁷⁄₁₆ x 16¼ in.)
B1977.14.6211

William Joy (1803–1867)

Dutch Fishing Boats at Anchor in an Estuary
ca. 1850–60

Much has been written in recent years about Luminism as an indigenous American style in nineteenth-century landscape painting. Luminism was not really a movement as such, and none of the artists involved would have recognized themselves as Luminists. It is, rather, a twentieth-century art-historical construct that attempts to provide theoretical and philosophical underpinnings for a group of mid-nineteenth-century American landscape paintings with certain shared characteristics: planar compositions with a horizontal emphasis, absence of a painterly touch, clear but glowing light, and a pervasive mood of stillness.[1] Whatever the usefulness and validity of the concept of Luminism, it is apparent from such works as William Joy's *Dutch Fishing Boats at Anchor in an Estuary* that it cannot claim to be uniquely American.

Joy's watercolor, one of a pair,[2] shares with the coastal scenes of the American Fitz Hugh Lane (1804–1865) just those characteristics which have been labeled Luminist. The simple planar construction, glowing light, smooth surfaces, and sense of calm reflect a sensibility closely akin to that of Lane and in advance of it. Parallels have been drawn between Luminist painting in America and contemporary trends in European landscape painting,[3] and Robert Salmon (ca. 1775–ca. 1842), a British marine painter active in Boston in the 1830s, has been generally cited as a precursor of Luminism. The Luminist sensibility demonstrated by William Joy suggests that the role of British marine art in the emergence of this particular aesthetic in America is greater than has yet been acknowledged. If Joy's watercolors of becalmed boats are suggestive of Luminism, his art as a whole and that of his brother John Cantiloe Joy

(1806–1866), with which it is closely and confusingly entwined, unquestionably carry on the Anglo-Dutch tradition of sea painting.

The Joys were natives of Yarmouth. They exhibited at the Norwich Society of Artists, William from 1819 to 1825 and John from 1823 to 1828. Both later moved to London. They worked together, frequently collaborating on pictures. As their works are generally unsigned or bear the signature "JOY," the task of distinguishing the work of one brother from the other is difficult. It may be that John had some hand in *Dutch Fishing Boats at Anchor*.

On the basis of comparison with dated Joy watercolors from the 1850s, this would seem to be a product of that decade as well; however, the lack of dated examples from other decades makes it virtually impossible to know if the stylistic traits of the 1850s watercolors were already in evidence in previous decades.

1. The concept of Luminism was first developed by John I. H. Baur in the late 1940s and 1950s; see, for example, his "American Luminism: A Neglected Aspect of the Realist Movement in Nineteenth-Century American Painting," *Perspectives U.S.A*, no. 9 (Autumn 1954), pp. 90–98. It gained currency with Barbara Novak's *American Painting of the Nineteenth Century* (New York: Praeger, 1969), and in 1980 was the subject of a major exhibition at the National Gallery of Art, Washington, D.C., *American Light: The Luminist Movement, 1850–1875*.

2. The pendant is also at the Yale Center for British Art, B1977.14.6210.

3. Theodore Stebbins, in his essay "Luminism in Context: A New View," in exhibition catalogue, *American Light*, pp. 219–21, finds British equivalents in the works of such Pre-Raphaelites as John Brett and John William Inchbold, and of Edward Lear. Stebbins makes no mention of the British marine tradition.

George Price Boyce (1826-1897)
A Road near Bettws-y-Coed, 1851

In the middle years of the nineteenth century, Bettws-y-Coed, a small village in the mountains of North Wales, became a popular stopping place for traveling artists in search of the mountainous beauties of Wales. Between 1845 and 1857, David Cox (cat. nos. 45, 69) spent a portion of every summer or autumn there, assuming the role of patriarch to the community of artists who gathered there to sketch the local scenery.

It was at Bettws-y-Coed in the autumn of 1849 that George Price Boyce first met Cox.[1] For the young Boyce it was a meeting of great significance. Trained as an architect, he had worked from 1846 in the architectural firm of Wyatt and Brandon. Cox confirmed him in his decision to give up architecture for painting landscape in watercolor.

Boyce was back at Bettws-y-Coed in August of 1851, sketching with Cox and taking lessons from him. The older artist's influence can be seen in both the subject and the handling of Boyce's *A Road near Bettws-y-Coed* of that year. The view along a wooded lane beneath mountains and a cloud-heavy sky is just the type of scene Cox himself sought out in the vicinity of Bettws-y-Coed. If Boyce's watercolor has nothing of the grandeur with which Cox so often invested this scenery, it does share that artist's gift for evoking sunlight and passing cloud.

The figure at right, perched on a tree limb which seems scarcely able to support him, adds a whimsical touch to the drawing, capturing something of the humor and playfulness of the summering artists at Bettws-y-Coed. Indeed, it may even be a lighthearted reference to the inn sign of the Royal Oak at Bettws-y-Coed, which Cox painted as a favor to the landlord. The sign depicted the famous incident of Charles II hiding from his pursuers in an oak at Boscobel.

The flicks of green and yellow with which Boyce builds up the masses of foliage derive from the technique that Cox described in his own work as a "mosaic of touches," but in Boyce's hands the technique is already moving toward that Pre-Raphaelite fineness of touch which would characterize his later work. There are in *A Road near Bettws-y-Coed* a prettiness of color and a daintiness of touch unlike Cox's rougher, more forthright vision.

Although Boyce's work retained elements of Cox's style through the mid-1850s, it was apparent to Cox as early as 1851 that Boyce was heading in a direction very different from his own. Of one of the watercolors Boyce produced that summer, Cox commented that it "looked like a Pre-Raffaelite drawing."[2]

Through the landscape painter Thomas Seddon (1821–1856), who also worked in North Wales in the early 1850s, Boyce was brought into the Pre-Raphaelite circle, becoming a close friend of Dante Gabriel Rossetti (1828–1882). The influence of Cox was supplanted by that of John Ruskin (cat. no. 70) and William Holman Hunt (1827–1910). Boyce's handling of watercolor became more painstakingly detailed, and his early views of Welsh mountain scenery were given over to quiet, intimate, frequently enclosed scenes of farmyards and rustic buildings.

1. For an account of Boyce's life, see Arthur E. Street, "George Price Boyce, R.W.S." and "Extracts from Boyce's Diaries: 1851–1875," *The Old Water-Colour Society's Club*, vol. 19 (1941), pp. 1–71. For a more complete discussion of Boyce's relationship with Pre-Raphaelitism, see the chapter on Boyce in Allen Staley, *The Pre-Raphaelite Landscape* (Oxford: Clarendon Press, 1973), pp. 107–10.

2. August 27, 1851; in "Extracts from Boyce's Diaries," p. 11.

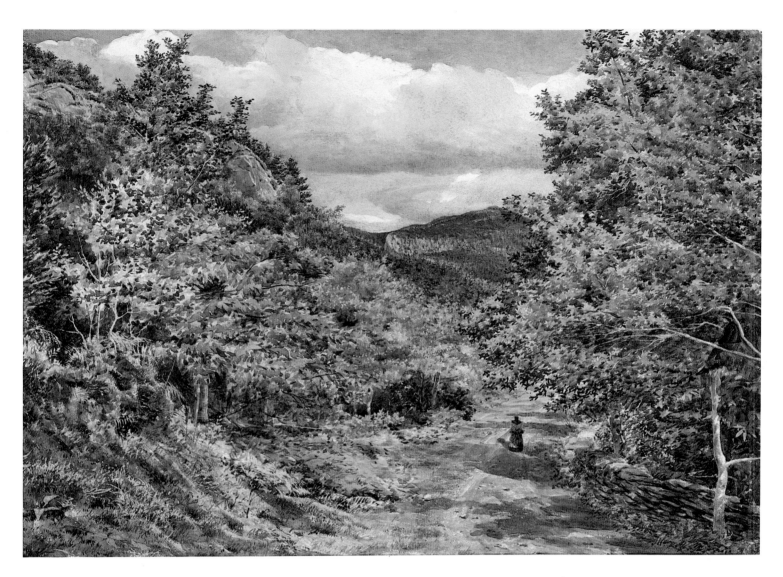

65. George Price Boyce (1826–1897)
A Road near Bettws-y-Coed, 1851
watercolor over pencil
378 x 530 mm (14⅞ x 20⅞ in.)
Signed in monogram and dated, lower left: *GPB 1851*
B1981.21

Richard Dadd (1817–1886)

Sketch for the Passions— Love—Romeo and Juliet, 1853

Sketch for the Passions—Love—Romeo and Juliet was one of the earliest works that form the series "Sketches to Illustrate the Passions," which Richard Dadd produced between 1853 and 1857, while an inmate of Bethlem Hospital.

A young artist of great promise, Dadd had distinguished himself while a student at the Royal Academy by winning numerous medals. It was in these years that together with William Powell Frith (1819–1909), Augustus Egg (1816–1863), and other fellow students he formed the sketching club known as "The Clique." His career gave every indication of steady advancement, when during a trip through the Middle East in 1842 and 1843 he began to lose his grip on reality. After his return to London in May 1843 his behavior became increasingly bizarre, and several months later he murdered his father and fled to the Continent. He was apprehended in France, extradited to England, certified insane, and committed to Bethlem in 1844.

The *Art-Union* referred to him as "the late Richard Dadd," explaining, "We must so preface the name of a youth of genius that promised to do honour to the world; for, although the grave has not actually closed over him, he must be classed among the dead."[1] This artistic obituary for Dadd proved premature. Although little known to the general public of his own day, he produced a sizable body of extraordinary work during the long years of his confinement first at Bethlem and later at Broadmoor Hospital.

In 1852, Dadd came under the care of Bethlem's new superintendent, Dr. William Charles Hood, who took a particular interest in his patient's art and acquired a number of examples. Among these were sixteen drawings from the "Sketches to Illustrate the Passions," including *Love—Romeo and Juliet*. That Dadd began the series in the year following Dr. Hood's arrival,

66. Richard Dadd (1817–1886)
Sketch for the Passions—Love—Romeo and Juliet, 1853
watercolor over pencil
357 x 258 mm (14¹⁄₁₆ x 10⅛ in.)
Inscribed by the artist, upper right: *Sketch for the Pas[sions]* |
LOVE—Romeo & Juliet | *Romeo—My life, my love* | *my soul, adieu. Vide* |
Shakespeare's Play— | *Richard Dadd* | *Bethlem Hospital. 1853*
B1976.1.39

together with the doctor's possession of so many of the watercolors in the series, suggests that Hood encouraged or even initiated the series as having therapeutic value.

Among the subjects in the series that Dadd produced in 1853 were three taken from Shakespeare. In addition to the balcony scene from *Romeo and Juliet* representing Love, Dadd chose a scene from *Othello* to represent Jealousy,[2] and the murder of Henry VI from *Henry VI, Part III* to represent Hatred. It has been suggested that the series had its genesis in these comparatively straightforward illustrations of scenes from Shakespeare and was subsequently expanded by Dadd to include wholly original interpretations of a variety of mental states.[3] By the time he left Bethlem, when he ceased to produce any further "Sketches," he had created over thirty of them.

While not as strange and disturbing as some of the later images in the series, *Love—Romeo and Juliet* with the anxious figure of the old nurse and the insubstantial form of Juliet lost within the folds of her garment is an unsettling depiction of the passion of love.

1. *Art-Union* (October 1843), p. 267. This provided the title for the exhibition *The Late Richard Dadd, 1817–1886* (London: Tate Gallery, 1974). The catalogue by Patricia Allderidge provides an admirably complete account of Dadd's life and work.

2. Also in the Yale Center for British Art, B1976.1.38.
3. Allderidge, *The Late Richard Dadd*, p. 88.

Edward Duncan (1803-1882)
The Bass Rock at Dawn, 1855

With its dramatic sky, rich color, elaborate watercolor technique, and subordination of the represented shipping to the overall atmospheric effect, Edward Duncan's *The Bass Rock at Dawn* is as typical of Victorian seascape as Robert Cleveley's *English Man-of-War Taking Possession of a Captured Ship* (cat. no. 12) is of eighteenth-century marine art. The Anglo-Dutch marine tradition held in balance a documentary concern with ships and nautical practice and a concern with rendering the appearance of wind and light and water. But for many marine artists working in the wake of J. M. W. Turner's monumental treatment of the elements (cat. nos. 31, 44, 56), the balance shifted decidedly in favor of an atmospheric approach to sea painting.

In the Victorian seascapes of Clarkson Stanfield (1793–1867), who was generally conceded to be the best marine painter of his day, and of Duncan, who also made a name for himself in this field, the emphasis was frequently on the more spectacular manifestations of sea and sky. Drama and picturesque incident supplanted the careful description of nautical minutiae. Accuracy was still a primary consideration, and Stanfield, who served for seven years as a seaman, was applauded for the correctness of his ships and rigging. But more valued was accuracy in the observation of the forms of clouds and waves and the effects of light.

Duncan was not a seaman turned painter, nor did his early career involve painting ships and the sea. As an apprentice to the engraver Robert Havell (active 1800–1840), he learned aquatint engraving. He painted watercolor landscapes rather in the manner of Robert's brother William Havell (1782–1857). It was only in 1826 that a project of engraving sea-pieces after William John Huggins (1781–1845) sparked his own interest in marine subjects. It was not,

however, Huggins's stiff and old-fashioned ship portraits that Duncan emulated, but Stanfield's highly wrought and intensely dramatic sea-pieces.

While Duncan, unlike Stanfield, had little firsthand knowledge of ships and the sea, he was an avid student of the works of other marine artists, amassing a large collection of drawings by such past masters as the van de Veldes (see cat. no. 12), as well as his contemporaries Anthony Vandyke Copley Fielding (1787–1855), George Chambers (1803–1840), and Edward W. Cooke (1811–1880).

If Duncan's art fed on other art, *The Bass Rock at Dawn* is striking testimony that his watercolors could achieve a freshness and immediacy that transcend formula and imitation. Although the watercolor technique is tightly controlled, there are subtlety and crispness in the handling. Ten years after he painted the version in the Center's collection, he repeated the composition on a larger scale.[1] His later version suffers from a slackness and wooliness which all too frequently afflict large, highly finished watercolors of the Victorian period.

1. In the Victoria and Albert Museum, London, 139–1889.

67. Edward Duncan (1803–1882)
The Bass Rock at Dawn, 1855
watercolor over pencil with scraping out
208 x 504 mm (8³⁄₁₆ x 19⅞ in.)
Signed and dated, lower right: *E Duncan | 1855*
B1977.14.142

68. James Holland (1800–1870)
Mediterranean Coast Scene with Feluccas, ca. 1855–60
watercolor over pencil with bodycolor
294 x 445 mm (11⁹⁄₁₆ x 17½ in.)
B1975.4.1545

James Holland (1800-1870)

Mediterranean Coast Scene with Feluccas
ca. 1855-60

The obituary for James Holland that appeared in *The Illustrated London News* attributed the "florid character of his colouring, especially in his later works," to his early career as a flower painter.[1] This was a facile way of accounting for that most distinctive feature of Holland's art—the striking combinations of brilliant color in his favorite Venetian and Mediterranean subjects.

Holland did begin by painting flowers, following his family's business of decorating porcelain. He moved to London in 1819 and began exhibiting at the Royal Academy in 1824. While flowers continued to provide the bulk of his subjects, he also turned his hand to architectural and marine views. The art of Richard Parkes Bonington (1802–1828), with its bright, rich color and virtuoso handling, exerted a considerable influence on Holland. Bonington's Venetian and coastal scenes shaped Holland's response to what would become his own most characteristic subject matter.

From 1831, Holland traveled regularly on the Continent, and more and more Continental views appeared among his exhibited works. He became an associate of the Society of Painters in Water-Colours in 1835. Eight years later, hoping to establish himself as an oil painter, he resigned from the Society. Failing to gain the recognition for which he had hoped, he rejoined the Society in 1856 and became a full member the following year.

The effects in Holland's later watercolors frequently seem forced. His color became strident and his technique heavy, with liberal applications of bodycolor. However, *Mediterranean Coast Scene with Feluccas* in its crisp incisive handling of pure watercolor recalls Bonington's seascapes. Its vivid blues and blue-greens represent the brilliancy of Holland's color before it degenerated into garishness.

1. *The Illustrated London News* (February 19, 1870), p. 199. This and other contemporary notices of the artist are gathered in Randall Davies, "James Holland (1800–1870)," *The Old Water-Colour Society's Club*, vol. 7 (1930), pp. 37–46.

David Cox, Sr. (1783-1859)
Going to the Hayfield, ca. 1855-57

From 1813, David Cox was a member of the Society of Painters in Water-Colours and a regular contributor to the Society's annual exhibitions. Yet it was only in the 1840s that his exhibited work began to receive substantial critical attention. With this new interest went a view of Cox as the "grand old man" of the watercolor tradition. In 1845, his name was coupled with that of DeWint (cat. nos. 35, 48) as "the two pillars of the good and true school of water-colour painting."[1] With the death of DeWint in 1849 and of Turner (cat. nos. 31, 44, 56) two years later, Cox was left as one of the last surviving links with the great generation of watercolor artists, at the very moment when the tradition they represented seemed threatened by the trends among the Society's members toward high finish and minute realism.

In the late 1840s and early 1850s Cox created his most individual and powerful water-colors. These were bold, often dark works in a technique of loose and expressive brushwork. The contrast with the tight and precise handling and brilliant color of John Frederick Lewis (cat. no. 59) was dramatic. But if Cox's works stood apart from their highly finished companions on the walls of the Society's exhibitions, they were in no sense holdovers from an earlier style. Nostalgia for the passing generation of watercolorists may have lent a certain aura to Cox's late works, but he was also recognized as an original, whose freedom of handling at times went beyond the bounds of propriety. Cox complained that the Society's hanging committee thought his watercolors too rough: "They forget they are the work of the mind."[2] The critics, while voicing reservations about his style, still admired his work. One wrote in 1852, "Mr. Cox's method is certainly not recommendable to others, but that will be a dark day for the Water-Colour Society when its fruits shall be no more visible upon the walls."[3]

69. David Cox, Sr. (1783–1859)
Going to the Hayfield, ca. 1855–57
watercolor over pencil
320 x 454 mm (12⁹/₁₆ x 17⅞ in.)
Signed, lower right: *DC*
B1977.14.133

In June 1853, Cox suffered a stroke which left his coordination, his eyesight, and his memory impaired, yet he continued to paint and to exhibit with the Society. The looseness of execution that Cox had already been pursuing was intensified in the aftermath of the stroke. His son, David Jr., wrote in 1855 that Cox was finishing little new work, but he added that "his ideas however seem to be as vigorous as ever, and his feeling for air & space and skies, perhaps, never better."[4]

Going to the Hayfield is from this last period of Cox's life. As with many of the works he produced in the years following the stroke, it is a reworking of a compositional type he had established years before. This particular type, one of Cox's most popular, had taken shape in the early 1830s and was repeated by the artist many times through the 1840s and early 1850s. The mounted figure leading a second riderless horse into the flat landscape, the pool of water at the edge of the hayfield, and the activity around a distant haystack were all standard features. Here, in perhaps his last version of the scene, these elements appear vague and insubstantial, ghostly reminiscences of their more solid predecessors. There is, however, no indication of a decline in the artist's powers. The handling is loose, but strong and deft, bearing out his son's assertion that his "feeling for air & space and skies" remained undiminished.

1. *The Spectator* (May 3, 1845), p. 426.

2. Letter to David Cox, Jr., April 18, 1853; quoted in Nathaniel Neal Solly, *Memoir of the Life of David Cox* (London: Chapman and Hall, 1873; reprint London: Rodart Reproductions, 1973), p. 228.

3. *The Spectator* (May 1, 1852), p. 423.

4. Letter of David Cox, Jr., to William Turton, February 19, 1855; published by Thomas B. Brumbaugh, "David Cox in American Collections," *The Connoisseur*, vol. 197 (February 1978), p. 88. David Cox, Jr.'s assessment was echoed by George Price Boyce (cat. no. 65) when he visited Cox in 1857, "In idea and in colour often his present things are as fine as the old." Entry for November 17, 1857; in "Extracts from Boyce's Diaries: 1851–1875," *The Old Water-Colour Society's Club*, vol. 19 (1941), p. 26.

John Ruskin (1819–1900)

A View of Baden in Switzerland, ca. 1863

From his first visit to Switzerland at the age of fourteen, John Ruskin was passionately in love with the Alps. A similar passion for the art of J. M. W. Turner (cat. nos. 31, 44, 56), developed during his years as an undergraduate at Oxford, led to the publication in 1843 of the first volume of *Modern Painters*, which announced Ruskin as one of the most original and influential critical voices in the British art world. From a simple defense of Turner, *Modern Painters* grew into a wide-ranging five-volume discourse on art past and present—a consideration of the subject in which Alpine scenery played no little part.

Ruskin's love for Switzerland and for Turner's art came together in the series of Swiss watercolors that Turner produced in the 1840s. Ruskin, regarding these drawings as the culmination of Turner's work, tried to acquire as many of them as he could. When, after the artist's death in 1851, Ruskin took up the task of sorting through the drawings of Turner's bequest, he was preoccupied with the drawings of Swiss subjects. This was the context in which Ruskin formed a plan for a history of the towns of Switzerland to be illustrated with engravings after his own drawings. It would serve, in part, as a background and supplement to the great Swiss watercolors of Turner.

This drawing has been associated with a Swiss tour Ruskin made with his parents in 1854, when he was beginning work on the scheme.[1] The history never materialized, although Ruskin kept returning to the project and to Switzerland for over a decade. While *A View of Baden in Switzerland* seems to have been made with this publication in mind, it is more likely a product of the latter days of the scheme, drawn during a visit to Baden in November 1863 in a final spurt of enthusiasm for the Swiss-towns project before he abandoned it altogether.[2]

The characteristics of Ruskin's drawing style of the 1860s are evident in the watercolor. The pencil drawing is loose, even wild, in those areas outside the focus of the artist's interest. In contrast there is a soft, subdued quality to his use of watercolor on colored paper, which is brought to life by his penwork and his highlights in bodycolor.[3] Ruskin's examination of Turner's late watercolors had a decided influence on his own drawing, leading him away from a style based on Samuel Prout (cat. no. 39), David Roberts (cat. no. 62), and James Duffield Harding (1797–1863) toward a greater freedom and expressiveness. The style of *A View of Baden* is, however, not simply an imitation of Turner. Its somber color and its particular combination of sharp detail and loose handling are pure Ruskin.

1. See John Baskett and Dudley Snelgrove, *English Drawings and Watercolors 1550–1850 in the Collection of Mr. and Mrs. Paul Mellon*, exhibition catalogue (New York: Pierpont Morgan Library, 1972), cat. no. 150.

2. The *Catalogue of Ruskin's Drawings*, in *The Works of John Ruskin*, ed. E. T. Cook and Alexander Wedderburn, vol. 38 (London: George Allen, 1912), lists two drawings of Baden from 1863: a view of towers at Baden (no. 151), and a view looking down on the town, on five sketchbook pages (no. 157).

3. For a full discussion of the development of Ruskin's drawing style in these years, see Paul M. Walton, *The Drawings of John Ruskin* (Oxford: Clarendon Press, 1972), chs. 4, 5.

70. John Ruskin (1819–1900)
A View of Baden in Switzerland, ca. 1863
watercolor, bodycolor, pen and gray and red ink, and pencil on tan paper
292 x 372 mm (11½ x 14⅝ in.)
Inscribed by the artist, lower right: *a*
B1975.4.1584

William Simpson (1823-1899)

Elephant Battery, 1864

The mid-nineteenth-century expansion of the taste for visual representations of foreign lands together with an increasing demand for topicality in such images fostered the phenomenon of art as reportage. Illustrated periodicals such as *The Illustrated London News*, which began publication in 1842, both responded to and fueled the public's growing appetite for visual information about world events. To supply this information there arose a breed of artist-correspondents. One thinks of Winslow Homer (1836–1910) in this country providing *Harper's Weekly* with illustrations of the American Civil War. In England, perhaps the foremost representative of this breed was William Simpson.

The widespread interest in India engendered by the events of the Indian Mutiny of 1857 prompted William Day of the London lithographic firm of Day and Son to send Simpson to India. He was to make drawings for an ambitious volume on India modeled on David Roberts's *The Holy Land* (cat. no. 62).

Simpson established his credentials for such an enterprise during the Crimean War. He had been sent to the Crimea by Colnaghi in 1854 to provide them with on-the-spot representations of scenes of the fighting. His *Illustrations of the War in the East*, published by Colnaghi and lithographed by Day and Son, was a tremendous popular success and gained for him the nickname "Crimean" Simpson. In the light of this success, as well as the earlier popularity of Roberts's *The Holy Land*, William Day reasoned that a major lithographic treatment of India would be likely to enjoy a similar success and revive the flagging fortunes of his establishment.

Between October 1859 and February 1862, Simpson traveled throughout India, sketching and gathering material for his great work.[1] According to his own calculations, he traveled

71. William Simpson (1823–1899)
Elephant Battery, 1864
watercolor over pencil with bodycolor
270 x 365 mm (10⅝ x 14⅜ in.)
Signed and dated, lower right: *Wm Simpson. 1864*;
inscribed by the artist, lower left: *Elephant Battery*
B1975.3.264

22,570 miles for the project.[2] After his return to London, he devoted some three or four years of constant work to producing two hundred and fifty watercolors from his sketches.

These watercolors provide an extraordinary panorama of the land and life of India. Much of his work depicts India as he found it after the Mutiny, but in some watercolors, such as *Elephant Battery*, he attempted an imaginative re-creation of the events of the Mutiny. *Elephant Battery* represents the siege of Delhi, the center of the rebellion. Visible to the left through the swirling clouds of smoke are the Lahore Gateway and, beyond it, the Jami Masjid. While the juxtaposition of gate and mosque is not topographically accurate, for many British viewers these well-known structures would have immediately identified the scene as Delhi.[3]

British artillerymen bombard the city with guns that have been pulled into position by teams of elephants, who are now being led away by their still-loyal Indian drivers. The image is striking and exotic, and Simpson has treated it with the brilliant color and bravura brush-work that raise his best work far above the level of hack illustration.

Simpson was justly proud of his achievement in producing the Indian watercolors. Unfortunately, lithography, which had been at its height of popularity when Simpson first came to London in 1851 and began work as a lithographer for Day and Son, was now being superseded by wood engraving as a means of popular reproduction. The financial collapse of Day and Son in 1867 brought the Indian project to an abrupt end. Simpson's drawings were sold to the firm's creditors, and the fifty lithographed plates that had already been made from the drawings were hastily brought out in a poorly produced volume. As Simpson put it, "So the great work on India, on which I had bestowed so much time and labour, never came into existence, and I lost the honour and reputation which would have been due to me if such a work had been properly produced and published."[4]

He had intended to use the profits from the book to free himself to paint for the annual exhibitions. The bankruptcy of Day and Son and the failure of the India volume forced him to continue in the role of artist-reporter. He went to work for *The Illustrated London News*, covering, among other stories, the Abyssinian Expedition of 1867, the opening of the Suez Canal in 1869, the Franco-Prussian War in 1870, the wedding of the emperor of China in 1872, and the Afghan War of 1878.

1. Three sketchbooks used by Simpson during his Indian tour were sold at Christie's, November 15, 1983 (lots 115–117). Many of his finished Indian watercolors were based directly on the pencil and watercolor drawings in these sketchbooks.

2. William Simpson, *The Autobiography of William Simpson, R.I.*, ed. George Eyre-Todd (London: T. Fisher Unwin, 1903), p. 173.

3. For this identification and observation, I am indebted to Raymond Head of the Royal Asiatic Society.

4. *Autobiography*, p. 178.

Sir Lawrence Alma-Tadema (1836-1912)
Fredegonda at the Deathbed of Praetextatus
ca. 1864

Within this survey of the British watercolor tradition, *Fredegonda at the Deathbed of Prae-textatus* stands somewhat apart. It was not intended, as so many of the works in this exhibition were, to stand on its own as a finished work of art. It is a compositional study, albeit a carefully worked-up one, for a painting in another medium. Nor is it, strictly speaking, a British work at all. Lawrence Alma-Tadema was born in the Netherlands and trained at the Academy in Antwerp, where he lived and worked until 1870.[1] The watercolor, which dates from this Antwerp period, was preliminary to an oil painting of the subject, with its composition reversed, that was exhibited at the Paris Salon of 1865.[2]

If Alma-Tadema had no connection with Britain at the time he produced *Fredegonda*, after his immigration to London in 1870 he became one of Victorian England's most popular and respected artists. He was made a Royal Academician in 1879 and was knighted in 1899, two of a score of international honors he received. Furthermore, *Fredegonda* is an example of the type of archaeologically aware treatment of historical subject matter which played an important role in the exhibition watercolors, as well as the exhibition oils, of English artists through much of the nineteenth century.

Alma-Tadema is best known for his genre scenes of ancient Greece and Rome, and it was through these works that he gained his remarkable contemporary reputation. His interest in the everyday life of classical antiquity dates from a visit to Pompeii and Herculaneum in 1863, one or two years before he began work on *Fredegonda*. It belongs to an earlier preoccupation with a different historical epoch. Inspired by his reading of *The History of the Franks* by

Gregory of Tours and Augustin Thierry's *Recit du temps merovingins*, he produced a series of paintings in the late 1850s and early 1860s depicting events of Merovingian history.

The subject of this watercolor is taken from Gregory's *History*.[3] As the result of a quarrel between Queen Fredegonda and Praetextatus, the bishop of Rouen, assassins hired by Fredegonda attacked the bishop as he was celebrating Easter mass. Lying mortally wounded, Praetextatus was visited by the queen, accompanied by Duke Bepolen and Ansovald (shown standing behind the queen). Alma-Tadema represents the dramatic moment when, in response to Fredegonda's profession of outrage at the act, Praetextatus accuses her of responsibility for his death and predicts that God will avenge him.

While the subject is Merovingian, something of the influence of the Pompeian visit and a nod to classicism are evident in the friezelike composition and the flat, bright color. In his concern with details of furniture and costume, there is already present that studied archaeological accuracy which, when combined with a sentimental and prettified realism, made his Roman pictures so popular.

1. For Alma-Tadema's life and work, see *Sir Lawrence Alma-Tadema, 1836–1912*, exhibition catalogue (Sheffield: Mappin Art Gallery; Newcastle upon Tyne: Laing Art Gallery, 1976), and Vern Swanson, *Sir Lawrence Alma-Tadema: The Painter of the Victorian Vision of the Ancient World* (London: Ash & Grant, 1977).

2. Now in the collection of the Fries Museum, Leeuwarden, Netherlands.

3. Gregory of Tours, *The History of the Franks*, trans. Lewis Thorpe (Harmondsworth: Penguin Books, 1974), pp. 462–63.

72. Sir Lawrence Alma-Tadema (1836–1912)
Fredegonda at the Deathbed of Praetextatus, ca. 1864
watercolor over pencil
218 x 290 mm (8⅝ x 11⅜ in.)
B1980.23

73. Edward Lear (1812–1888)
A View of the Pine Woods above Cannes, 1869
watercolor with scraping out and gum arabic
167 x 511 mm (6⁹⁄₁₆ x 20½ in.)
Signed in monogram and dated, lower right: *EL 1869*;
inscribed by the artist, lower left: *Cannes*
B1981.25.2644

Edward Lear (1812-1888)
A View of the Pine Woods above Cannes, 1869

A dedicated traveler and a prolific draftsman, Edward Lear continued into the second half of the nineteenth century the topographical tradition that had always been very much at the heart of British watercolor.[1] Lear saw his artistic activity in this light and was concerned with documenting fully what he referred to as his "topographic life." Even his drawing procedure and the nature of much of his finished work recall eighteenth-century topographical practice. Working from a pencil sketch done on the spot, carefully annotated with location, color, time, and date, Lear elaborated these sketches in a process he called "penning out." He traced the pencil outlines in pen and ink, adding pale washes of color.

While these drawings are descendants of the eighteenth-century "stained drawings," they are also symptomatic of a reaction against the highly finished exhibition watercolors of the middle of the century. The aesthetic of the sketch, which was shared by a number of artists of the period and lay behind the establishment by the Society of Painters in Water-Colours in 1862 of a second yearly exhibition devoted to its members' sketches, was central to Lear's topographic work. In his process of elaborating the sketch into a finished work, Lear incorporated the original annotations, even strengthening them with pen and ink. The notes became an integral part of the composition, giving the illusion of spontaneity and directness. Lear consciously exploited the natural, unselfconscious act of sketching, producing an artificial equivalent of the type of sketch represented by David Cox's *A French Marketplace* (cat. no. 45).

A View of the Pine Woods above Cannes, with its brilliant color and hard, brittle forms, represents a different class of watercolors, less frequent in Lear's work. Based on the aesthetic

of the highly finished exhibition watercolor, it is aligned with the exhibition works of Francis Danby (cat. no. 55) and William Turner of Oxford (cat. no. 47).

Suffering from poor health, Lear, from the 1850s, sought to escape the harsh, damp English winters in various Mediterranean locales. In the late 1860s he intended to establish a winter residence at Cannes and stayed there from late December 1867 to April 1868, and again in the winter and spring of 1870. He wrote to a friend and patron in January 1868:

> Cannes is a place literally with *no* amusements: people who come must live . . . absolutely to themselves in a country life, or make excursions to the really beautiful places about when the weather permits. I know no place where there are such walks *close* to the town: and the Esterel Range is what you can look at all day with delight. . . . There is *no fog* of any sort. . . .[2]

A View of the Pine Woods above Cannes shows the Esterel mountains with a clarity that evokes the crystalline quality of the air which so impressed Lear. In the spring of 1870, he decided against taking up permanent residence in Cannes and instead built a villa in San Remo on the Italian Riviera, the first of two villas in San Remo in which he made his home for the rest of his life.

While at Cannes, Lear spent much of his time writing the texts for illustrated volumes dealing with his travels in Crete in 1864, on the Nile in 1854, and in Nubia in 1867. In the letter already quoted he recorded his desire "to topographize and topographize all the journeyings of my life, so that I shall have been of some use to my fellow critters besides leaving the drawings and pictures which they may sell when I'm dead."[3] The statement is indicative of the seriousness with which Lear viewed his role as topographer.

1. The most complete account of Lear's life remains Angus Davidson, *Edward Lear* (London: J. Murray, 1938).

2. Letter to Lady Waldegrave, January 9, 1868; in *Later Letters of Edward Lear*, ed. Lady Constance Strachey (London: T. Fisher Unwin, 1911), p. 93.

3. Ibid., p. 91.

John William Inchbold (1830-1888)

In Richmond Park, 1869?

While John William Inchbold was one of the most accomplished landscape painters of the Pre-Raphaelite circle, he seems always to have cut a rather pathetic figure. His personality, retiring yet brusque, was far from ingratiating, and Dante Gabriel Rossetti (1828–1882) described him as "less a bore than a curse."[1]

Inchbold came to London from Leeds in 1836 or 1837; he learned lithography in the firm of Day and Haghe and studied in the Royal Academy schools. In the early 1850s, he began exhibiting paintings at the Royal Academy which in their bright color and obsessive concern with minute detail embrace the tenets of Pre-Raphaelitism. John Ruskin (cat. no. 70), who was championing the Pre-Raphaelites in these years, thought highly of Inchbold's work. It was probably at Ruskin's prompting that the artist visited Switzerland in 1857. In the following year, he went back to Switzerland, spending a fortnight there in Ruskin's company. Those were undoubtedly painful weeks. Ruskin, disappointed with Inchbold's recent work, tried to show him the nature of his faults. Ruskin wrote shortly afterward: "At last I think I succeeded in making him entirely uncomfortable and ashamed of himself, and then I left him."[2] It was about this time that Inchbold turned from the strict Pre-Raphaelite style that Ruskin espoused.

During the years in which he was most influenced by Pre-Raphaelitism, Inchbold worked almost exclusively in oils. As he moved away from Pre-Raphaelitism to a broader, looser style, he tended to work more in watercolors. The handling of *In Richmond Park* is much freer than the minute stippling of his oils in the 1850s, yet by using a dry brush, he creates an effect that is a shorthand for sparkling Pre-Raphaelite detail. The brilliant greens and blues and the unusual

juxtaposition of foreground figures and background also suggest continuing links with the Pre-Raphaelite manner.

If the obscured pencil inscription beneath the signature does in fact read "69," then this watercolor dates to a particularly unfortunate year for Inchbold. Suffering financial difficulties, he was forced to give up his studio and had to seek residence with a succession of friends and acquaintances. In the late 1870s he moved to Switzerland. Apart from an occasional visit to England, he remained abroad until his death.

1. Quoted by Allen Staley, *The Pre-Raphaelite Landscape* (Oxford: Clarendon Press, 1973), p. 112. Staley's chapter on Inchbold (pp. 111–23) is the best and fullest treatment of the artist.

2. Letter to his father, August 9, 1858; in *The Works of John Ruskin*, ed. E. T. Cook and Alexander Wedderburn, vol. 14 (London: George Allen, 1904), p. xxiii.

74. John William Inchbold (1830–1888)
In Richmond Park, 1869?
watercolor and bodycolor over pencil with scraping out
173 x 253 mm (6¹³⁄₁₆ x 9¹⁵⁄₁₆ in.)
Signed in pen, lower right: *I. W. INCHBOLD | Richmond Park*,
over a pencil inscription of the artist's monogram and the date *69*[?];
inscribed by the artist, verso: *May .16* [illegible] *Richmond Park | afternoon*
B1975.4.587

75. Henry Moore (1831–1895)
Showery June, Picardy, ca. 1870–80
watercolor over pencil with scraping out
282 x 388 mm (11¹/₁₆ x 15¼ in.)
Signed, lower right: *H Moore*.
B1975.4.1564

Henry Moore (1831-1895)
Showery June, Picardy, ca. 1870-80

Henry Moore is remembered chiefly as a marine painter. Throughout his career he showed an interest in recording the appearance of the open sea, and from about 1880 this interest became more and more consuming. Moore's involvement with marine painting, like Edward Duncan's (cat. no. 67), grew not from a nautical background but out of an appreciation of the pictorial possibilities of seascape and a concern with atmospheric phenomena fostered, in Moore's case, by an acquaintance with the writings of John Ruskin (cat. no. 70).

Coming from a family of painters in York,[1] Moore moved to London in 1853 and began exhibiting with the Royal Academy, the Society of British Artists, and the British Institution. His work of the 1850s reflects the tenets of Pre-Raphaelite naturalism. The watercolors that resulted from his excursions to Switzerland in 1855 and 1856 show a Ruskinian attention to geological and meteorological detail.[2] In his *Academy Notes* for 1857, Ruskin praised one of Moore's Swiss watercolors, "It seems to me *very* perfect in general harmony of light, and in the sweet motion of the clouds along the horizon."[3]

While sensitive natural observation remained a constant in Moore's art, he passed from a Pre-Raphaelite fineness of touch to a looser, more fluid technique, evident in *Showery June, Picardy*, which has more in common with Impressionism. The effect of brilliant sunlight breaking through the clouds after a summer shower is strikingly caught in this watercolor. It testifies to Moore's concentration on capturing transitory atmospheric effects, a preoccupation which the titles of his many exhibited works make evident.

Moore worked in both watercolors and oils, but in the 1870s he seems to have devoted special attention to his work in watercolors. He became an associate of the Society of Painters

in Water-Colours in 1876, and much of his exhibited work of the late 1870s and early 1880s appeared at the Society's annual exhibitions.[4] Although *Showery June, Picardy* was not exhibited, it seems likely that it dates from about this time.

He had already established a reputation as a marine painter. When he contributed a sea piece and a landscape to his first exhibition with the Society of Painters in Water-Colours, a critic commended his expertise in the one field, while denigrating his effort in the other, "It is doubtless for his rare power in rendering sea under certain aspects that he has been elected, and not for his facility in landscape."[5] *Showery June* demonstrates that he could be as sensitive and original in his treatment of landscape as in the seascapes for which he is better known.

1. The most famous member of the family today is Henry's younger brother Albert Moore (1841–1893), the painter of dreamy women in classical drapery. During their lifetimes, Albert was less well-known than Henry.

2. An example dated 1856, *Mer de glace*, is in the collection of the Yale Center for British Art, B1975.4.1344.

3. *Academy Notes*; in *The Works of John Ruskin*, ed. E. T. Cook and Alexander Wedderburn, vol. 14 (London: George Allen, 1904), p. 104.

4. Even when he was elected associate of the Royal Academy in 1885 (becoming a full academician in 1893), Moore continued to send a few watercolors each year to the Society's exhibitions.

5. *Art Journal* (July 1876), p. 209.

William Paton Burton (1828-1883)
The Marketplace, Tanta, Egypt, 1874

The first edition of Murray's *Handbook for Travellers in Egypt* appeared in 1847. It was a condensed version of a two-volume work, published four years earlier by the noted Egyptologist Sir John Gardner Wilkinson.[1] In these same years David Roberts's *Egypt and Nubia* appeared before the public (cat. no. 62). When a fourth edition of Murray's *Handbook* was published in 1873, the year before Burton produced this view of Tanta, a preface noted the great changes that had taken place in Egypt since the time of the first edition: rail and telegraph lines had been built, the Suez Canal had been completed, and new archaeological discoveries had been made. As the preface put it:

> The changes of which these are a few instances have, in a great measure, arisen from, and in their turn caused, an increased communication between Egypt and the west. Resident foreigners in Egypt may now be counted by thousands, instead of, as was the case twenty years ago, by tens: and the increased facilities for travel, combined with the increased thirst for "doing" all possible countries, send every winter a greater number of travellers to the Nile.[2]

Egypt had become less exotic than it had been for Roberts, but its very accessibility created a broad touristic interest in depictions of it.

Murray's *Handbook* describes Tanta's three annual festivals in honor of the holy figure Seiyid Ahmed-el-Bedawi, who is buried there. During the spring and summer celebrations, the open spaces around the city are crowded with tents, people, and animals, the most important cattle and horse fairs in Egypt taking place at these times. The mass of people and camels that Burton places before the city may well represent some of the celebrants and dealers with

their stock during one of these festivals. The *Handbook* noted that more wine was consumed at the festivals than at any other time of the year, "so at Tantah [*sic*], greater excesses are committed by the modern Egyptians than on any other occasions"; nonetheless, the guide went on to advise, "The traveller who finds himself in Egypt at the time of either of these fêtes will do well to pay Tantah a visit: he will have a good opportunity of seeing national manners and customs."[3]

William Paton Burton studied in Edinburgh and worked for the Edinburgh architect David Bryce (1803–1876) before turning to landscape painting. From 1862 to 1880 he was a frequent exhibitor at the Royal Academy and the Society of British Artists. Most of his work represents English scenery, although he did paint views in Holland, France, and Italy as well as Egypt.

1. *Modern Egypt and Thebes: Being a Description of Egypt, Including the Information Required for Travellers in That Country*, 2 vols. (London, 1843).

2. *A Handbook for Travellers in Egypt*, 4th ed. (London: John Murray, 1873), pp. v–vi.

3. Ibid., p. 113.

76. William Paton Burton (1828–1883)
The Marketplace, Tanta, Egypt, 1874
watercolor over pencil
369 x 521 mm (14½ x 20½ in.)
Inscribed by the artist, lower left:
Market Place | Tanta Egypt | W P Burton 1874
B1975.3.1105

Thomas Danby (1821-1886)
The Passing of 1880, ca. 1880

Thomas Danby was the fourth son of Francis Danby (cat. no. 55). He was with his father in Paris in the 1830s, and as a teenager he made money copying pictures in the Louvre. In the early 1840s, he rejoined his mother, now separated from his father and living in London with the painter Paul Falconer Poole (1807–1879). The younger artist may have absorbed something of Poole's romantic and literary approach to subject matter in the years he resided with him, but compositionally and technically they shared little common ground. Thomas Danby remained devoted to a conception of poetic landscape that was much closer to the art of his father.

This strange watercolor, with its surface carefully abraded to give it the soft, hazy quality of a dream image, corresponds stylistically to a drawing entitled *The Procession of Krishna*, which Adams describes as typical of Francis Danby's last years.[1] It is possible that this, and other similar drawings, should be reattributed to Thomas Danby; however, if the identification of these drawings as work of the father is correct, then sustained or renewed contact between father and son in the father's last years is indicated.

In its wooliness and its visionary, allegorical nature, *The Passing of 1880* suggests the landscape equivalent of the ambitious figure compositions of George Frederic Watts (1817–1904). The nature of the allegory remains obscure. An elaborate barge with a harpist seated in the stern is rowed towards a light gleaming on a distant mountainous shore, led by what seems to be a prehistoric bird. This may simply be an image of the passing of a year—any year—but it is possible that the end of 1880 had a special significance, either personal or public, which Danby commemorated in this watercolor.

1. Eric Adams, *Francis Danby: Varieties of Poetic Landscape* (New Haven: Yale University Press, 1973), cat. no. 154, fig. 156. The watercolor is listed as in the collection of Mrs. Edward Gibbons, Worcester.

77. Thomas Danby (1821–1886)
The Passing of 1880, ca. 1880
watercolor with bodycolor and scraping out
314 x 482 mm (12⅜ x 19 in.)
Signed, lower right: *Thomas Danby*;
inscribed in another hand, verso: *The Passing of 1880 | Royal Jubilee Exhibition |*
Manchester 1887 | Ex collection Walter Field
B1975.4.1488

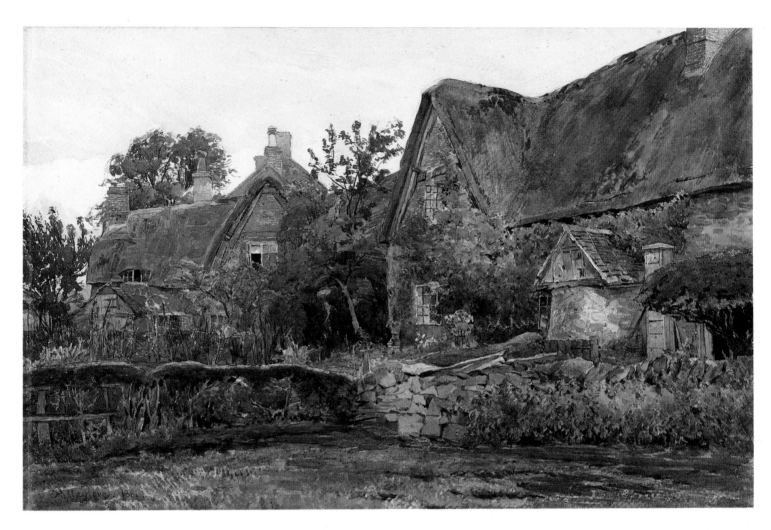

78. John Fulleylove (1845–1908)
Thatched Cottages and Cottage Gardens, 1881
watercolor over pencil
348 x 510 mm (13⁵⁄₁₆ x 20¹⁄₁₆ in.)
Signed, lower left: *Fulleylove 1881*
B1975.4.1919

John Fulleylove (1845–1908)

Thatched Cottages and Cottage Gardens, 1881

John Fulleylove's watercolors of southern France, Oxford and Cambridge, Paris, Versailles, Greece, the Holy Land, Edinburgh, and London formed the basis for a series of exhibitions and illustrated a number of travel books in the last decades of the nineteenth century and first decade of the twentieth. He was a topographical artist at a time when the function of the topographer had largely been taken over by photography. As with his predecessors William Pars (cat. no. 6) and "Grecian" Williams (cat. no. 32), Fulleylove's watercolors of Greece, made during a trip there in 1895, exhibited at the Fine Art Society the following year, and reproduced in *Greece Painted by John Fulleylove, Described by the Rev. J. A. M'Clymont*, published in 1906, mark a high point of his work as a travel artist.[1]

While Fulleylove's Greek series represents a late flowering of the topographical tradition, his *Thatched Cottages and Cottage Gardens* is a late development of another traditional theme in British art, stretching back to the Picturesque cottage subjects of Thomas Gainsborough (1727–1788) and Francis Wheatley (cat. no. 25). From the late eighteenth century onward, the humble cottage has been a potent symbol for the English of rural peace and domestic contentment. Within the range of Victorian treatments of the theme of the rustic cottage, Fulleylove comes closer to the neat and cozy vision of Helen Allingham (1848–1926) than to the poetic intensity of Samuel Palmer (cat. no. 46). Yet his approach is less idealized than that of either of those artists. Fulleylove's watercolor technique is looser and bolder than Allingham's, his color is stronger than her delicate pastels, and his presentation of these cottages is more dispassionate, with no neatly attired children and young mothers to reinforce the image of domestic bliss. Nonetheless, his cool pervading greens and the irregular lines of the cottages obscured by and merging with the surrounding vegetation suggest a comfortable oneness with nature and a timeless rural felicity.

Thatched Cottages and Cottage Gardens is one of a pair. Its companion, also signed and dated 1881, reverses the compositional format of this watercolor.[2]

1. Five of Fulleylove's Greek watercolors are in the Yale Center for British Art, B1975.3.836–837, B1975.3.-1017–1019.

2. In the Yale Center for British Art, B1975.4.1920.

SELECTED BIBLIOGRAPHY

This bibliography is limited to works of general interest on the subject of British watercolors. Books on individual artists are indicated in the footnotes to the catalogue entries. The emphasis in this selection is on recent publications; more complete bibliographies may be found in the volumes by Martin Hardie, Andrew Wilton, and Michael Clarke.

Baskett, John, and Dudley Snelgrove. *English Drawings and Watercolours 1550–1850 in the Collection of Mr. and Mrs. Paul Mellon*. Exhibition catalogue, with introduction by Graham Reynolds. New York: Pierpont Morgan Library, 1972.

Bayard, Jane. *Works of Splendor and Imagination: The Exhibition Watercolor, 1770–1870*. Exhibition catalogue. New Haven: Yale Center for British Art, 1981.

Clarke, Michael. *The Tempting Prospect: A Social History of English Watercolours*. London: British Museum Publications, 1981.

Cohn, Marjorie B. *Wash and Gouache: A Study of the Development of the Materials of Watercolor*. Exhibition catalogue. Cambridge: Fogg Art Museum, Harvard University, 1977.

Hardie, Martin. *Water-Colour Painting in Britain*. Edited by Dudley Snelgrove with Jonathan Mayne and Basil Taylor. 3 vols. London: Batsford, 1966–68.

Mallalieu, H. L. *The Dictionary of British Watercolour Artists up to 1920*. Clopton, Woodbridge, Suffolk: Antique Collectors' Club, 1976.

Noon, Patrick J. *English Portrait Drawings & Miniatures*. Exhibition catalogue. New Haven: Yale Center for British Art, 1979.

Roget, John Lewis. *A History of the "Old Water-Colour" Society*. 2 vols. London: Longmans, Green, 1891. Reprint (2 vols. in 1). Clopton, Woodbridge, Suffolk: Antique Collectors' Club, 1972.

White, Christopher. *English Landscape 1630–1850: Drawings, Prints & Books from the Paul Mellon Collection*. Exhibition catalogue, with preface by Andrew Wilton. New Haven: Yale Center for British Art, 1977.

Williams, Iolo. *Early English Watercolours, and Some Cognate Drawings by Artists Born Not Later than 1785*. London: Connoisseur, 1952. Reprint, with introduction by Edward Croft-Murray and Malcolm Cormack. Bath: Kingsmead Reprints, 1970.

Wilton, Andrew. *British Watercolours, 1750 to 1850*. Oxford: Phaidon, 1977.

Yale Center for British Art. *Selected Paintings, Drawings & Books*. Foreword by Paul Mellon. New Haven: Yale Center for British Art, 1977.

INDEX

The American Federation of Arts